D0908885

ANALYZING AN ART MUSEUM

Anna Hendon

ANALYZING AN ART MUSEUM

William S. Hendon

PRAEGER

PRAEGER SPECIAL STUDIES • PRAEGER SCIENTIFIC

Library of Congress Cataloging in Publication Data

Hendon, William Scott, 1933-
 Analyzing an art museum.

 Includes bibliographical references and index.
 1. Art museums--Management. 2. Art museums--
Educational aspects. 3. Art museums--Economic aspects.
I. Title.
N470. H46 069'. 9'70813 79-10753
ISBN 0-03-050386-8

PRAEGER PUBLISHERS,
PRAEGER SPECIAL STUDIES
383 Madison Avenue, New York, N.Y., 10017, U.S.A.

Published in the United States of America in 1979
by Praeger Publishers,
A Division of Holt, Rinehart and Winston, CBS Inc.

9 038 987654321

© 1979 by William S. Hendon

Printed in the United States of America

To Mary Ann

PREFACE

The purpose of this book is to offer some assistance to interested museum directors and staff persons who may wish to empirically examine their museum services and operations. The book is managerial in focus, although I hope it is not insensitive to art and to art museums. Techniques developed and employed for the case study should have relevance for other museums. Policy questions raised are thought to be typical, although the proper mix of policy questions will differ from museum to museum. Finally, the analysis is not complete, in the sense of going into every aspect of museum operations where analysis could be made; rather, a few simple analytic devices were pursued with the idea in mind that whatever was developed should be capable of being employed by a museum staff without having to seek outside consulting help.

Many persons have helped in this project. Initially, the data were gathered in a study of the Akron Art Institute undertaken in 1972 by Edward Hanten and myself and funded by the Akron Community Trust. I wish to acknowledge my great appreciation to Hanten; without his help, the original study, and the present book, developed from it, could not have been possible. My debt to him runs throughout the work. I want also to mention my colleague, Frank Costa, who developed the national museum survey.

Various staff persons at the museum were of signal help: Donald Harvey and Orrel Thompson, early on, and John Copelans and Marjory Harvey, in 1978, all provided invaluable assistance in data collection.

In the Department of Urban Studies at the University of Akron, graduate research assistants all contributed mightily. Alan Pearson, Roy Patton, Bob Cook, and Mark Riley helped with their computer skills. In addition, Riley and Jack Pierson were instrumental in developing the art-publics concept and its application. Other students who assisted included David Falconeri, Danene Bender, Dale Connors, and Edward Budzyna.

Bruce Hansen did the footwork on classifying the museum's collections, and Al Papa did yeoman service on the original study.

Finally, I wish to acknowledge Ms. Arlene Lane and her secretarial staff for their considerable assistance in the preparation of the manuscript. Lynn Larke, Sue Hoff, and Lori House all typed various parts of drafts. The figures and frontispiece were done by Anna Hendon.

CONTENTS

Appendix

LIST OF TABLES AND FIGURES

ANALYZING AN ART MUSEUM

Chapter One

INTRODUCTION

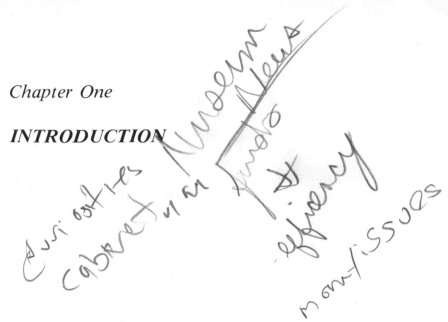

The local art museum today is important as an institution serving a diverse and increasing array of art publics—a multipurpose institution that serves publics who vary from casual visitors to fully committed and dedicated artists or scholars. The growth from the traditional art museum as treasure storehouse to the multiservice art institution is obvious. Art museums undertake a variety of educational efforts. They collect for study and for exhibition. Their service efforts commonly include crafts, music, and lecture programs. Visitors increase, and the increasing interests of diverse publics demand that museums respond by serving these needs. And so they do, but funds to meet these needs have not kept pace with the rising demands for service; thus as visitors increase, problems mount.

Although increased funds would help to solve the problems, there is no doubt that museums must look to more efficient use of the funds they already have. Few museums are known for the efficiency of their operations. Yet, if they were more efficient, museums could better serve their art publics.

To an economist, efficiency lies at the very heart of management problems that have been raised in the museum literature. General management problems appear to inhibit museum service, problems that are not solely the result of lack of funds or lack of facilities. For example, Thomas Vaughan argued, in a speech delivered to the American Association of Museums and in a subsequent article in *Museum News*, that a profound weakness of museums is their lack of a code of formal rules and procedures. He indicates a need for explicit goals and policy; precise definitions and duties of the museum board, the director, and the staff; formal employee policy with regard to probation, job description, promotion, salary range, sick leave, medical and fringe benefits, leaves of absence, retirement, due process in dismissal, peer evaluation, and solicitation by employees. Few museums, he argues, have such policies.[1] Vaughan also cites museums for

ding to have an explicit collection policy, particularly as it relates to questions of ethical employee conduct.[2]

Similarly, James Kittleman argues that a well-run museum is an accident, because museums were dominated so long by collectors who charted the future course of the museum; because of lack of adequate management and administrative training; and because museums must now operate in the public arena to obtain financial support, a phenomenon with which they are largely unfamiliar.[3] According to Kittleman, at least some, if not all of the following aspects of sound management are lacking in every museum:[4]

1. adequate definition of objectives and goals;
2. a strong board of trustees wedded to high standards;
3. bylaws that reflect the cooperative relationships between board activities and administration;
4. board-member selection processes that identify qualified persons in the community, with distinct abilities and varied experience, who can serve for limited terms;
5. a plan of administrative organization built around functions instead of people; the board should have functional committees that are coordinated with administrative activities;
6. recognition that leadership is needed at the top, as well as in every supervisory position;
7. a policy manual, developed by the administration and approved by the board, which will serve as an operational road map for good management;
8. personnel administration standards for both professionals and nonprofessionals;
9. recognition of the continuing need for planning at the board level and throughout the administration;
10. professional program leadership based on present collections and future accessions; this is the raison d'etre of museum management and its basis for public support;
11. an understanding of the continual and growing need for financial support, for the organization of annual fund-raising efforts, and for a long-term development program;
12. the building of public membership in the museum, through inspirational programming attractive to the varied public that the museum serves;
13. fiscal responsibility, embodied in strong financial planning, departmental budgeting, and thorough management controls;
14. a strong program of communication both within and outside the museum;
15. the development of an esprit de corps among the members of the museum family, born of mutual respect and trust and a genuine desire for teamwork in management;

16. a sense of urgency; an ambition to succeed in the development of a first-class museum with high standards.

Then, of course, there is the long-standing argument as to whether a museum director should be a professional manager or should be exclusively involved in art. This is really a professional argument, between those who emphasize art history, and those who think museum directors should also have training in a management field such as public administration. Such an argument is often tied to whether there is a conflict between pursuing the aesthetic mission of the museum and, at the same time, having a well-managed museum in the business sense.

If Vaughan and Kittleman are correct, then there are fundamental management problems facing most of today's art museums, problems that additional funds are not altogether likely to solve. If, on the other hand, the art historian's view is correct, then museums should continue as they are, with only a modest nod to managerial change, because to do otherwise means that museums may fail to do well those things in art that have been museums' primary tasks. But if the art historian's view is not correct, then museums may flounder on the reefs of political and financial realities and sink majestically into the sea—in many instances, with few people really noticing.

OBJECTIVE OF THE STUDY

The objective of this research is to produce a case study of an art museum that concentrates on the issue of efficiency in museum resource allocations. The topic is developed through a case study of the Akron (Ohio) Art Institute (AAI), by means of a cost-benefit analysis. Only by a systematic economic evaluation of museum programs and activities can efficient decisions be made in terms of which programs to concentrate upon, and which ones appear less promising within the constraint of allocating scarce resources among competing demands.

In another way, an economic analysis could provide the basis for better planning for the future. If a careful assessment of programs is made on a regular basis, and the art publics of the museum are known, the director may have some statistical basis for knowing the trends of taste and preferences among the art publics served.

In short, one way to improve a person's standard of living is to show the person how to better manage present income; similiarly, one way to increase a museum's services is by improving the decision-making process.

The specific objectives of the research are—

1. to develop and apply a technique for a museum to identify the various art publics it serves;

2. to develop and apply a comparative analysis for studying the operation of other museums;
3. to develop and apply a one-year cost analysis of education, exhibition, and development activities;
4. to develop and apply an assessment of the one-year economic benefits to be derived from exhibition, education, and development activities.

These research objectives are directed at the Akron Art Institute, as one of several hundred small-to-middle-sized museums. Usually, when we think of art museums, we think in terms of major art museums in the United States. Yet, while the major museums number in the dozens, museums like Akron's number in the hundreds. From the standpoint of art history, perhaps the major museums are of most importance; they are the Neiman Marcuses, the Saks 5th Avenues, in some sense even the Bloomingdales of the art world. But the Akron Art Institutes, whether they be in Kalamazoo, in San Antonio or Chippewa Falls are the typical local art museums of America's towns and cities. They are the local franchise stores of the art world. As such, they are the principal public or quasi-public art museums of our society, not the paragon cases perhaps, but the paradigm cases. Whether they function well makes a great deal of difference to whether art has a strong impact locally or does not. Whether we judge by numbers of visitors, by value of collection, by size of physical facility, these middle museums are the key local art institutions.

This study of Akron's museum is for the most part, a cross-sectional study of one fiscal year of the museum's operations; the fiscal year 1971-72 represented the year selected for study, with the research work initiated in 1972. Cross-sectional studies must be carefully done so as not to argue too strongly about either the past or the future of museums. Every effort has been made to limit the discussion to those elements of the museum that a cross section makes possible, and not to impute too much to future or to earlier years.

BACKGROUND FOR THE STUDY OF THE ECONOMICS OF THE ARTS

The arts are a new area of study in economics, and had this section been written ten years ago, the number of bibliographical selections to examine would have been quite small. Even now, when one looks into bibliographical sources for economic studies of art, one is not impressed with the volume of literature. These remarks, notwithstanding, what follows is by no means an exhaustive review of the literature.

Among the few works of the early 1960s are Richard Rush's *Art as an Investment*, published in 1961; the U.S. House *Hearings on Economic Conditions in the Performing Arts*, published in 1962; and the most widely quoted and one of the most useful books to this day, William J. Baumol's

and William G. Bowen's *Performing Arts: The Economic Dilemma*.[5] Bowen and Baumol argued that the performing-arts industry faced an income-earnings gap, an ever-widening gap between costs of production and revenues. The problem was the comparative inability of the performing-arts labor resource to increase its productivity via technological change. Another book has been important to early researchers—Alvin Toffler's *The Culture Consumers*.[6] In England, Alan Peacock's work on the performing arts was yet another early contribution.

By 1970 the literature began to flow as increasing (although still small) numbers of economists began to conduct research into the arts and other cultural areas. Tibor Scitovsky, writing in an article for the *American Economic Review* in 1974, and later in a book, *The Joyless Economy*,[7] used our failure to support the arts as an argument for what is wrong with society. Following Baumol's lead, Steven Globerman began, in the early 1970s, a series of research efforts on the arts in Toronto for the Canadian Arts Council. From that work, Globerman and Sam Book published an article on statistical cost functions for the performing arts.[8] Quite apart from these pursuits, at the Midwest Economics Association meeting in 1973, a session on "Economics and Aesthetics" was chaired by William S. Hendon. Papers presented there included an analysis of works of art held solely for investment purposes, by John Stein,[9] and a paper on the economics of aesthetics in architecture, by George Hellmuth, a St. Louis architect.

Hendon, along with Edward Hanten, completed the first economic analysis of an art museum, the Akron Art Institute, in 1973. This study developed basic methods of evaluation of museum programs, management policy and techniques, future and current planning decisions, and a general development plan for the Akron Art Institute.[10]

At the Midwest Economics Association meeting, 12 economists formed what has since been called the Association for Cultural Economics, the aim of which is to encourage academic economists to do research in cultural topics. Since that time the organization has grown to a membership of over 200, both in the United States and abroad, and has led to the development of the *Journal of Cultural Economics,* the first semiannual issue of which appeared in May 1977.

The literature of the economics of art moved slowly, but by 1975 and 1976, a large number of studies began to appear. Frank Tinari, at Seton Hall University (South Orange, New Jersey), prepared a paper on "A Survey in Grants Economics: The Findings of Empirical Studies of Household Monetary Donations." Andrew Weintraub looked at the economic dilemma in the performing arts in an article for the first 1975 issue of the *Performing Arts Review* (an excellent journal for those interested in policy). Mark Blaug edited an excellent book on *The Economics of the Arts*.[11] Jack Nickson, Carl Colonna, and John Stein began a debate on the rights of artists in regard to subsequent sales of their works, in the first issue of the *Journal of Cultural Economics*. Globerman took up the question of the consumption

efficiency of spectators in the arts, arguing that the greater the education of spectators, the more efficient they are as consumers of culture.[12] A comprehensive study of audiences, done recently by Paul DiMaggio, Michael Useem, and Paula Brown, for the National Endowment for the Arts (NEA), is entitled *Audience Studies of the Performing Arts and Museums: A Critical Review*.[13] Dick Waits addressed the issue of income-redistribution effects of art museums. Michael O'Hare did work on evaluative methods and other issues in the arts for the Twentieth Century Fund. From O'Hare's project on Indirect Aid to the Arts, Mark Schuster, at MIT, has done a paper on "Program Evaluation and Cultural Policy." Lou Henry and Carl Colonna presented a paper on the impact of revenue sharing on public libraries, at the meetings of the Virginia Association of Economists in 1976. At the Southwest Economics Association meeting in 1976, Roger Vaughn took the National Endowment for the Arts to task for subsidizing arts institutions, instead of subsidizing individual consumers and producers of art. Harry Walker and Robert Bonnington developed an approach to surveying symphony audiences to ascertain their tastes and preferences.[14]

At the Midwest Economics Association meeting in April 1976, Douglas Heerema presented an economic history paper in which he looked at British painting of the eighteenth and nineteenth centuries as a source of perceptions of the industrial revolution. Virginia Lee Owen detailed the economic-market differences between Florentine and Sienese artists. Other historical work includes J. Michael Montias's paper on the income differences between guild and nonguild painters in early Delft. Floyd Durham has analyzed the development of an art colony in Fort Worth, Texas. Scitovsky discussed the possibility of orienting consumer tastes toward more cultural goods as a means of reducing energy consumption.[15]

At the macroeconomic level, Dick Knight initiated work (unpublished) on the economic impact of the University Circle museums on Cleveland's economy. Louise Weiner, of the U.S. Commerce Department, presented a paper for the White House Conference on Balanced National Growth and Economic Development, entitled "Perspectives on the Development of Potential of Cultural Resources."[16] The National Endowment for the Arts awarded research contracts for work on the demand for the arts, the impact of art museums on the local economy, impacts on regional economies, and other development issues. Research and policy highlights of these studies appear in a proceedings from a conference co-sponsored by the NEA and Johns Hopkins University at the Walters Art Gallery in Baltimore, in December 1977.[17] One work of special note has been the research of David Cwi and Katherine Lyall, *Economic Impacts of Arts and Cultural Institutions: A Model for Assessment and a Case Study in Baltimore*. And, like subsequent NEA studies, the first NEA division report, *Employment and Unemployment of Artists, 1970-1975,* is of great interest to economists.

Thomas Moore has published a book, *The Economics of the American Theatre*.[18] And, in 1978, Dick Netzer published *The Subsidized Muse:*

Public Support for the Arts in the United States.[19] This major study of public support in the arts has become a standard reference. Another work of interest is a book by the Australian National University's Glen Withers and David Throsby, *The Economics of the Performing Arts*, (scheduled to be published in 1979). Also, there is E.T. Grist's "Inflation and Cost Problems in the Theatre," which appeared in the *Westminster Bank Review* of May 1976.

Articles appearing in the June 1978 issue of the *Journal of Cultural Economics* include Mark Blaug's study of Covent Garden in which he assesses various policies to reduce opera-ticket prices (and finds little hope for such policies); Leslie Singer's "Microeconomics of the Art Market," the application of Lancastrian demand theory to art markets; Marianne Felton's extensive study of composers, "The Economics of the Creative Arts: The Case of the Composer"; and James L. McLain's analysis of the status of visual artists, "The Income of Visual Artists in New Orleans." (McLain has also done work on the economics of the Mardi Gras.)

The December 1978 issue of the *Journal of Cultural Economics* included a short article on the Paris Opera by Dominique LeRoy; Peacock's article on historic preservation, "Preserving the Past: An International Economic Dilemma"; Owen's rejoinder to Roger McCain's comment on her research into the Florentine and Sienese art schools; James Shanahan's "The Consumption of Music": Integrating Aesthetics and Economics"; and Rosemary Hale's article on "The Economic Aspects of History Preservation."

The U.S. Conference of Mayors has issued a position paper, "The Taxpayer's Revolt and the Cuts: Woodsman Spare That Tree," on the role of the arts in urban growth and development; and Harvey Perloff has completed a book researching the arts industry and community development. A conference on cultural economics was held in Minneapolis in October 1978, on The Role of The Arts in Urban Economic Development. The conference was sponsored by the National Endowment for the Arts, the Department of Commerce, and the Office of Policy, Research and Development, in HUD, among others.

Articles scheduled for publication in 1979 in the *Journal of Cultural Economics* include "Private Demand Subsidies: An Econometric Study of Cultural Support in Australia," by Withers; and "What Price Patronage Lost," by James Gapinski. Gapinski also has written "The Production Structure of Nonprofit Performing Arts Organizations," a research effort summarized in the *Washington International Newsletter* of September 1977. Other works to be published in the *Journal of Cultural Economics* include Montias's previously mentioned paper on artists in Delft; an article by V.N. Krishnan on "Cultural Change, Technology and Indian Economic Development"; McCain's "Reflections on the Cultivation of Taste"; and Globerman's work on price awareness among art consumers.

Other work currently going on includes Edward Banfield's book on the

visual arts and public policy; and a symposium on subsidy in the arts, edited by the present author and Shanahan, and featuring papers by Cwi, Bruce Seamon, Arnold Berleant, and Haig Khatchadourian, with comments by Milton Russell and McCain. This symposium will be published in the *Journal of Behavioral Economics.* In addition, the National Endowment has awarded contracts on the following research: *Creative Personnel in the Media Fields of Radio, Television, and Film*; a study of economic conditions, needs, and communication networks of visual artists; a study list of arts organizations; and a study of U.S. folk–craft artists.

While most of the work in cultural economics has been directed toward the arts, not all of it has. Among the nonarts literature, and of most importance, has been Kenneth Boulding's "Toward a Cultural Economics," which appeared in the *Social Science Quarterly* in 1972. Robert Shelton, of the National Academy of Sciences, has done work on the economics of religion. Tetzunori Koizumi, at Ohio State, has done two papers on religious beliefs and the Japanese conceptions of economic man and behavior. One of his papers has appeared in the *Journal of Cultural Economics.*

One cannot know what future research directions will bring in cultural economics. The entire nonarts side of the field is not well developed and awaits further work. On the arts side, the cultural economics field has pursued and will continue to pursue (among others) the following areas of study:

1. arts and urban redevelopment
2. economic history of the arts
3. economics of religion
4. cultural aspects of development in developing countries
5. the arts and neighborhood development
6. economic impacts of the arts
7. issues in public subsidizing of the arts
8. economic status of cultural institutions
9. economic status of artists
10. supply-and-demand studies
11. consumer behavior in the arts
12. economics of historic preservation
13. status of arts institutional management
14. art collecting and art markets
15. art and cultural planning
16. needs assessment for cultural services
17. intergovernmental relations and the arts

All of these areas need to have substantial work done in them and, happily, it looks like this work will be forthcoming.

ANALYTICAL DESIGNS OF THE RESEARCH

The present work focuses on an assessment of a museum's educational activities and exhibitions as well as the general area of museum development. Within these areas, several study designs are required.

This study of the art museum in Akron is a partial analysis of the programs of the local art museum and an analysis of its closest audience, its visitors. From the standpoint of the analysis of programs and services the museum provides for the community, it is important to gain some insights into whether or not the programs are valuable both to participants and to the community at large. One level of this value is the economic one; that is, is the service performed efficiently? Cost-benefit analysis is used to determine service efficiency. Another level of valuation lies in the developing of a model of art publics, in order to determine the major classes of art publics of the museum, and to ascertain what their value and attitude perceptions might be in other-than-economic terms. Both the efficiency analysis and the analysis of art publics ought to prove useful (necessary but not sufficient) in the effort toward improved planning and programming at any museum.

Identification of Art Publics

One research effort is the development of a device for permitting museums to identify the particular art publics they serve. The idea comes from Bruce Watson's work on a typology of art publics.[20] Watson identified a continuum of six different art publics, as opposed to discrete publics. These art publics are divided into persons with essentially positive, as opposed to negative, attitudes toward art; further subdivision splits the two attitude groups into three value groups each. The scheme below illustrates the basic Watson typology.

	Attitude	
Value	Positive	Negative
Intrinsic	Art for art's sake	Pseudocritical
Intrinsic/extrinsic	Educational	Didactic
Extrinsic	Recreational	Status seekers

To apply this typology, a series of statements was developed to elicit a Likert-type scale of responses from visitors to the museum in regard to their particular attitudes toward art, broken down by the three value groups. Respondents replied to the statements within a range of four possible answers, from "strongly agree" to "strongly disagree."

Educational Programs, Exhibitions, and Development: Benefits and Costs

Educational programs, exhibitions, and development can be analyzed by the use of effectiveness measures that center around an activity's

enjoyableness and the participant's willingness to spend time and money on the activity. For all three areas, the willingness-to-pay measures assess a mix of the money costs that the art public spends on donations, supplies, equipment, round-trip travel, and fees. The willingness-to-pay measures rely in part on the recreational economics literature, including Marion Clawson's work on the derived-demand curve and Jack L. Knetsch's refinements of the work.[21]

In general terms, cost-benefit analysis includes the following procedures:

1. a brief description of the project or program being evaluated;
2. an assessment of who is affected directly or indirectly by the project or program;
3. a narrative description of the proposed program outcomes (what are the outputs) and how these will affect the relevant populations (persons directly or indirectly affected);
4. a measurement of the economic value of the outputs of the project, that is, the benefits;
5. an accounting of the economic costs;
6. an accounting of the indirect effects, the externalities, that result from the project, both economies and diseconomies;
7. an assessment of the constraints under which the project functions and the effect of these constraints on outputs;
8. an examination of the impact of time on benefits and costs—that is, what, if any, discounting should be employed in valuing costs or benefits?;
9. an examination of the redistribution impacts of the outputs and the inputs; and
10. where necessary, a consideration of alternatives to accomplish the same aim or goal.

Although usually expressed in technical terms, the above items reveal cost-benefit analysis as a way of thinking through the efficiency aspects of the production of goods and services, a process which should be evaluated not less than once each year—in other words, an ongoing evaluation.

Museum Comparisons: A Survey. A further needed analysis was a comparison of Akron's museum with museums in other cities of the same or similar size. A survey schedule was designed that permits a comparison of the Akron museum's budgets, physical facilities, visitation records, collection, personnel, and other relevant items with the same elements in other similar museums.

THE AKRON ART INSTITUTE IN BRIEF

The Akron Art Institute was founded in 1920 at a meeting of concerned citizens; however, it did not begin to functionally operate until February of 1922. The AAI moved several times, and in 1937 it occupied Akron's Commins Mansion (a pre-Civil War structure), which was purchased for $15,000, a purchase made possible by an anonymous gift of $7,500. In January of 1942 the mansion was destroyed by fire, with damages estimated at between $150,000 and $160,000, including the building and its contents. This included the loss of a rare collection of oriental potteries, ceramics, and porcelains.

In 1947 the Art Institute moved again, to its present location, the old City Library building. The city provided the building on a lease of $1 per year, but the institute was to be responsible for maintenance. A professional art school opened on the first floor in 1947, and the entire building was opened for use by the institute in 1950.

In 1971 the city gave title to the building and grounds to the Akron Art Institute, with one condition attached. If the institute was to sell the present building and relocate, the new site must be within a radius of two and one-half miles of the present site. This was obviously an attempt to ensure that the institute would continue to remain within the center of the city of Akron.

MUSEUMS AS ECONOMIC UNITS: SOME PRELIMINARIES

In an economic sense, we can view the art museum in most communities as a form of local monopoly, which in turn functions under a kind of oligopolistic system at the regional and national levels. Although there is usually only one art museum in a town or city, museums interact nationally; they lend each other art, buy art from each other, and operate in art markets as buyers of capital equipment—that is, art is used to provide a service to the consumer.

A museum provides a variety of potentially satisfying experiences: (1) education, in the sense of providing formal classes (in competition with other class activities), and education through exhibition (a near-monopolistic situation); (2) scholarship, by the use of collections for study by art scholars and students (usually a local monopoly); (3) recreation, in the sense of providing a place to go (in competition with other uses of leisure time); (4) a moral, that is, spiritual experience (provided in competition with religious institutions); (5) an aesthetic experience (in competition with a myriad of aesthetic experiences), in a sense, another kind of spiritual interaction; and (6) an outlet for satisfaction for status-conscious people. These outlets for satisfaction have to do, in each case, with the interaction of

the viewer with art in some intimate context, but not all of them represent what is called the aesthetic experience as expressed in either philosophy or psychology.

These many experiences are gained from the provision of services such as the research use of museum library facilities, meeting space for community groups, auditorium space for performances and lectures, art appraisal for museum members, and outlets for art buying and selling. Services also include shops and refreshment or food-service activities, specific programs for public school children that take place in the schools, inner-city youth programs, and a variety of other related service outputs. The local museum is, in economic terms, therefore, a multiproduct firm, competing in some markets with its outputs, oligopolistic in others, and monopolistic in a few instances.

Art museums are also part of a growth industry (although they would hate the term industry). Visitations increase and demands for outputs increase. Costs increase as well.

Museum outputs, however, are so diverse that services cannot be wholly or satisfactorily defined. They have not, to this date, been systematically detailed by any of the academic disciplines, nor by museum people themselves. For the sake of convenience, we can refer to the consumer's experience with art museums in terms of a "visit," either to the museum, or when the art is taken to the viewer. Though inadequate as a statement of output, the term "museum visit" brings some order to a perception of the bare quantities of the consumer experience with these many museum services.

THE AIMS OF ART

Usually, the _aesthetic experience_ is thought to be central to the satisfaction derived from a consumer's encounter with art. The aesthetic experience is essentially a personal experience upon which individuals place value. The art itself can be referred to descriptively by reference to the similarities that a particular object has to other objects generally considered art, the so-called paradigm cases of art. At an evaluative level, art can be judged good or bad according to the impact it has upon qualified viewers in optimum conditions of viewing.

The aims of art are different from the aims of most other objects. While most objects are thought to have use or function, art, in an aesthetic sense, has only the aim of providing an experience. In other words, art, when used for decoration, or for education, is used in an extraaesthetic way. Objects which can be called art may be used to accomplish other purposes, but not art considered from the standpoint of the aesthetic experience. In the aesthetic sense, these extraaesthetic aspects or uses of art are broader than,

but nonetheless often similar in concept to, the economic notion of external-ities, the idea of spillover effects resulting from consumer satisfaction with art. Both the aesthetic and extraaesthetic aspects reflect value to the con-sumer.

Because a sophisticated appreciation of art requires an understanding of the art codes that are necessary to decipher the work and gain the aesthetic experience, the museum curator can become very cynical about his customers. As Kenneth Hudson suggests:

> The difficulty of which most curators of large museums are well aware is that they and the members of their professional staff are highly educated people and that many of their visitors are nothing of the kind. They naturally wish to improve this situation, to bring visitors closer to their own level of taste and knowledge; but they disagree, often fundamentally, as to how this can best be done and more than a few have come to believe that the attempt is futile, that the serious work of the museum should go on behind closed doors, while the public is given a circus to keep it amused and contented.[22]

But, Hudson also notes:

> A museum with a staff of experts is, inescapably, in a "we-and-they" position with regard to the general public. During the past twenty-five years especially, many of the most creative people in the museum world have come to believe that such a position is sterile, in that it prevents a museum from helping those who could most benefit from help and encouragement.[23]

Art, if it has aesthetic value, has the ability to achieve the state of affairs that we call the aesthetic experience. Its value, then, lies in what it conveys. A work may be characterized as impressive, thrilling, enjoyable, absorbing, powerful, thought provoking, and such artistic abilities or capacities may be thought to be evaluative criteria.

Basically, the aesthetic criteria for evaluating the work of art are thought to be the extent to which a work may evoke a stimulation of the viewer's intellect, imagination, and emotions. The first criterion, stimulation of the intellect, is essentially regulative to the extent to which a work is enjoyable. The second criterion, stimulation of the imagination, is important in that it refers to the critical evaluation of a work's formal, material, and technical features. The third criterion, stimulation of emotions, appears to be the principal criterion because it is only in the arousal of feelings that art appears to be universal. Not all art expresses ideas or stimulates the imagination, but a universal characteristic of art is that it can stimulate feelings and be enjoyable to the viewer. This enjoyment is the center of the aesthetic experience.

Does this often take place in a museum? As Hudson argues:

In its original setting, a painting or a piece of sculpture contributes to a mood of relaxation, which makes contemplation possible. Put into a gallery, it has to compete with other works, in an atmosphere which is neutral, if not actually hostile. An art gallery, says Malraux, "is as preposterous as would be a concert in which one listened to a programme of ill-assorted pieces following in unbroken succession." [*Voices of Silence*, 1954] In such a situation, our approach to art has grown steadily more intellectualized. If our emotions are crippled, we can only interpret through our brain. . . .

Only the person of exceptional imagination, knowledge and powers of detachment can restore to an object the associations and the qualities which the museum has taken away. There is simply too much of everything, in too artificial a situation to make anything more than an intellectual response possible, although just occasionally the extraordinary force of a work of art will allow it to break loose from the gallery-bonds which hold it down. It is no accident that museums have become temples of scholarship, since their intellectual emphasis is so strong. But most visitors to museums are not intellectuals, and this is the source of the major problems which curators have been facing for many years.[24]

Indeed, many visitors may come primarily to kill time, to eat lunch, to get in out of the rain, or to get out of the house. Parenthetically, the casual consumer who pays for the experience may feel very negative about art. He may seek art for the presumed value it is supposed to have for him, but not enjoy the experience. Hudson observes:

The growth of connoisseurship during the eighteenth and nineteenth centuries inevitably made ordinary people feel inferior when faced with works of art. So long as a religious painting or statue or monstrance remained in a church, it had no elitist association. It belonged to everybody and had meaning for everybody. Once it was moved to an art gallery, a different set of values came into play. It had to be judged in its own right, as an artistic production, and that needed experience and a specialized vocabulary. Museums have a remarkable power of making the uneducated feel inferior.[25]

Hudson notes further:

Not all art is meant to be looked at in a spirit of reverence, a truth which often escapes art historians. To stand quietly and as near as possible invisibly among, say, the large collection of Picassos at the Museum of Modern Art in New York, and to listen to the earnest conversation which surrounds even the painter's most frolicsome and light-hearted canvases is to realize the leaden feet on which criticism and scholarship can make their way.[26]

Thus, while the aesthetic experience is the central purpose of a visit, stimulation of the emotions may not often occur; there are other reasons for paying a visit to an art museum. Thus "visit" as a general measure of the museum's output is a better indicator than it might at first appear.

ART AS AN ECONOMIC GOOD: A SUMMARY OF SOME OF THE ASSUMPTIONS

In characterizing art and works of art as economic goods, a number of points can be made. First, works of art are produced by individual artists or groups of artists (professional or amateur in either case), for formal or informal markets. By formal markets, we mean actual markets in which the work is produced and sold at a price. By informal markets, we mean markets in which no price is paid but where the art is given to another person or group. To be characterized as art in the economic sense, those works to which informal markets apply must have some economic value that can be estimated by a shadow price. Second, a work of art is essentially a sensible thing, but it may be in some ways insensible. Third, a work of art may be a single work or it may be a group of things or ideas. Fourth, all works of art are perceived to be painting, music, sculpture, poetry, and so on, but not all such works are works of art. A distinction is necessary when we are evaluating art. Fifth, we distinguish between the physical inputs of the work of art and the work itself. The work may be an artifact, but it will not be the sum of its sensible parts. Sixth, we may further distinguish between physical works of art and works of art in the subjective sense, such as music, that is, art in a descriptive sense. In a descriptive sense, any work may be art, but in an evaluative sense, only qualified works may be so called.

A seventh attribute of art and works of art is that there is little reason to believe that there are many universals in art. An eighth aspect is that the emotional feelings that the work may prompt are not thought to be part of the work; rather, beauty is in the eye of the beholder. The consumption of art is personal in this sense. A ninth idea is that what is represented by the work is not part of the work itself—a map is not the territory covered. A tenth idea about works of art is that words themselves are probably not sufficient means to describe art. Eleventh, art is a form of wealth to the individual and to the society. Twelfth, art can either be a producer good or a consumer good with external effects. Art may fall into a class of material goods held by individuals or the society; it may be considered an external immaterial good. In some instances, art may be considered, in the Marshallian sense, an internal immaterial good. As an economic good we may suggest a thirteenth idea: art may be exhaustible as an economic good, or its consumption may in some instances be inexhaustible. Finally, taste in the economic sense is descriptive and is not evaluated as to good or bad. Aesthetic criteria, however, are a method of evaluating good or bad art.

These ideas represent only a few aspects of art that are important to the economist in considering art and works of art as economic products.

Given the above, we view the museum visit, the consumption of art, as the consumer taking a chance, that is, paying for a chance at an aesthetic or other kind of enjoyable experience with art. Such a concept applies when we speak of each museum visitor. We use enjoyment, satisfaction, and utility interchangeably, and note that each individual has his own peculiar set of preference functions. The set of preference functions held by the individual determines the way in which he will allocate his scarce resources to the consumption of art.

ORGANIZATION OF THE BOOK

Chapter 2 discusses the evolution of the art museum, including descriptive characteristics of museums and how these characteristics came to be. Chapter 3 presents an organizational and fiscal comparison of a sample of middle-sized art museums, to distinguish characteristic structural differences and similarities between the Akron museum and other museums of its relative size. Chapter 4 analyzes the present and past memberships of the Akron museum and develops a typology of art publics, indicating what such a typology means in terms of museum planning and policy.

Chapters 5 and 6 analyze the museum's educational programs and activities. Chapters 7 and 8 analyze the museum's exhibition programs. Chapter 9 analyzes the museum's development and combines some of the findings of the previous chapters.

NOTES

1. Thomas Vaughn, "A Simple Matter of Standards," *Museum News,* January/February, 1977, pp. 31-34.

2. *Ibid.*, p. 45.

3. James Kittleman, "Museum Management," *Museum News,* March/April, 1976, p. 44.

4. *Ibid.*, p. 45.

5. William J. Baumol and William G. Bowen, *Performing Arts: The Economic Dilemma* (Cambridge: MIT Press, 1968).

6. Alvin Toffler, *The Culture Consumers,* rev. ed. (New York: Random House, 1973).

7. Tibor Scitovsky, *The Joyless Economy* (New York: Oxford University Press, 1976).

8. Steven Globerman and Sam H. Book, "Statistical Cost Functions for Performing Arts Organizations," *Southern Economic Journal* 40, no. 4 (1974): 668-72.

9. John Picard Stein, "The Appreciation of Paintings: Value and Price," and George Helmuth, "The Economics of Architecture" (Papers presented at the Midwest Economic Association meetings, Chicago, April 1973).

10. Edward W. Hanten and William S. Hendon, *The Akron Art Institute Study* (Akron: Center for Urban Studies, University of Akron, 1973).

11. Mark Blaug, ed, *The Economics of the Arts* (Boulder: Westview Press, 1976).

12. Jack W. Nickson and Carl M. Colonna, "The Economic Exploitation of the Visual

Artists"; John Picard Stein, "Following Rights"; Steven Globerman, "Consumption Efficiency and Spectator Attendance"; and C. Richard Waits, "Art Museums and Income Distribution" (Papers presented at the Eastern Economics Association meeting, Bloomsberg, Pa. (April 1976). These papers all appear in *Journal of Cultural Economics* 1, no. 1 (May 1977).

13. Paul DiMaggio, Michael Useem, and Paula Brown, *Audience Studies of the Performing Arts and Museums: A Critical Review*, Report No. 9 (Washington, D.C.: Research Division, National Endowment for the Arts, 1978).

14. Roger Vaughn, "The Use of Subsidies in the Production of Cultural Services"; and Harry Walker and Robert Bonnington, "Surveying Symphony Audiences"? (Papers presented at the Southwest Economics Association meeting, Dallas, Tex., April 1976). Vaughn's paper also appears in *Journal of Cultural Economics* 1, no. 1 (1977).

15. Virginia Lee Owen's paper, "The Florentine and Sienese Renaissance: A Monopsonistic Explanation," was presented at the Western Economics Association meetings in Los Angeles in 1976. It has also been published in the first number of the *Journal of Cultural Economics* 1, no. 1, (June 1977). Floyd Durham's "An Exploration of Some of the Causes of a Developing Painter's Colony in Fort Worth, Texas," Tibor Scitovsky's "Can Changing Consumer's Tastes Save Resources?" and Douglas Heerema's "The Artist as a Source of Economic Understanding" all appeared in the *Journal of Cultural Economics* 1, no. 2 (December 1977). Marianne Felton's "The Economics of the Creative Arts: the Case of the Composer," James McLain's "The Income of Visual Artists in New Orleans," Leslie Singer's "Microeconomics of the Art Market" and Mark Blaug's "Why are Covent Garden Seat Prices so High?" appear in the *Journal of Cultural Economics* 2, no. 1, (June 1978).

16. Louise Weiner, "Perspectives on the Development of Potential of Cultural Resources," Final Report (Washington, D.C.: White House Conference on Balanced National Growth and Economic Development, Summer 1978).

17. David Cwi, ed., *Research in the Arts: Conference on Policy Related Studies of the National Endowment for the Arts* (Washington, D.C., and Baltimore: National Endowment for the Arts and Walters Art Gallery, 1977).

18. Thomas Moore, *The Economics of the American Theatre* (Durham, North Carolina: Duke University Press, 1975).

19. Dick Netzer, *The Subsidized Muse: Public Support for the Arts in the United States* (London: Cambridge University Press, 1978).

20. Bruce Watson, "On the Nature of Art Publics," *International Social Science Journal* 20, no. 4 (1968): 667-80.

21. See Marion Clawson, "Methods of Measuring the Demand for the Value of Outdoor Recreation," reprint 10 (Washington, D.C.: Resources for the Future, 1959), and Jack L. Knetsch, "Outdoor Recreation Demand and Benefits," *Land Economics* 39, no. 4 (1963): 387-96.

22. Kenneth Hudson, *A Social History of Museums: What the Visitors Thought* (Atlantic Highlands, N.J.: The Humanities Press, 1975), p. 118.

23. Ibid., p. 119.

24. Ibid., pp. 12-13.

25. Ibid., p. 14.

26. Ibid., p. 21.

CHAPTER TWO

THE EVOLUTION OF MUSEUMS

The idea of a museum contains several, sometimes conflicting, elements, each of which has evolved over time, to form the segmented concept embodied in today's museum. How has the art museum evolved? What are its antecedents and how can it be characterized today? These and other questions will be addressed in this chapter in order to place the analysis of the Akron museum in context. The chapter is designed as a general discussion of the evolution of museums, and will not refer to the Akron Art Institute. The reason is simple: Akron is not historically a very important museum, even though it is important locally. Yet, an understanding of the evolution of museums and their current similarities is important to understanding the Akron museum. Most of the policy questions raised in museums today are faced by major museums as well as by middle-size museums like the one in Akron. Questions of finance, what to collect, what to exhibit, how to exhibit it, or, in other words, any question which occurs in a major museum, may also be asked in a smaller one. The major difference between museums is not, therefore, in its policy questions or even its goals and aspirations; rather, the difference is a matter of scale. The questions may be the same but, because of scale differences, the answers seldom are; indeed, the policy solutions suggested at the Metropolitan will be vastly different from those considered at the Amon Carter Museum in Fort Worth.

Although there is scholarly disagreement on whether or not art museums arose more from private collections than from the actions of citizens' groups, there is little doubt that collections preceded museums.

THE EVOLUTION OF COLLECTIONS

Alma Wittlin traces the origin of museums to collections that served various functions.[1] Economic-hoard collections prevailed in a period when

economies were primitive and production was mainly for subsistence. Communities' hoard collections preceded those of individuals. In Rome, the collections of Sulla, Cicero, and others represented a form of "condensed wealth," according to Wittlin. S. Dillon Ripley suggests that it was during this time that collections first became associated with a "sacred band" of collectors. It was not until Rome that collections were dedicated to the Muses (the Greek word *mouseion* means a place or home for the Muses).[2] With the dissolution of the Roman empire, the possession of an economic hoard became increasingly productive in efforts to attain political power. In medieval Europe, the emphasis gradually shifted from the purely material value of the contents to the symbolic value contained in the association of objects with national events and outstanding persons.

Besides economic hoards, the bargain-hunter variety of collector (whose motive is profit) is prevalent in the history of collections. As Wittlin points out, economic hoards were regarded as hedges against inflation and instability in the economy; this was especially important at times when national economies were marked more by instability than by any other characteristic.[3]

A second type of collection is the social-prestige collection, the main function of which is its image-making effect on people. Besides national collections in Europe, the nouveau riches of nineteenth century America were entranced by this function of collections. Similar to the conspicuous consumption by the collectors of seventeenth century England, the wealth in these collections was static, that is, not used for productive purposes.

Magic collections represent a third type of collection. Objects thought to have magical powers were collected in the temple of Apollo at Delphi as well as in the medieval churches (saintly relics). Although specific objects retain these powers for some today, this type of collection no longer serves a strong common social need.

Collections as expressions of group loyalty, representing kinship with superior ancestors, were important both in Rome and in the later classicism of the mid–eighteenth century.[4] In European collections of the sixteenth and seventeenth centuries, a new approach to leisure was represented—leisure was to be spent in a distinguished manner, and man's command over objects was to play a central role in this. During the era of Renaissance man, the emphasis shifted to collections of objects illustrating man's natural environment and human ingenuity, including his artistic skill.

Wittlin notes that a fifth type of collection, that designed to stimulate curiosity and inquiry, evolved when the opposition to scholasticism documented by classical study developed into a general spirit of inquiry and invention. In the colonies, the American Philosophical Society, founded by Benjamin Franklin, and the American Academy of Arts and Sciences, founded by John Adams, represented this type of collection. During the eighteenth century, many private collections were begun in the colonies, but most of them were of short duration.

Collections as a means of providing an emotional experience are intimately related to the emotive power of art. Wittlin notes Susanne Langer's proposition that, in its elementary form, mind is a state of feeling rather than knowing; art as an essence of meanings serves to crystallize the mind's various ruminations. This aspect of collections is important to an understanding of the motives of collectors. Lacking the talent necessary for creation, the collector receives sustenance from the knowledge that creative ability surrounds him.

Wittlin describes collections as being characterized by two additional aspects: the selection of items, and their combined presentation. Since the manner of presentation may change the meaning and impact of a collection, incongruities between objects and their manner of presentation constitute a major problem that has plagued collections through their history. Communication is central to the purpose of a collection, and communication is also central to the work of art itself. However, the quality and purpose of communication is different in each case. Between the artist and art, communication is confined to mediating the elements of nature according to schemes internal to the artist. Between the collection and its various publics, communication is open ended; however, the various publics have different preconceptions regarding their interaction with art. For the artist, the important thing is the act of creation itself; for the public, the object, rather than the process, is paramount.

The art publics of today in any museum can be seen to fall approximately into classes of viewers based on most, if not all, of these historic reasons for collecting. This fact leads inexorably to the fact that art publics are diverse. Bruce Watson suggests three further reasons why art publics are indeed diffuse.[6] First, communication between the work and the public is impersonal and may be lacking because their only access to the work is as consumers. The viewers have to attempt to interact with the work, not with the artist, and then with each other. What is communicated between the viewers is not the content of the work, but their own mental states (often unconscious). There is no necessary relationship between the overt response and the covert feeling, so that the reactions of viewers to the works are not amenable to categorization.

A second factor contributing to the amorphous nature of art publics is that although they are initially heterogeneous and unselective in composition, the quality of participation (which is related to the original motives for viewing) differentiates the public. Membership in art publics generally is unselective, except for those closest to the act of creation itself. Third, there is not one community of interests, but several, in a democratic society. Three reasons for this stand out: the overall level of interaction and communication is too diffuse for a general sense of community to develop; there is no method of ascertaining whether the overt response is a direct reflection of a covert feeling; and the viewer may be reacting either to the single object or to the gestalt of the object and its surroundings.

When collections were primarily private ones, the above difficulties did not matter much. What was important was the collector's private satisfaction. Through the eighteenth century, the monologues on art were restricted to owners of collections and selected cognoscenti whose viewing reinforced shared common attitudes. This reduced problems of communication to those which could be immediately solved by the owner of the collection. These early collections were often referred to as cabinets of curiosities.[7] They contained numerous objects classified by the man-animals-plants-rocks schema in the seventeenth century. Later schemata were somewhat more sophisticated.

The cabinets afforded opportunity for encyclopedic study and were often owned by renowned teachers. This function changed in the mercantilist era, when works of art were valued for their monetary worth. Louis XIV of France regarded works of art as a capital investment, besides recognizing their value as domestic propaganda.[8] Through the seventeenth century, the general public was virtually ignored in regard to art, other than as recipients of domestic propaganda. In the latter part of that century, the number of visits to private collections rose, and admission requirements lost their selectivity. However, the public often was unprepared for the viewings, and their various reactions often angered owners of the objects. Wittlin points out that the public lacked both a background of specific knowledge into which the new experiences could be fitted and a general education of a literate kind.[9] The collection of John Tradescant and his son, in South Lambeth, London, consisting of natural-history objects and coins, was one of the few of this period that was designed specifically for dissemination of knowledge to the public.[10] This collection later formed the nucleus of the first university museum, the Ashmolean Museum at Oxford, founded in 1682.

According to Wittlin, the remedy for the above problems was to be a more coherent organization of the presentation. Especially in Spain, the public performance served as a framework for presentation of the object; works of art were used in dramas or were central to a religious procession. Through this, the public became more acquainted with art objects. Unfortunately, this sometimes was symptomatic of the problems associated with early museums. Sir Ashton Lever opened his private collection to the public in 1774 in London. Because the public was too often insolent, he began to charge admission to reduce the crowds. In the process, he turned into a showman, and the original purpose of the museum was lost. When he could no longer maintain the novelty of the exhibit, the museum closed under a bond of financial difficulties and was later sold at public auction.[11]

During the eighteenth century, collections did serve as training grounds for students and artists, primarily because of the owners' desire to expand their collections.[12] When collections were first opened to the public in America, the European distinction between "private" and "public" lost much of its power. This was primarily because the Enlightenment ideal of

educating the masses was an important part of the revolutionary zeal and democratic ideals of that time.

EARLY AMERICAN MUSEUMS

With little art and a vast new country, early museums in America were primarily devoted to natural history. The first museum in America was a museum of natural-history collections opened in Charleston, South Carolina, in 1773. The exhibits of Charles Willson Peale in Philadelphia, and those of his sons, Rembrandt and Reubens Peale (who ran a gallery and museum in Baltimore in 1814), were displays of natural-history objects.[13] As Ripley points out, early American museums suffered from a lack of resources. Patrons were few and philanthropy hardly existed. Nonetheless, museums were quickly founded in Salem, Boston, and Philadelphia, and later in Hartford. The university museum, an English, not a European, tradition, was born in the United States at Yale in 1832, but university museums were not open to the public at large.[14]

Collections were transformed into a more distinctly public institution, the public museum, between the late eighteenth century and the early part of the nineteenth.[15] Rather than being born solely of the Roman and Greek idea of a sacred place dedicated to the Muses, many early U.S. museums evolved out of collections. Their being opened to the public was a result of a combination of Enlightenment ideals and entrepreneurship. In Europe, most museums came into being under the duress of early-nineteenth century societal transformations. But, art was still bought in the framework of the mercantilist spirit, and few guidelines for exhibits existed. Only in Germany did the national museum (the Thesaurus Brandenburgicus) originate as part of an overall plan: to mold the new German citizen and to illustrate the evolution of European thought.[16] In Britain, the first public museum was the British Museum, opened in 1759 and based on the natural-history collection of Sir Hans Sloane.[17] Yet, even the British Museum was inaccessible to the public for a period.

In the United States the driving force behind the founding of early museums was private initiative, especially crystallized by the work of citizens' committees. In early U.S. museums, as exemplified by Charleston and by the Peales, the emphasis was on practical applications of the natural sciences. In both Europe and the United States, the nineteenth century saw the development of national galleries and museums. Coincident with the rise of nationalism in Europe, these institutions often corresponded to Wittlin's category of collections as expressions of group loyalty.

EARLY ART MUSEUMS

Along with Wittlin, Joshua C. Taylor suggests that the art museum in America arose in a different manner than the traditional museums of

Europe. "Originally there were no princely collections, grandly housed, to be filtered gradually into the public domain as in Europe. Collections tended to grow to fill the mission of a conscientiously established museum."[18] Rather than beginning with the display of collections, Taylor argues that U.S. museums were primarily founded by associations of citizens and artists, to provide an educational base of culture to a local society cut off from the larger European society.[19]

But it should also be pointed out that the few art museums developed in a different manner than the larger science and history museums. Not taking a broad approach to learning and knowledge, art museums did not integrate knowledge, but created a world apart; they arose to display the fine arts in a distinctly limited sense. "Works from early Mediterranean cultures counted as art; works from other areas including preconquest America and, initially, Japan, were ethnic artifacts."[20] On the other hand, earlier displays of art often "showed a generous attitude toward the material: they included works by local artists, prints and paintings purchased abroad by self-conscious amateurs, and designs of a practical nature. Art and ingenuity were rarely distinguished from one another."[21] Aside from museums, there was little or no public art; that is, there was minimal art in public buildings, and churches were largely devoid of art.[22] Taylor says, "In the United States throughout much of the nineteenth century, art had no visual environment of its own."[23]

Taylor notes further:

> When the art museum finally appeared in the United States, it was only in small part related to the long existent tradition of miscellaneous collecting. It sprang instead from a new consciousness of artistic values, from the thesis that accepted works of art are not simply collectible curiosities or cultural artifacts, but have a moral and aesthetic existence of their own. Although this concept of art had long become a public cliché, it had prompted little action outside a limited circle for artists and patrons. In the 1870's when several major museums of art were formed (the Metropolitan in New York, 1870; the Museum of Fine Arts, Boston, 1870; Philadelphia Museum of Art, 1876; Art Institute of Chicago, 1879), the fine arts were deliberately separated from manufacturing, the quantitative collecting of objects, and the pursuit of cultural history in general. [24]

But, as Theodore Low points out, these years of rapid museum development were productive more of collections and financial support than a consistent philosophy. Undoubtedly, as charters, museum reports, and addresses reveal, education was the first fact of the nature of an art museum, but civic pride, and even financial gain for the city, were more often pursued as the arguments for establishing museums.[25] Local art associations moved quickly to establish temporary exhibits, develop educational classes, and ultimately to form public museums. Although the private collector was not usually a museum initiator, the donation of quality collections, in combination with the rising art scholarship, helped to determine the ultimate direction of the art museum.[26]

According to Low, although the public ideal was present at the birth of our great museums, it was not given much chance to develop. For example, when the Metropolitan opened on Sunday for the benefit of workers, there was a great cry against letting the "unwashed" into the museum. The reasons for disregarding fundamental educational responsibilities to the entire public were not all elitist concerns. As Low argues:

> It was logical that the newly born museums should concentrate their initial attention and effort on physical growth. Obviously they had to have collections before those collections could be used. . . . Instead of merely temporarily postponing the fulfillment of their duties to the community, they became hypnotized by the charms of collecting and of scholarship. The ideal of the museum as a social instrument was soon completely buried only to be disinterred at intervals to convince a skeptical public of their good intentions. . . . Two factors were largely accountable for this blindness. In the first place the staff of the early museum was chosen for its scholarship and not its social consciousness. Thus scholarly work achieved a place of prominence in museums far out of proportion to its relative importance. . . . The second factor was that museum men instinctively turned to Europe for their ideas. This was particularly true in the case of the art museum since European art at that time was considered the only good art. What they failed to realize was that there could be such a thing as a museum with distinctly American characteristics. . . . The men entrusted with the job of running the museums rapidly became little more than pseudo-Europeans who thought only in terms of European precedents; . . . [thus] museums soon became little more than isolated segments of European culture set in a hostile environment. This fact resulted in an ever increasing tendency on the part of museums to remain aloof and to look with disdain on the vast majority of Americans whose acquaintance with art was so negligible. Furthermore, this attitude, coupled with the emphasis on scholarship, had the unfortunate faculty of strengthening itself, and the shell which the museums somewhat unconsciously had erected around themselves grew thicker and more impenetrable. As a result, museum men have drifted farther and farther away from the public until . . . [it's] virtually impossible for many of them to see the problems which confront them in their true light.[27]

Although art museums immediately sought sanctuary from a larger public, Ripley observes that the forces tending to focus public interest on museums in general included the new liberal educational ideas of the nineteenth century, the new interest in history, the development of scientific methods of inquiry in the history of art, and the development of evolutionary thought concurrent with discoveries in geology and paleontology.[28] Private collections were opened to the public but continued to be administered as if they were private, marked by restricted entry, jumbled presentation, and persistent visions of grandeur. As noted earlier, in the United States, museums had ostensibly been opened to the public in the hope of

educating the public. The nineteenth century's scientific method caused research to become a function of museums. Art also came to be seen as a healthful recreation and a means of marking out the historic cultural character of the society.[29] The civic interest developed in a particular, rather closed form. In New York City in 1869, the organization of the American Museum of Natural History, and of the Art Museum (eventually the Metropolitan Museum of Art), was particularly important because it represented a "landmark in civic-trustee relations."[30] This was the partnership principle, whereby a city would erect a building and provide funds for maintenance, while the trustees "owned" the collections and raised funds for a staff of "investigators" and public lecturers.[31]

Speaking generally of all kinds of museums, Wittlin demarcates three periods of developmental reform: the period up to 1914, the period between the world wars, and 1945 to the present.[32] Ripley points out that by the end of the nineteenth century, two contrasting developments existed. First, certain museums came to exist purely as storehouses and catchalls. Although they were elegant, no overall plans were in effect. Second, the museum as a practicing laboratory or an education center was embodied more in the university museum than in the independent museums.[33] The storehouse concept was gradually refined over the last years of the nineteenth century, until what we know as the modern art museum came into existence. Many of the present physical facilities of major U.S. art museums were originally built in the last part of the nineteenth century and the first part of this century. As indicated earlier, museums became symbolic of the community's rise to prominence and sophistication. The architecture of these museums was predominantly Graeco-Roman, further symbolizing the presence of something sacred, art housed in a civic sanctuary. Contemplation of the art objects in this setting was an inward, religious experience as contrasted with the secular, profane task of teaching.

According to Ripley and Low, these developments served to alienate three groups of people from museums: art historians, the artists themselves, and the general public.[34] In this setting of civic boosterism, reform was needed. "Public education" was the rallying cry for some. The first alliance between a city school system and a public museum was effected in the first school museum, established in St. Louis in approximately 1903. For most museums, this first period of reform was marked by a specialization of contents. Also, the use of a pluralistic team composed of the wealthy, a large number of subscribers making small contributions, committees of private citizens, and public authorities became firmly established as the preferred method of organizing a museum.

The first period of reform in museums ended in controversy around 1914 with more success in admitting bodies to museums than in training and admitting minds. The manner of presentation of art remained, by modern notions, chaotic because most of the architecture of museum buildings was poorly suited for exhibition purposes; concessions to the public remained

restricted to letting more people in; and the loaning of exhibits was a rare occurrence. Museums remained ill-adjusted for three basic reasons: a static element was built in as the result of ties to private collections; attitudes remained opposed to a general diffusion of knowledge; and only in rare cases was the purpose of a museum or of a specific exhibit clearly defined.[35]

The second period of reform (between the world wars) was marked by an increasing emphasis on education and the widening scope of the education function of museums.[36] This trend had its critics, who felt that a museum is not primarily an educational tool, because the relation between the work of art and the viewer is far more than an educational function; rather, the simple pleasure of viewing a work of art is important and should not be thrust into the background. Still, by concentrating on educating the public, the importance of the opportunity to see a work of art was emphasized, the implication being that people are sociological beings. As a result, emphasis was still put on increasing the numbers of viewers without probing into the quality of the experience.

Exhibits were loaned to schools, factories, and other places that had large numbers of the uneducated. New methods of presentation and selection of objects were developed beyond all precedent, even though some had originally been devised in Europe; examples include period rooms and dioramas. House museums and trailside museums represented a trend toward small museums outside urban centers. Although the period between the wars was also the period of the Great Depression, when many unemployed artists worked for the Roosevelt government, the extension of services outlined above prepared the way for the increased amounts of leisure time available to the public after World War II. The total-environment concept was epitomized by Williamsburg and Greenfield Village.[37]

New trends in the type of art included in exhibits and in the increasing emphasis on pictorial art were evident. In many ways the earlier Armory Show of 1913 represents a watershed in the evolution of American tastes.[38] Intended to show all of the various tendencies in American art and in the most advanced experimental art (mainly from Europe), the exhibit, which opened in New York and traveled to Chicago and Boston, aroused reactions significant to an understanding of American tastes and the consumer market for art. The exhibit had flaws as an exhibit since it offered only an incomplete picture of modernism. The reactions to the show, led by Theodore Roosevelt's comment that Duchamp's "Nude Descending a Staircase" reminded him of a Navajo blanket, and Lehmbruck's "Kneeling Woman," of a praying mantis, were indicative of the divisions in American art publics. Barbara Rose points out that both proponents of the show (the artists) and the critics confused art and politics, a confusion which occasionally surfaces today. Further, critics invoked morality in their criticisms of the show. In the wider context of an insecure America being inundated by waves

of immigrants, the reactions to the show illustrate the varying functions that art plays in this country.

The intentions of the show (educating the public and enlarging the art market) were frustrated by public reaction to it, but it did mark the beginning of modern American collections, which later formed the basis of museums such as the Museum of Modern Art in New York. In addition, collectors began to seek advice from artists rather than from connoisseurs or dealers. In spite of the positive effects, the show had little immediate influence on any of the other problem areas existing at the end of the first period of reform (noted by Wittlin). The show's effects on artists were powerful, but America's museums continued to neglect modernism.

If the Armory Show was a watershed, the art museum, in the period between the wars, hardly noticed. Major art museums in the United States, largely founded and developed after 1870 and into the first decades of the twentieth century, moved toward a general aesthetic resulting in stark and severe display of art, or in the later historical display of art (period rooms) that became so popular in the 1920s. The Philadelphia Museum (1928) was devoted to historic presentations, and most large museums by the late 1930s, had one or more period rooms. The permanent collection still ruled as little effort was made toward setting up temporary display areas, special education facilities, conservation labs, and other post-World War II services.

Wittlin notes that the second period of reform ended with a "mood of dilemma" regarding the primary functions of a museum. The idea of a multiplicity of functions became more widely accepted, as evidenced by two developments: study collections were separated from collections for the general public; and it was recommended by architects that museum buildings should consist of several parts, each serving a different function.[39] In general, it was accepted that a museum's various functions have to be defined, and that planning must proceed according to those functions.[40] Since World War II the modern museum has continued to actively consider its development, raising some of the traditional questions and raising new ones as well.

DEFINING TODAY'S ART MUSEUMS

There is significant agreement today on what a museum is. Although applicable to museums in general as well as to art museums, the International Council of Museums now defines a museum as an establishment in which objects are the main means of communication. Interacting with the objects are various publics. The functions of a museum originate in this interaction and are distinct from the functions of other institutions, such as libraries, because of the distinct nature of the interaction. Objects communicate in three environments simultaneously, those of the "senses, memory, and

imagination".[41] The relationship between people and objects, and thus the framework for museums, are composed of these three dimensions.

The International Council of Museums also defines a museum as "a permanent establishment administered in the public interest with a view to conserve, study, exploit by various means and, basically, to exhibit, for the pleasure and education of the public, objects of cultural value."[42]

For the purposes of the accreditation program of the American Association of Museums (AAM), a museum is defined as an "organized and permanent non-profit institution, essentially educational or aesthetic in purpose, with professional staff, which owns and utilizes tangible objects, cares for them, and exhibits them to the public on some regular schedule."[43]

The key words in the definition are defined as follows:

"organized": . . . The institution is a duly constituted body with expressed responsibilities.

"permanent": . . . The institution is expected to continue in perpetuity.

"non-profit": . . . The museum has produced documentary evidence of its tax-exempt status under the regulations of the U.S. Internal Revenue Service or the Canadian Department of Internal Revenue.

"essentially educational or aesthetic": . . . The museum manifests its expressed responsibilities by knowledgeable utilization of its objects and exhibits for elucidation and enjoyment.

"professional staff": . . . at least one paid employee, who commands an appropriate body of special knowledge and the ability to reach museological decisions consonant with the experience of his peers, and who has access to and acquaintance with the literature of the field. Stress is placed on continuity of professional staff, even seasonal employment which is continuous and not automatically terminated at the end of each season. The employee works sufficient hours to meet adequately the current demands of administration record-keeping, and care of collections.

"collections": . . . The museum owns and utilizes tangible objects, things animate and inanimate. The tangible objects have intrinsic value to science, history, art, or culture. The exhibits are evidence of the subject matter of the museum rather than tools for communicating what one knows of that subject matter, serving as instruments in carrying out the museum's stated purpose and reflecting that purpose.

"care": . . . the keeping of adequate records pertaining to the provenance, identification, location of the museum's holdings and the application of current professionally accepted methods to their security and to the minimization of damage and deterioration.

"open to the public on some regular schedule": . . . [The museum has] regular and predictable hours which constitute substantially more than a token opening, so that access is reasonably convenient to the public. The hours and seasons the museum is open adequately support public demand.[44]

Wittlin defines a museum as now fulfilling three main functions: as depositories devoted to preservation and conservation of objects of particular value; as centers of research; and as educational agencies.[45] Peripheral functions, such as those fulfilled by a multidisciplinary cultural center, are mainly educational in nature. A central characteristic of museums is that they offer an "immediate encounter with authenticity." Their prime assets are the direct appeal of art works to the eye and to the sense of touch, and their potential capacity to present a number of facts simultaneously and in a palpable context. Rather than being ends in themselves, they facilitate the interaction between the work of art and the viewer. The flexibility of modern museums allows many uses. As Wittlin observes, most visitors hardly distinguish between recreation and learning in the museum context.

In aspects of the basic definition of a museum, the museum is expected to follow the recognized methods of the profession, along with the minimum acceptable standards as determined by the AAM's Accreditation Commission. The accreditation system seeks to determine whether a museum operates at a minimum level of professional competence, adequate to its context, community, situation, and stated objectives, in accordance with the basic definition.[46]

Prior to 1970, the nation's museums were governed by widely varying standards, but museum-staff professionals, while they recognized that complete uniformity of operation was not possible or desirable, nonetheless saw a need to develop guidelines and workable professional standards of museum service. As a result, the American Association of Museums began a program of accreditation to establish and apply minimal standards of museum operation.[47]

Principles of AAM accreditation are as follows:

1. Organizations, not individuals, are accreditable.
2. Accreditation is not a requisite for membership in the AAM, nor is membership in the AAM a requisite for accreditation.
3. The accreditation process provides an opportunity for the individual museum to undertake a rigorous self-examination, and a format in which to do it.
4. Accreditation certifies that a museum is currently meeting accepted standards established by the profession, without presuming to distinguish among various grades of achievement or excellence beyond the established minima.
5. Accreditation proceeds from the informed judgment of experienced individuals within the profession, based upon information supplied by the museum applying for accreditation.
6. The accreditation procedure is carried out in confidence except for certain basic statistical data that questionnaires supply to the AAM headquarters for its permanent public records.
7. The principles and procedures of the accreditation system apply equally to all museums.[48]

According to Thomas W. Leavitt, however, valuable as they are, the establishment of professional standards for museum workers, and the enlarging of museum-training programs throughout the country, cannot produce superior museum personnel or great museums. Standards for museum workers, like the accreditation of public school teachers, tend only to guarantee certain minimum levels of performance.[49] Without excellent museum staff, no museum can effectively use even the most stimulating collection.

There is also general agreement on what constitutes broad classes of public art that one might find in art museums today. The plurality of art throughout history provides a rich and democratic public art, as detailed by Sherman Lee. He refers to public art as being exemplified by the classical friezes and sculptures of the Greeks and Romans, as well as the public arts of the Renaissance. Another form of museum art is, of course, religious art, not completely public in the truly religious sense, but appropriate to the museum if carefully shown. Fine art or secular art in a strong intellectual tradition, whether classical, Renaissance, or modern, represents art that, although made to be privately owned, is also a major element in the public context of museums. Decorative arts, although commonly separated as applied art, fall into this same category of private-ownership potential. Folk art, in contrast, is an essentially lower social art, is consummately an applied art with extraaesthetic uses, belongs in museums, but is separate in both value and context from other forms of art.[50]

The evolving public nature of museum functions from the beginning led to today's art museum having an important educational function to fulfill. In helping people make better use of their increased leisure time, museums are increasingly being called upon to educate their various publics. However, because of the polymorphous nature of those publics, this educational function has often gone unrecognized. As Walter Pach suggests, "We need more than an application of the bed-time story technique to 'art history.'"[51] Ripley believes that there should be a conscious effort to interrelate museums with education at all levels. A primary reason for this is the intimate and unstructured contact between the art works and the viewers. Both Ripley and Wittlin believe that education has not retained the active interest of museums. Ripley suggests that a possible reason for this is today's generally high level of literacy, meaning that people no longer have to go to a museum to know a work of art.

Perhaps a useful way to further perceive today's museums is to chart a few other recent general trends. The most striking (and most readily measurable) are the quantitative gains both in museum construction and in the number of visitors. For example, between 1960 and 1963, a new museum was constructed every 3.3 days in the United States. Comparable figures for 1940-49 were one museum every 10.5 days. Exact figures for the number of visitors are unavailable; however, most museums talk about a vast increase

in usage. Wittlin notes that in 1961, 79 percent of museums in the United States offered educational programs, as compared with 15 percent in 1932.

Several other phenomena characterize events in today's museums. For one thing, in meeting public needs, most museums have had some kind of expansion or renovation of the museum building, to add classrooms, auditoriums, special display areas, and so on. Therefore costs have risen for museums commonly by about 10 percent per year. According to Taylor, conservation of art has now reached new levels of interest in museums, both in restoration of individual works and in the collection as a whole.[52] Museum shops have expanded sales and the variety of goods offered for sale.

Even building design has been newly conceptualized—as evidenced by the Guggenheim (completed in 1959), the Whitney (1966), and the Hirschorn (1974)—with emphasis on a continuous flow of gallery space, as opposed to mere discrete galleries.[53] Another fundamental museum-building change has been the move away from the static concept of displaying a permanent collection, and toward the development of the previously noted temporary display areas; public areas such as lounges, restaurants, children's areas; and, along with more office space, conservation labs and museum storage areas.[54]

Conservation as a widespread museum practice is a particularly modern phenomenon. While large museums like the National Gallery have conservation departments, smaller museums cannot afford such laboratories. Some 17 regional associations now exist, in which groups of museums participate. Illustrative of these is the Inter-Museum Conservation Association on the Oberlin College campus. Started in 1952 with Richard Buck as director, six midwestern museums participate with representatives on the association's board of trustees. Besides obtaining conservation work from the museums, members of the association staff visit each participating museum once a year for examination of the collection as a preventive measure.

Yet another significant change since World War II has been the wide expansion of art scholarship, which has brought much wider perceptions of what constitutes museum art. Collections of non-Western (such as oriental) art have grown significantly. The cultural artifact has become collectible as art, and American art, including western American art, has become an added part of museum collections.[55] Contemporary art has now gained widespread acceptance as a major part of, or in some cases the basis of, museum collections. All of these developments have created real problems of public service for museums, supply problems of basic economic dimensions.

PROBLEMS IN TODAY'S ART MUSEUMS

Kenneth Starr, director of the Milwaukee Public Museum, suggests that three patterns of change—(1) increased numbers and types of consum-

ers, (2) an expanded variety of internal and external services, and (3) efforts by museums to become more relevant to daily needs—have resulted in three general problem areas. The first problem is that the museum's annual operating budget (75 percent of which is devoted to salaries, 20 percent to supplies and services, and 5 percent to replacement and new equipment) is increasingly inadequate to meet needs. Second, financial pressures have prevented improvement and expansion of services to serve previously unserved publics. Third, there is an unmet need both for renovation and new facilities.[56] Museum people feel that museums are underfinanced.

In the face of these unmet needs, there is an acknowledged confusion both on the part of the public and on the part of museums themselves about the role of museums. Starr feels that the public understands only the most traditional functions of a museum, in spite of various outreach programs, such as that in which the Art Institute of Chicago provides black guides for black groups, and the various neighborhood museums sponsored by traditional museums. Stephen Prokopoff points out that collections simultaneously cater to the cultural demands of the public and help to create this demand.[57] In a sense, this is indicative of the changing characteristics of leisure and of recreation facilities, and of art museums as well.

The consensus in regard to the supply problems seems to have been summarized by Prokopoff's list of current unmet needs: (1) an improvement of physical plant so that existing services can be performed more effectively and frequently; (2) an increase in staff to meet increased demand and in training of staff members; (3) outreach programs aimed at people who are not habituated to using museum programs; (4) specialized programs aimed at specific groups; and (5) the provision of historically or socially important exhibitions that are too expensive for the regular budget.[58]

An additional problem especially characteristic of large urban museums is that afflicting the Field Museum of Natural History in Chicago. Although it is supported by tax monies from the city of Chicago, 65 percent of its visitors are from outside the Chicago city limits.[59] If a museum has a regional or even national drawing power, this creates special problems in allocating the costs of providing its services. With declining financial resources, the city and its residents may not be able to afford to subsidize visitors from other areas.

Finally, as Walter McQuade points out, there are increasing problems to managers as a result of low employee wages and resulting employee unions. There are questions of financing by government versus who controls the museum. There is the continuing conflict between museums and local artists. There are the continuing conflicts on education—that is, how does one appropriately educate? There are the historic questions of aesthetic quality versus large numbers of visitors.[60] In short, there are continuing questions of role and function. The period of museum evolution since World War II could be called the age of introspection for the multipurpose urban institutions of art.

SUMMARY

In this review of the evolution of museums, we have seen that museums have evolved from a private gallery serving only its owner and selected cognoscenti, to an important public institution whose primary function (at least when trying to attract funds) seems to be education. However, it is evident that museums are currently grasping for some definite identity amidst their various evolved functions. The prime problems with current American museums of art seem to lie in this arena of proper function and in economic ways and means. In all but the largest museums, the marginal costs of providing additional services to meet perceived needs are outstripping revenues, so that museums are reduced to a battle to survive, when they need to be reassessing their effectiveness.

NOTES

1. Alma S. Wittlin, *Museums: In Search of a Usable Future* (Cambridge and London. MIT Press, 1970), pp. 4-59.

2. Dillon Ripley, *The Sacred Grove: Essays on Museums* (New York: Simon and Schuster, 1969), p. 25.

3. Wittlin, op. cit., p. 10.

4. Ibid., p. 36.

5. Ibid., p. 60.

6. Bruce Watson, "On the Nature of Art Publics," *International Social Science Journal* 20 (1968): 667-87.

7. Ripley, op. cit., p. 27, and Wittlin, op. cit., p. 67.

8. Wittlin, op. cit., p. 69.

9. Ibid., p. 71.

10. Ripley, op. cit., p. 29.

11. Ibid., pp. 31-34.

12. Wittlin, op. cit., p. 76.

13. Ripley, op. cit., pp. 34-36.

14. Germain Bazin, *The Museum Age*, trans. Jan Van Nuis Cahill (New York: University Books, 1967), p. 245.

15. Wittlin, op. cit., p. 81.

16. Ibid., pp. 93-96.

17. Ibid., pp. 101-5; and Ripley, op. cit., p. 34.

18. Joshua C. Taylor, "The Art Museum in the United States," in *On Understanding Art Museums*, ed. Sherman Lee (Englewood Cliffs, N.J.: Prentice-Hall, 1975), p. 34.

19. Ibid.

20. Ibid., p. 37.

21. Ibid., p. 36.

22. Ibid.

23. Ibid.

24. Ibid., p. 37.

25. Theodore Lewis Low, *The Educational Philosophy and Practice of Art Museums in the United States* (New York: Teachers College, Columbia University, 1948), pp. 26-27.

26. Taylor, op. cit. p. 40.

27. Theodore L. Low, *The Museum as a Social Instrument* (New York: Metropolitan Museum of Art, for the American Association of Museums, 1942), pp. 8-9.

28. Ripley, op. cit., p. 37.

29. Taylor, op. cit., p. 35.

30. Ripley, op. cit., pp. 48-49.

31. Ibid.

32. Wittlin, op. cit., p. 121.

33. Ripley, op. cit., pp. 67-71.

34. Ibid., pp. 73-74.

35. Wittlin, op. cit., pp. 141–43.

36. Wittlin, pp. 150-57.

37. Ibid.

38. The following discussion of the Armory Show is from Barbara Rose, *American Art Since 1900: A Critical History*, Praeger World of Art Series (New York: Praeger, 1967), pp. 67-83.

39. Wittlin, op. cit., p. 156.

40. Ibid., p. 203.

41. Ibid., p. 3.

42. M.H. Fitzgerald, *Museum Accreditation: Professional Standards* (Washington, D.C.: American Association of Museums, 1973), pp. 8-9.

43. Ibid.

44. Ibid.

45. Wittlin, op. cit., pp. 1-2.

46. Fitzgerald, op. cit., p. 9.

47. Ibid., p. 1.

48. Ibid., pp. 8-9.

49. Thomas W. Leavitt, "The Beleaguered Director" in *Museums in Crisis* ed. Brian O'Doherty (New York: George Braziller, 1972).

50. Sherman Lee, ed., *On Understanding Art Museums*, op. cit., pp. 10-13.

51. Walter Pach, *The Art Museum in America* (New York: Pantheon Books, 1948), p. 234.

52. Taylor, op. cit., p. 47.

53. Ibid., pp. 50-51.

54. Ibid., pp. 48-50.

55. Ibid., pp. 56-58.

56. U.S., Congress, House, Subcommittee on Education, Committee on Education and Labor, *H.R. 8677 Hearings*, 92d Cong., 1962, pp. 106-8.

57. Ibid., p. 76.

58. Ibid., p. 77.

59. Ibid., p. 56.

60. Walter McQuade, "Management Problems Enter the Picture at Art Museums," *Fortune*, July 1974, pp. 100-3.

Chapter Three

STRUCTURAL AND BUDGETARY COMPARISONS OF MUSEUMS

While this study is devoted to an analysis of art publics, and the education, exhibition, and development activities of the museum, Akron's museum operates in a milieu of other museums. And within that milieu, budgets, location, facility size and scope, staff size, and other matters have a good deal to do with whether the programs are well executed, or whether problems may exist within service performance.

In order to determine the extent to which the Akron museum conforms to or varies from conditions and practices of other art museums of comparable size in the United States, a survey was conducted among middle-sized museums in various cities in the United States (see Appendix C at the end of the book). Thirty-two museum directors responded, providing a variety of descriptive and analytical data.

Many things come late to Akron. But, founded in 1922, the Akron Art Institute falls into the average age range of museums of its size in cities throughout the United States. Of the museums surveyed, the average year of inception was 1917 (see Table 3.1). The pattern of growth indicates a clustering of museum development between 1910 and 1920, with a decline during the early years of the 1920s and an increase toward the end of that decade. The decade from 1931 to 1940 saw the formation of 22 percent of the museums responding. Growth continued through the 1940s and 1950s, but then the formation period of museums slowed, as indicated by the fact that only one of the museums surveyed was started after 1960.

An examination of the original sources of development funds of the art museums surveyed indicates that the majority of them had mixed support sources initially, but were funded primarily through private monetary donations (see Table 3.2). Public funding, that is, government support, accounted for the next most important category. The third most important source of initial funding was the donation of art collections. By comparison, the Akron Art Institute was initiated primarily through private funding.

TABLE 3.1

Period When Institute or Museum Was Established

Period	Museums Reporting Various Periods of Inception	
	Number	Percent
Before 1900	4	13
1900-10	1	3
1911-20	4	13
1921-30	5	16
1931-40	7	21
1941-50	6	18
1951-60	4	13
1961-70	1	3
1971 or later	0	0
Total	32	100

Source: Compiled from sample data.

PHYSICAL FACILITIES

Regarding the question of the facilities available to museums in the United States, it should be recognized that the Akron Art Institute is one of a distinct minority of museums presently using only their original structure (see Table 3.3); Akron has used its present facility since 1947 (it had first occupied the building at its inception in 1922, but had then moved). Only 13 percent of the museums responding indicated that they presently use only the original structure. Forty-eight percent of the museums have had addi-

TABLE 3.2

Original Source of Funds for Establishment

Source of Initial Funding	Museums Reporting Various Funding Sources	
	Number	Percent
Foundation grant	4	8
Private funding	22	46
Donation of art collection	9	19
Public funding	12	25
Other	1	2
Total	48	100

Source: Compiled from sample data.

TABLE 3.3

Physical Facilities of Art Museums

Physical Facility	Museums Reporting Various Facilities	
	Number	Percent
Presently use only original structure	5	13
Original structure plus addition(s)	19	46
Expansion currently underway or projected	13	33
New structure	3	8
Total	40	100

Source: Compiled from sample data.

tions, 33 percent have expansions currently underway, and 8 percent are housed in relatively new structures (see Table 3.4). It would appear that the largest expansionary period in terms of facilities has been the period of 1966 to 1970, in which 13 of 32 museums responding completed additional facilities.

From the standpoint of total square footage in its plant, the Akron Art Institute is one of the smaller museums among museums sampled. For the museums responding, the median was slightly in excess of 30,000 square feet, as compared to slightly less than 23,300 square feet for the Akron Art Institute (see Table 3.5). When we compare square footage among museums, it should be recognized that the survey included a number of rather large museums in communities comparable to the population of Akron; therefore, some upward bias in the results can be anticipated. For example, seven of

TABLE 3.4

Period When Additions Were Completed

Period of Expansion	Museums Reporting Various Expansion Periods	
	Number	Percent
Before 1950	5	16
1950-55	5	16
1956-60	4	12.5
1961-65	2	6
1966-70	13	40
1971 or later	2	6
No response	1	3
Total	32	100

Source: Compiled from sample data.

TABLE 3.5

Total Square Footage of Plant (Including Expansion)

Museum Size	Museums in Various Size Categories	
	Number	Percent
1,000-10,000 square feet	3	10
10,001-20,000	5	17
20,001-50,000	11	35
50,001-75,000	2	7
75,001-100,000	2	7
100,001-200,000	5	17
200,001 or more	2	7
Total	30	100

Source: Compiled from sample data.

the museums had in excess of 100,000 square feet. Such museums are only partially comparable since they may be at least three times as large as the average museum. Because of these larger museums, mean total square footage was nearly 78,000 square feet.

Demonstrating how unadaptable old library buildings can be for art museums, while the Akron museum is somewhat smaller in total space relative to other museums in cities of comparable size, it is very small in terms of total gallery and exhibition square footage. Indeed, at 8,700 square feet of exhibition space, the Akron Art Institute falls into the smallest group of museums surveyed (see Table 3.6). Compared to the median exhibition space of almost 16,000 square feet, the Akron Art Institute thus falls into the

TABLE 3.6

Square Feet of Exhibition Space

Exhibition Space	Museums with Various Amounts of Exhibition Space	
	Number	Percent
1,000-10,000 square feet	9	33
10,001-20,000	10	37
20,001-50,000	5	19
50,001-75,000	0	0
75,001-100,000	0	0
100,001-200,000	3	11
200,001 or more	0	0
Total	27	100

Source: Compiled from sample data.

1,000-10,000 square-foot class that includes about 33 percent of the museums surveyed. While exhibition square footage varies widely, it is true, that unlike the Akron museum, the majority of buildings were originally built to house an art museum; 77 percent of the museums are in this category. Among those few which had not been initially built as art museums, 86 percent of them have been successfully adapted to the purposes of an art museum, according to officials responding to the survey. Like many museums, Akron has the problem of a small building. Once an old Carnegie library, its gallery space, educational facilities, and space for special programs are all inadequate. One wonders if people ever try to return their library books to the art museum.

Because of the limited space, the institute is limited in providing a regular and varied stream of large exhibitions; thus the fare is not sufficient to encourage large numbers of people to regularly visit the Akron Art Institute. A trip to a museum is too costly, in time and effort, when the casual visitor can only expect a few minutes of gallery viewing. Appropriate to the notion of the artist's garret, the classroom facilities on the building's third floor can only accommodate about 30 students at one time, and there is no space available for expansion. Also, the facilities for special programs on the lower level are inadequate in both space and design. The auditorium is inconvenient and uncomfortable for many special programs, and too small for others. Storage facilities for the permanent collection are marginal, and it is questionable whether it will be adequate to provide additional storage space a few years hence; especially if the collection emphasis is on contemporary art that involves large canvases.

LOCATION

About 84 percent of the museums surveyed were located within three miles of the center of their city (see Table 3.7) and 50 percent of the museums

TABLE 3.7

Distance, in Miles, from Center of City

Distance from Center	Museums Reporting Various Distances from Center	
	Number	Percent
Less than ½ mile	7	22
1/2-1	9	28
Over 1, ≤ 3	11	34
Over 3	5	16
Total	32	100

Source: Compiled from sample data.

TABLE 3.8

Number of Parking Spaces on Site

Number of Spaces Provided	Museums with Various Amounts of Parking Space	
	Number	Percent
50 or less	16	49
51-100	5	16
101-200	5	16
201 or more	6	19
Total	32	100

Source: Compiled from sample data.

were within a mile of the center. Locationally, the Art Institute, which is only a short distance from the center of the city, is typical. One problem with the location of the Akron Art Institute has to do with parking space. Roughly half of the museums surveyed have in excess of 50 parking spaces, while the remaining 50 percent have less than 50 (see Table 3.8). The Akron museum, with its scant number of parking places, represents an extreme condition relative to parking space availability among the museums surveyed. Put another way, perhaps the Akron museum is safer not to have more parking, thereby not participating in the trend toward covering the city with parking spaces, what Wolf Von Eckert has called the "urbicide" of American downtowns.

Of equal concern is the fact that the Akron museum is located in an area where there is very little pedestrian traffic. The numbers of walkins from the street represent only a very small fraction of the number of people attending the museum.

Another kind of disadvantage is the location's neighborhood. The institute is located in an unattractive, declining commercial area that inhibits it from drawing large numbers of people during the evening hours; it is located only one short block from the center of Akron's prostitution "corner." Some members of the museum undoubtedly think this an appropriate location, given the museum's direction in its collection and exhibitions, but there is not much question that the public's fear of crime has something to do with people's reluctance to come downtown in the late afternoon and evening hours.

With regard to the museum's location relative to other recreational activities, we should be concerned with the ways that people informally use the museum when going to other facilities within the community. Proximity to the public library, while it helps, does not appear to be sufficiently important in maintaining a steady, casual use of the institute by people in the downtown area. The casual shopping trip, the window shopping or strolling

through shopping malls, is the most significant recreational activity pursued by people in the city of Akron. With the decentralization of the shopping function, from the downtown area to regional shopping centers, it seems logical to assume that leisure time will, for the majority of Akronites, not be spent in the downtown area.

AKRON'S SERVICE AREA

The area the Akron Art Institute should serve is defined differently by various interest groups. As Edward W. Hanten points out: "Some members of the Board feel it should be a museum of national import serving the entire lower Great Lakes area; other Board members see its function as that of serving only Akron and the surrounding built-up area, and still others see Northeastern Ohio as the area that the Institute should serve."[1] Hanten notes further: "A program directed towards Akron would by necessity be different than one directed towards Northeastern Ohio or the entire lower Great Lakes Area. The program would probably be much more specialized, i.e., Contemporary Art, if regional appeal is the objective, whereas a program for the Akron Area only would probably be more comprehensive."[2]

Museums, like recreational activities, compete for the leisure time of individuals. They compete in this regard not only with other museums but with other recreational and cultural activities. Within northeastern Ohio, the Cleveland Museum has the greatest influence because of its excellent collection and facility. As Hanten suggests: "The smaller museums within the area located in Canton, Massillon, Youngstown, and Akron must, if they are to compete on a regional basis, develop a unique program. The uniqueness must include emphasis in an area of art that sets it apart, and thus enable it to gain acceptance on the regional level."[3] The Akron Art Institute has developed a modest regional appeal, but its impact is largely limited to the immediate Akron region.

The museum does not keep records of the place from which visitors begin their trip, and while this fact leaves the museum staff free to make claims, the only indicator that can be used to denote area of service is the membership survey, along with a brief survey of gallery visitors, conducted during the year. Using membership as a sole indicator has limitations, for only approximately 15 to 20 percent of the visitors to the galleries are members, but the institute appears to draw primarily from the city of Akron and its adjacent suburbs to the north, within Summit County, where over 90 percent of the membership resides (see Table 3.9). A brief survey of gallery visitors to the institute disclosed that 75 percent came from within a radius of 11 miles and only 10 percent came from over 30 miles.

It is clear that the primary area of service is Summit County; thus the

TABLE 3.9

Individual Members of Akron Art Institute, by Location of Residence

Location	Number of Members	Percent of Members
City of Akron, and Fairlawn (a suburb)	1,316	80.3
Suburbs in Summit County		
South of Akron	25	1.5
North of Akron	177	10.8
East of Akron	38	2.3
West of Akron	26	1.6
Adjacent Ohio counties	57	3.5
Total	1,639	100.0

Source: Compiled from sample data.

institute would serve, or at least compete for the attention of, a population estimated at 572,000 in 1973. In 1972 it was estimated that the institute drew less than 1 percent of this population to its programs.

MUSEUM BUDGETS

From a budgetary standpoint, the Akron museum lies somewhere in the middle among institutional budgets (see Table 3.10). Sixteen percent of the museums surveyed had budgets of less than $100,000, while 41 percent of them had budgets of less than $200,000. The Akron Art Institute fell into the middle grouping—$200,000 to $300,000 budgets—in which 25 percent of the museums function. From a standpoint of budget comparisons with other museums, it does not appear that the Art Institute is particularly underfi-

TABLE 3.10

Size of Current Annual Operating Budget

Operating Budget	Museums with Various Budgets	
	Number	Percent
Less than $100,000	5	16
$100,000 to $200,000	8	25
$200,000 to $300,000	8	25
$300,000 to $500,000	4	13
Over $500,000	7	21
	32	100

Source: Compiled from sample data.

FIGURE 3.1

Total Income and Expenses, Akron Art Institute,
June 1965–June 1972

Source: Akron Art Institute, audited financial statements and balance sheets.

nanced, if we assume that the scale of operation at the other museums is somewhat comparable. It is certainly not a prosperous budget; yet it is one which enables the Art Institute to pursue most of the activities it deems desirable, with the exception of accessions, in which it is notably lacking.

For several years prior to this study, the museum failed to balance its budget. Not until fiscal year 1971 was the museum able to balance (see Figure 3.1). Among comparable museums this is not uncommon. Thirty-four percent of the museums surveyed had deficits in fiscal 1971-72. Hanten shows that in fiscal 1971 the Akron Art Institute showed an operating surplus of $19,654, and in 1972, $9,149.71. One mitigating factor was the sharp rise in museum income after 1969. Obviously expanding its budget

TABLE 3.11

Operating Income of Akron Art Institute, 1968-72

Fiscal Year	Total Operating Income	Memberships		Donations & Grants		Tuitions	
		Amount	%T.I.	Amount	%T.I.	Amount	%T.I.
1968	$146,120.16	$ 80,970.00	56.0	$18,190.88	12.4	$10,305.92	7.0
1969	140,743.23	90,790.00	65.0	4,652.37	3.3	8,736.50	6.0
1970	167,921.88	76,870.00	45.7	30,732.69	18.3	12,159.84	7.2
1971	221,382.83	125,824.00	56.8	25,389.00	11.6	12,990.80	5.8
1972	248,628.96	122,682.00	49.4	33,000.00	13.3	17,832.25	7.1

Fiscal Year	Total Operating Income	Investment (Endowments)		Special Fund Raising		Other	
		Amount	%T.I.	Amount	%T.I.	Amount	%T.I.
1968	$146,120.16	$ 11,732.90	8.0	$18,435.39[a]	12.6	$ 6,485.07	4.4
1969	140,743.23	13,438.28	9.5	19,500.00[b]	13.8	3,636.08	2.5
1970	167,921.88	16,420.87	9.7	25,025.00[b]	14.9	6,713.48	3.9
1971	221,382.83	27,628.77	12.4	25,400.00[c]	11.4	4,149.05	1.8
1972	248,628.96	24,474.25	9.8	44,100.00[c]	17.7	6,538.99	2.6

[a]Women's fund raising.
[b] Arts Council fund raising.
[c]Day at the races.
Note: %T.I. = percent of total income.
Source: Akron Art Institute, audited financial statements.

TABLE 3.12

Operating Expenses, of Akron Art Institute, 1968-72

Fiscal Year	Total Operating Expenses	Employees[a]		Education Programs		Exhibitions	
		Amount	%T.E.	Amount	%T.E.	Amount	%T.E.
1968	$149,224.40	$ 93,902.13	62.9	$ 6,230.00	4.1	$18,849.83	12.6
1969	146,778.55	84,044.18	57.2	7,026.47	4.7	18,853.32	12.8
1970	205,435.09	125,368.12	61.0	7,793.10	3.7	29,547.69	14.3
1971	201,728.05	121,214.79	60.0	11,678.46	5.7	21,416.18	10.6
1972	239,479.25	131,433.39	54.8	15,681.76	6.5	33,806.34	14.1

Fiscal Year	Total Operating Expenses	Utilities[b]		General Business[c]		Other	
		Amount	%T.E.	Amount	%T.E.	Amount	%T.E.
1968	$149,224.40	$ 8,688.13	5.8	$10,214.21	6.8	$11,340.10	7.5
1969	146,778.55	9,252.64	6.3	12,182.56	8.2	15,419.38	10.5
1970	205,435.09	11,483.27	5.5	12,816.55	6.2	18,426.36	8.9
1971	201,728.05	12,258.94	6.0	13,652.07	6.7	21,407.61	10.6
1972	239,479.25	18,151.75	7.5	15,623.87	6.5	24,782.14	10.3

[a]This category includes wages and salaries, social security, payroll taxes, and any other employee benefits.

[b]Includes telephone and telegraph, heat, light, and water.

[c]Includes postage, office supplies and expenses, repairs and maintenance, and insurance.

Note: Percentages following amounts in each category are computed by dividing the particular amount of expense by the total amount of expense.

%T.E. = percent of total expenses.

Source: Akron Art Institute, audited financial statements.

and its income, the museum performed rather well in operating as close to its budget as it did. Prior to 1971 it consistently showed an operating loss, running as high as $37,513.21 in fiscal 1970 (see Tables 3.11 and 3.12). The fact that the budgets were balanced over 1971-72 should not lead to too much optimism, for the source of the revenue base for the institute could be seriously altered on short notice.[4]

INCOME

In his analysis of the museum's income, Hanten reveals that the income increased by slightly over 70 percent from 1968 to 1972. The major sources of revenue in 1972 (as shown in Table 3.11) were membership (49.4 percent), special fund raising (17.7 percent), donations and grants (13.3 percent), endowment income (9.8 percent), and tuition and tuition grants (7.1 percent). Over 61 percent of operating revenues are derived from donations, grants, and special fund raising, and only about 29 percent from membership and endowment. Thus, there is no real firm base of support for the institute as it has little endowment and no government support.[5]

The sources of income growth are interesting. In 1968, the museum depended on memberships for 56 percent of its budget, but by 1972 this had dropped to about 50 percent although there was a dollar increase from about $81,000 to about $123,000. Donations and grants were small in 1968 and 1969, at about 4 to 12 percent of income, and in 1972 remained relatively the same, accounting for about 13.3 percent of income or about $33,000. Tuitions grew as enrollments increased, but remained relatively constant at about 7 percent of income; similarly, endowment income over the five-year period remained at about 9 to 10 percent, while growing from about $12,000 to nearly $25,000. Special fund raising accounted for about 13 percent of income in 1968, but had grown from $18,000 to $44,000 by 1972, a relative increase of about 18 percent of income. Growth came in most areas except memberships, but donations, grants, and special fund raising account for the largest gains.

A comparison with other museums of comparable size shows their source of support to be much more reliable than that of the Akron Art Institute. Only one of the museums received relatively less from membership and endowment.

EXPENSES

In analyzing expenses, Hanten showed that expenses increased slightly over 60 percent from 1968 to 1972, with the major cost being personnel. Salaries and benefits accounted for about 62 percent in 1968 to slightly under 55 percent of the total expenditures in 1972 (Table 3.12). The

proportions allocated to programs did not appear to change significantly over the five-year period, although allocations for education and exhibitions increased slightly.[6] As Hanten suggests, "apparently the budget allocations were not used as a planning tool internally. Each program received its relative proportion regardless of effectiveness."[7]

A review of the net costs on a per visitor basis indicates they have risen from $3.12 per capita in 1968 to $6.34 in 1972. This represents an increase of 103 percent (see Table 3.13). Obviously the facility is not used nearly to capacity, and while attendance is not the only criterion of a successful program, the per capita costs are exceedingly high, compared to other museums of comparable size. Only the Delaware Art Museum in Wilmington was higher, with $6.57 per capita. The range was from $1.99 to $6.57 per capita.

Through 1969 there was a parallel relationship between attendance and cost, but since 1969 there has been an inverse relationship, with costs increasing and attendance decreasing (see Figure 3.2). Obviously, no one expects costs per visitor to remain constant over time, but one must be concerned with the increasing costs relative to use.

SOURCES OF REVENUE

An analysis of sources of revenue for current operating budgets among the museums revealed a wide variety of possible sources. The largest source, accounting for some 16 percent of the operating budgets in the museums surveyed, came from membership fees (see Table 3.14). Equal to membership fees was government support which accounted for another 16 percent of museum budgets. Next in order of importance came the sale of art reproductions, class fees, admission fees, and other user-charge activities of the museums, making up about 13 percent of total budget, followed closely by endowment earnings, at about 12 percent of the total budget. Private foundation grants made up about 9 percent of museum budgets, followed by

TABLE 3.13

Cost per Visitor, Akron Art Institute, 1968-72

Year	Cost Per Visitor	Total Annual Operating Expenses	Total Annual Attendance
1968	$3.12	$149,224.40	47,702
1969	2.50	146,778.55	58,486
1970	4.11	205,435.09	49,945
1971	4.79	201,728.05	42,056
1972	6.34	239,479.25	37,736

Sources: Akron Art Institute, attendance sheets and audited financial statements.

FIGURE 3.2

Total Attendance and Expenses, Akron Art Institute, June 1965–June 1972

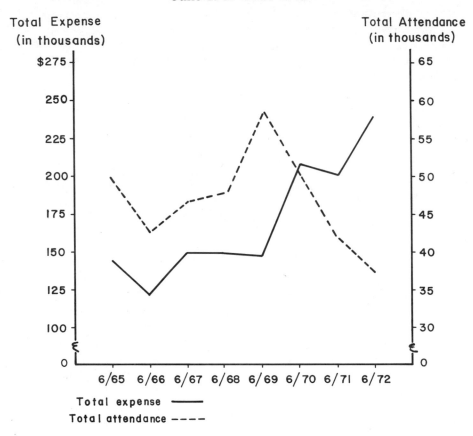

Total Expense
(in thousands)

Total Attendance
(in thousands)

Total expense ———
Total attendance ————

Source: Akron Art Institute, audited financial statements, annual reports, and monthly attendance sheets.

fund raising and corporate grants, at 6 percent each. In comparison to the other museums, the Akron Art Institute shows a number of notable sources lacking. Most significant would be the lack of government support, private foundation grants, shop sales, and user charges.

ENDOWMENT

Like most of the museums, endowment is a small proportion of Akron's budget. Its endowment fund grew from about $175,000 in fiscal 1965 to over

TABLE 3.14

Proportion of Current Operating Budget Derived from Various Sources

Source	Proportion
Membership fees	16
Government support	16
Sale of art reproduction, class fees, admission fees for cultural events, World of Art	14
Endowment earnings	12
Private donors	11
Other	10
Private foundation grants	9
Annual or periodic fund raising	6
Corporate grants	6
Total	100

Source: Compiled from sample data.

$447,000 in 1972 (see Table 3.15). This represents an increase of more than 255 percent. While relative increase is spectacular, the actual dollar growth has amounted to only $271,971.17, or an average of $38,853.02 per year. With costs rising, endowments do not appear to be a potential source of large income increases unless special efforts are made to increase them.

The endowment income increased from $7,436.55 in 1964 65 to $24,474.25 in 1971-72. Major increases came in 1966-67, and in 1969-70 when the endowment fund increased by over $100,000, but these endowment increases do not represent a large increase in total museum income.

TABLE 3.15

Total Endowment and Earnings, Akron Art Institute, 1965-72

Fiscal Year	Total Endowment	Endowment Earnings	Endowment Earnings As Percent of Total Operating Income
1964-65	$175,097.24	$ 7,436.55	5.4
1965-66	180,978.99	7,484.81	6.3
1966-67	284,346.56	9,348.53	6.7
1967-68	296,868.05	11,920.27	8.0
1968-69	302,074.10	11,988.68	9.5
1969-70	408,776.47	16,238.35	9.7
1970-71	422,577.77	23,515.46	12.4
1971-72	447,068.41	24,474.25	9.8

Source: Akron Art Institute, audited financial statements and annual reports.

TABLE 3.16

Kinds of Works of Art Institution Presently Acquires

Kind of Art Acquired	Museums Acquiring Various Kinds of Art	
	Number	Percent
American (no particular time period)	4	14
Prints, decorator arts	1	3
Varied	20	69
Latin American	1	3
Twentieth century art	1	3
Other	2	7
Total	29	100

Source: Compiled from sample data.

MUSEUM COLLECTIONS

The museums surveyed do not appear to be highly specialized. Sixty-nine percent of the respondents indicated that they presently acquire a wide variety of works (see Table 3.16). A few that specialize said they collect American painting; in the case of three museums, they specialized in prints, Latin American or twentieth century art, or decorative arts. Only 23 percent described their collections as specialized. Half of the museums specifically indicated that they had acquired varied collections (see Table 3.17).

A final question having to do with exhibitions asked respondents whether or not their museum sponsors annual exhibitions by local artists. Twenty-seven of the 32 respondents, or 84 percent of the total, indicated that

TABLE 3.17

How Would You Describe Your Collection?

Nature of Collection	Museums with Various Kinds of Collections	
	Number	Percent
American (no particular time)	3	10
Contemporary, modern	2	6
Art/history	1	3
Varied	16	52
Early stages of development	1	3
Other	8	26
Total	31	100

Source: Compiled from sample data.

they did indeed have annual exhibitions by local artists. Such exhibitions, when they are held, appear to draw relatively large numbers of visitors. The Akron Art Institute does not conduct an annual June show or May show, but it does exhibit individual local artists.

The Art Institute has a collection valued at between $800,000 and $1,000,000. This is not a large collection, but the institute does hold some valuable works. The collection is kept in the vault on the lower level, and only a few people are aware of the extent of the collection, for it is seldom displayed, a failing due primarily to the lack of gallery space.

One fact is evident: To keep the type of investment represented by the collection in the vault, where it is not realizing a return to the institute, is not good management. The collection should be taken from the basement and put to work in the community— for example, by placing works of art in public places, and by lending or renting works to individuals and public and private institutions within the community.

There has been considerable debate as to whether the Art Institute should continue to be a collecting institution. But to fail to collect would be a dangerous course, and to dispose of the collection would be even more dangerous. Given that there is fashion in art, what is deemed today to belong in a Hefty trash bag may tomorrow become a highly valued piece. Most persons interviewed in this study thought the museum should collect, but they recognize the limitations due to lack of accessions funds.

As Hanten notes in regard to the Art Institute's accessions: "There was also considerable debate as to what the accessions policy should be. The Board has accepted the policy of emphasizing Twentieth Century Art. Most of the Board recognized this to be primarily Contemporary Art and conceded this was a logical approach. It would appear that a Contemporary Art accessions policy is the only logical policy the Board can accept. Contemporary Art works can still be purchased at prices small museums can afford and works are available."[8]

Given art markets today, given a desire for a regional or even national reputation, and given funds for acquisition, there is not much doubt that high-quality contemporary art probably represents an efficient use of the acqustions budget. But is this direction the only appropriate one?

ACCESSIONS BUDGETS

Regular budgets for acquiring art tend to be somewhat small among many of the museums surveyed (see Table 3.18). Fifty-three percent of the museums had acquisitions budgets of less than $10,000. Nineteen percent of the museums surveyed had budgets of between $10,000 and $25,000, and only 25 percent of the museums surveyed had acquisitions budgets in excess of $50,000. Few museums of this size can really be said to have an aggressive accessions posture. They are not large-scale collectors. The fact that the

TABLE 3.18

Size of Budget for Accessions

Budget for Accessions	Museums with Various Accessions Budgets	
	Number	Percent
Less than $10,000	17	53
$10,000-$25,000	6	19
$25,000-$50,000	1	3
$50,000-$100,000	4	13
$100,000-$200,000	2	6
Over $200,000	1	3
No response	1	3
Total	32	100

Source: Compiled from sample data.

Akron Art Institute does not have an acquisitions budget every year is significant. If it is assumed that the building of a collection is desirable, there is not much doubt that the Akron Art Institute could function much better if it were involved in a regular process of acquiring individual high-quality pieces of art on a modest scale from year to year. The ability to have a high-quality art collection in an essentially historical context is not really possible for the Art Institute unless it has a considerable increase in its acquisitions budget.

From fiscal 1968 through 1972, Hanten showed that Akron had raised only $110,589.28 for accessions and had accepted gifts of art valued at $85,650.72 (see Table 3.19). Obviously, no great collection is going to be

TABLE 3.19

Accessions to the Permanent Collection, Akron Art Institute, 1968-72

Fiscal Year	Total Annual Accessions	Amount Expended on Accessions	Value of Gifts to the Permanent Collection*
1968	$40,300.00	$31,790.00	$8,510.00
1969	7,105.00	0	7,105.00
1970	58,635.00	13,703.13	44,931.87
1971	13,525.00	10,681.13	2,843.87
1972	76,675.00	54,415.02	22,259.98
Total	196,240.00	110,589.28	85,650.72

Sources: Business manager, Akron Art Institute; audited financial statements.
*This figure represents the difference between the total annual accessions and the dollar amount spent for accessions.

realized with funds of this magnitude. Unless the museum can acquire between $250,000 and $300,000 per year for acquisitions, it cannot hope to become the good contemporary-art museum of the lower Great Lakes area that some hope to see. The board would probably be better advised to allocate its efforts in acquiring quality exhibitions, rather than trying to collect, if its accessions budget does not increase.[9]

MUSEUM STAFF

The staff size of the museums surveyed reflected a bimodal distribution indicating variations in museum size. Most museums had fewer than 15 employees, but a few had more than 25 employees (see Table 3.20). Twenty-two percent of the museums surveyed had five or fewer full-time paid staff persons. Turning to the positions themselves, all of the museums in the survey had a director. Only 13 out of the 32 museums had an assistant director; 19 of the museums had curators, 19 of the 32 had educational directors, and only 15 had full-time librarians and registrars (see Table 3.21). Seventeen of the museums had a business manager and a gallery technician, and 12 of the museums had security directors. Only five of the larger museums had a director of development. The Akron Art Institute had 13 full-time staff positions budgeted, with 12 currently occupied. The vacancy was for the position of director. One does not gain an impression that the full-time paid staff at the institute is extremely large or extremely small. It is probably slightly larger than average, but still well within the middle range as compared to other art museums surveyed.

When we turn to nonpaid help—that is, volunteer hours that citizens provide per week—the Akron Art Institute, with a total of 60 volunteer hours per week, falls into the modal category but more toward the lower end

TABLE 3.20

Size of Full-Time Paid Staff

Full-Time Staff	Museums with Various Sizes of Staff	
	Number	Percent
Under 5 persons	7	22
6-10	7	22
11-15	5	15
16-20	4	13
21-25	2	6
25 and over	7	22
Total	32	100

Source: Compiled from sample data.

TABLE 3.21

Full-Time Paid Staff Positions

Staff Position	Museums That Have Various Staff Positions	
	Number	Percent
Director	32	100
Assistant director	13	40
Curator	19	59
Educational director	19	59
Librarian	15	46
Registrar	15	46
Director of security	12	37
Business manager	17	53
Director of development	5	15
Gallery technician	17	53
Other	16	50

Source: Compiled from sample data.

(see Table 3.22). Roughly 65 percent of the museums have more hours of volunteer help per week than Akron. Indeed, 35 percent of the art museums surveyed had 100 hours or more of volunteer help each week. The 60 hours of volunteer help that the Art Institute currently has each week is probably less than it profitably could be. Volunteers represent a significant source of membership participation and fundamental task completion in the operation of museums. Volunteers include docents, receptionists, and persons who work in museum sales shops. The Akron museum is well staffed for a museum of its size. It has a staff of 13 including eight professionals.

TABLE 3.22

Volunteer Hours Provided per Week

Number of Hours	Museums Reporting Various Amounts of Volunteer Hours	
	Number	Percent
0-50	8	25
51-100	8	25
101-200	5	16
201-500	2	6
500 or more	4	12
No response	5	16
Total	32	100

Source: Compiled from sample data.

But, in reviewing the museum's staff, it is difficult to establish the responsibilities of each of the positions. The institute did not have job classifications, and as a result, there was considerable confusion as to where specific responsibilities lie, resulting in a certain amount of overlap. As Hanten noted:

> It would appear that the Institute tried too hard to emulate the positions of the large museums without clearly defining responsibilities. As one progresses from the Director downward, ambiguity exists relative to responsibilities. For example: The relationship between the Director and the Curator is unclear relative to selection and installation of exhibitions. Indeed, in an Institute the size of Akron's there is a serious issue as to whether a Director, knowledgeable in art, should not also fill the Curator's position. Up to this time there has been considerable overlap in activities, leaving one, usually the Curator, with time to fill.[10]

MUSEUM MEMBERSHIP

The Akron Art Institute had 1,850 paid memberships at the time of the survey, of which 1,639 were individual memberships. Thus, at slightly in excess of 1,600 individual memberships, the Akron Art Institute falls into the higher categories of membership, represented by approximately 43 percent of the museums surveyed (see Table 3.23). Among all the museums surveyed, the Akron museum had the largest number of corporate members. This degree of corporate support could be of great budgetary significance to the institute and its operations, if these memberships could be the subject of a large fee increase. But, nearly half of these corporate members are clubs rather than business corporations.

A review of the membership statistics for Akron's museum indicates an interesting cyclical fluctuation. The membership shows an increase over a two- or three-year period, followed by a two- or three-year period in which it declines (see Table 3.24). The decline in membership parallels the museum's commitment to contemporary art, established after a brief leaderless period. It may be that the specialization of the museum has meant an initial loss of local membership, which has not been replaced by a regional or national constituency, or it may be that the facts are merely coincidental.

The 1971–72 membership was made up of 1,639 individual members and 211 industrial and organizational memberships. Total membership breaks down into about 1,400 family members, 186 associate and contributing members, and 16 patrons (see Table 3.25). When the overall membership declines, this drop invariably is reflected in a declining general membership.

The general membership in the Akron Art Institute compares to the membership of museums in other cities in the United States, in that it is

TABLE 3.23

Current Membership

Number of Memberships	Museums Reporting Various Figures on Individual Memberships	
	Number	Percent
0-500	3	9
501-1,000	9	29
1,001-1,500	5	16
1,501-2,000	2	6
2,001-5,000	11	34
5,000 +	1	3
No response	1	3
	32	100
	Corporate Memberships	
0-10	10	31
11-50	11	35
51-100	6	19
101-150	2	6
151-200	2	6
No response	1	3
	32	100

Source: Compiled from sample data.

fundamentally class oriented. As has been indicated, the institute serves primarily upper middle-class groups in Akron. This relatively prosperous membership is drawn primarily from the city of Akron, specifically the northwestern areas, including Fairlawn, a prosperous suburb. Blue-collar and black neighborhoods are poorly represented, sometimes not at all; some

TABLE 3.24

Membership, Akron Art Institute, 1966-72

Year	Membership	Percent Change
1965-66	1,741	34.6
1966-67	2,344	34.6
1967-68	2,111	−10.8
1969-70	N.A.*	—
1970-71	N.A.*	—
1971-72	1,850	

*Accurate membership data not available.
Source: Akron Art Institute, membership data.

TABLE 3.25

Breakdown of 1972 Membership of the Akron Art Institute

Type of Membership	Individual Memberships	
	Number	Percent
Student	54	3
General	1,367	84
Contributing	96	6
Associate patron	90	5
Patron	16	1
Sustaining Fund	16	1
	1,639	100
	Industrial and Club Memberships	
Less than $50	99	47
General	61	29
Associate patron	26	12
Patron	6	3
Sustaining fund	19	9
	211	100
Total memberships	1,850	

Source: Membership data.

census tracts contain no members from these neighborhoods, while the range extends to as many as 283 members in a tract.

MUSEUM ATTENDANCE

Among museums surveyed, there has been growth in attendance for some and decline for others. Table 3.26 reveals solid growth in museum attendance in the 0-30,000 category and, more so, in the 30,000-100,000 categories. The Akron Art Institute's decline in attendance is not characteristic of the 30,000-60,000 class into which it falls. Attendance at the institute is much lower than average for its class.

An additional question that had to do with attendance asked whether or not special programs had been devised in the museums for inner-city residents. Eighteen of the 32 museums, or 56 percent, indicated that no such programs had been pursued. On the other hand, 11 of the generally larger museums indicated that they had developed some kind of inner-city program. The Akron Art Institute had participated in a neighborhood arts program, but as of 1973 its participation had ceased.

The attendance at the Akron Art Institute consistently decreased from July 1970. While statistics indicate the attendance from July 1, 1971 to June 30, 1972 (37,736) was the lowest in the Art Institute's recent history, there is

TABLE 3.26

Number and Percent of Museums Reporting Various Total Attendance Figures for Fiscal Years 1969-72

Attendance	1971-72		1970-71		1969-70	
	Number	Percent	Number	Percent	Number	Percent
0-30,000	4	13	5	16	3	11
30,001-60,000	7	23	8	24	10	35
60,001-100,000	7	23	7	22	5	18
100,001-150,000	6	19	5	16	2	7
150,001-200,000	1	3	1	3	3	11
200,001-250,000	1	3	1	3	2	7
250,001 or greater	5	16	5	16	3	11
Total	31	100	32	100	28	100

Source: Compiled from sample data.

FIGURE 3.3

Annual Attendance, Akron Art Institute, 1962–72

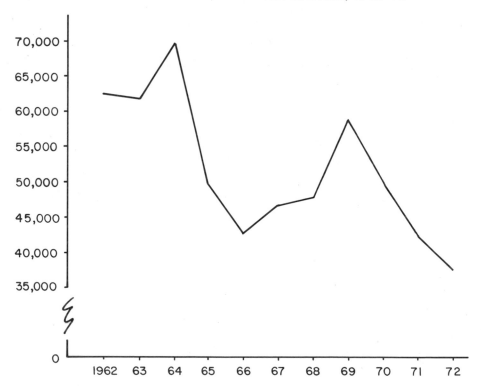

Source: Compiled from annual reports, Akron Art Institute.

FIGURE 3.4

Monthly Attendance, Akron Art Institute, 1970–72

FISCAL YEAR		
7-1-69 - 6-30-70	——	49,945
7-1-70 - 6-30-71	– – – –	42,056
7-1-71 - 6-30-72	··········	37,736

Source: Akron Art Institute, monthly attendance records.

evidence that previous attendance figures may have been considerably inflated, so that, in fact, 1971-72 may have shown greater attendance than some previous years.

The attendance dropped from 49,945 in 1969-70 to 42,000 in 1971-72 (see Figure 3.3). This trend appears to be just the opposite from the national trend, for museums of comparable size are reporting increasing attendance. Attendance figures include all persons coming to the museum, regardless of purpose. It includes the visitors to the galleries, persons enrolled in art classes, board members attending meetings, and attendees at special events. The Akron Art Institute's attendance is only about one-third to one-half that of other similar-sized museums. The reason for the decline in the institute's attendance is not completely clear, but obviously, what appeals to staff

members does not necessarily appeal to citizens. The loss in attendance can almost be entirely accounted for by the loss of visitors during the peak exhibition season running from October through May (see Figure 3.4). The 1969-72 period represents a transition from the more traditional exhibitions to those with contemporary emphasis. It was also during this period that the museum's local show was discontinued. Whether these factors were the prime reasons for the attendance decline cannot be stated with certainty. In 1969-70 the major attraction was the industry-sponsored "Contemporary Light Show." "New Realism" and "Fifty Years in Review" were also prime attractions. In 1970-71 general attendance dropped, but "Regional Artists," "Holograms," and "Faculty Invitational" were main attractions. In 1971-72 no exhibition drew outstanding attendance but the "Warhol Show," "Celebrate Ohio," and "Faculty Invitational" drew the most visitors. Obviously, the attendance pattern does not indicate a strong viewing preference other than the fact that broad-based shows do draw some support. Finally, perhaps lack of aggressive leadership with explicit goals accounts for the museum's decline.

ADMISSION CHARGES

When asked about admission charges, few museums indicated that they charged any form of general admission (see Table 3.27). Likewise, few of them charged for special events or special exhibitions. Eighty percent of the museums responding said that they did not charge a general admission for adults and 93 percent said that they did not charge a general admission for children. The figures were slightly less for special events (such as lectures), yet 66 percent said they did not charge adults for special events and 80 percent did not charge for children at these events. With regard to special exhibitions, 70 percent of the museums admitted adults without charge, and 83 percent of the museums admitted children without charge.

Akron charges no admission fee, except for some special events, and admission charges among museums of the size of the Akron Art Institute do not appear to be a common situation. The extent to which a general admission charge should be levied on persons coming to the Art Institute is not, at this time, known. It is not possible to clearly indicate just how much a general admission charge would cut into visitations, although it probably would. On the other hand, for special events there is some validity to the idea of a user charge. Such special events as the quilting-folkfest combination activity incur additional expense for the Art Institute, and a user charge seems justified for such events.

When a charge is levied, an appropriate fee level for special events or exhibitions should be based on a comparison with charges for such programs in the private sector of the economy, rather than simply covering the costs of the program to the Art Institute. In other words, to the extent that

TABLE 3.27

Number and Percent of Museums That Have Various Admission Charges for Adults and Children

Charge	Adult		Child	
	General Admission			
Free	24	80	28	94
$.25	0	0	1	3
$.50	4	13	1	3
$1.00	2	7	0	0
Total	30	100	30	100
	Special Events			
Free	19	67	24	80
$.50	1	3	3	10
$1.00	6	21	2	7
$1.50	0	0	1	3
$2.00	1	3	0	0
$2.50	1	3	0	0
$25.00	1	3	0	0
Total	29	100	30	100
	Special Exhibitions			
Free	21	70	25	83
$.25	0	0	2	7
$.50	2	7	3	10
$1.00	7	23	0	0
Total	30	100	30	100

Source: Compiled from sample data.

the Akron Art Institute charges for special events, it should be a reasonably competitive charge, rather than one which is anticipated to be cost covering. As a source of funding, the special events hold some promise for generating revenues in excess of costs for art museums, even if the general admission charge is not acceptable.

SUMMARY

Summarizing some of the foregoing survey results, it appears that characteristically the Akron Art Institute, founded in a wave of museum development in the early 1920s, was funded from private funding. Unlike most museums, the Art Institute still uses its original building, to which there have been no additions. Among museums in its general size class, it is slightly smaller than average, both in total museum space and in exhibition

space. Like gallery space, classroom space is inadequate. In general the museum is too small to induce a large number of visitors to spend any considerable amount of time there.

Most museums in the survey were within three miles of the downtown area. Akron's museum is in the city center, where parking and other problems abound. Although a new public library is within two blocks of the museum, there appear to be few positive clustering effects.

The service area of the museum is largely the Akron region, with a few visitors coming from distances in excess of 30 miles from the museum. Only an estimated 1 percent of this regional population was attracted to the museum in one year.

Since the museum operates with an average-sized budget, like most of its fellow museums, there is usually little if any money for accession of art. If these museums are collectors of art, they certainly do not collect on a regular basis. Grants, donations, and special fund raising account for growth areas in the museum's income picture, with memberships declining. In general, there was significant growth in museum budgets in the late 1960s and early 1970s.

Akron's costs per visitor to the museum have risen sharply, as budgets have increased but visitation apparently has declined. For most of the museums surveyed, costs and incomes have gone up, but so have visitor numbers.

Most museums in this size category (in terms of visitors, budgets, physical size, city-population size) had varied art collections. Only four indicated highly specialized collections. In general, accessions budgets are small, as indicated above; most of these museums cannot be considered regular and aggressive collectors. Only 31 percent of them had accessions budgets in excess of $25,000. Akron suffered by having virtually no dollars for collecting.

From the standpoint of staff, Akron has a larger-than-average number of museum professionals, but the number of volunteer hours the museum gains is less than that for comparable museums.

Memberships in the museum are much higher than is usual for such museums. Its corporate and institutional membership is the largest of all museums surveyed, indicating better-than-average local support, even though general membership is declining.

Most of Akron's museum members reside in prosperous neighborhoods in northwest Akron. Blue-collar and black neighborhoods are poorly represented, if at all.

Total attendance among the museums shows a mixed pattern of growth for some and a decline for others. Akron's visitor numbers have declined. Seasonally, Akron's visitors are probably least numerous in the summer period.

As to admission charges, few museums in this group charge any form of

fee to enter, except for special events, when a fee may be charged for adults. Akron does not charge for its activities, except for the occasional special event.

POLICY QUESTIONS TO WHICH THE MUSEUM SHOULD ADDRESS ITSELF

A comparative analysis does not necessarily lead to firm conclusions about questions of a museum's budget, building, programs, and so on, but it does suggest that there are policy questions that the staff and trustees may wish to examine in more detail. In many instances, if a museum differs widely from its fellows, this may represent either a strong positive direction or it may suggest that there is a problem which needs to be looked into.

Comparatively, there is not much doubt that Akron's museum has not kept pace with other museums from the standpoint of physical facilities. Using an old library building may not well serve the museum's modern activities, just as a building constructed years ago for a museum may no longer serve the museum's evolving interests and purposes. The main point here is that if a museum building does not evolve over time as programs evolve, then efficient service is not likely to be forthcoming. Although it is hypothetical, one might almost suggest a principle of museum development; that is, if programs change over time, then physical facilities must change with them or the service will be less successfully offered. Of particular note for Akron is the lack of adequate gallery space and storage space.

As to location, one may offer several policy questions. First, does the museum wish to be a magnet for the central core? Second, and relatedly, are there other significant facilities and services in the central core that can create an agglomeration effect for the museum? Third, is location primarily concerned with a civic duty (to support a central core), or is it primarily concerned with ease of access for visitors to the museum, or is it primarily concerned with questions of ease of access for the entire community? Location questions have not been well examined in Akron, and goals for policy with regard to location have not been developed. If the first question raised above is the one that obtains, then Akron's museum should stay in the central core. If the second question obtains, then the museum should be located near most of its current visitors, in northwest Akron. If it is a matter of attempting to expand one's clientele, then the center of the city has the advantage of being accessible (given parking) for most persons, but is a kind of locational compromise that benefits potential visitors at the expense of current visitors from northwest Akron. Additionally, the core is not terribly attractive, and a suburban location can mean a parklike setting of some attractiveness. Also, if the museum wishes to gain financial support from the local government, then it should likely stay in the central core. At any event, location questions have not been systematically analyzed by the museum. Further insights into location are given in later chapters.

Another whole area of policy is implicit in questions which relate to the kind of support that a museum has. Support from a variety of sources creates a difficult process of continuing support, because if support comes from a wide variety of sources, then the director is faced with returning to each of these support sources each year and pleading his case again. Also, differing fiscal years among sources may keep accounting and business people in the museum constantly under pressure to develop regular reports for sources for periodic review. In addition, different sources may have different requirements, and there may be actual conflict between sources where regulations on use of funds or financial reporting are concerned. Yet diversity appears to be desirable, given that most museums cannot hope to have a sufficiently strong endowment to cover all of their expenses; further, diversity of support seems to be the rule rather than the exception. The main policy question appears to be whether or not to seek local government support, along with a consideration of the implications of so doing. In addition, there is always a need to consider ways and means of increasing endowment.

Collection is another matter of policy to be considered when a comparative analysis is pursued. Most museums have what they describe as a varied collection, as does Akron. Only about 16 percent of the museums have a specialized collection. Specialization has its own problems, and attempting a general collection has another set of problems. More detail on collection will be given in later chapters.

Another area of policy concern arises from the foregoing comparative analysis of staff size. Akron has a larger-than-usual staff; is this a great boon or is the size of the staff a burdensome luxury? Similarly, how well does the Akron Art Institute do with regard to attracting and utilizing its volunteers? Policy questions arise, and Akron, in comparison to other museums of similar scale, appears to have more staff persons and fewer volunteers.

Another set of policy questions centers around museum membership. Who are the members? How many of them are there? Who do we wish to focus recruitment efforts on? Which segments of the population offer less likelihood of success in recruitment, and which ones more? Since corporate members appear to be relatively more numerous in number in Akron than in other museums, what is the role of corporate memberships, and what impact does this phenomenon have on the museum? Is the fact of corporate membership a blessing? Is it a mixed blessing? Is the general pursuit of new members done well? Is it done poorly? Is it in any sense objectively and systematically pursued?

Of course, the most glaring difference between Akron and the other museums in the survey is Akron's decline in visitation. But, are visitation figures collected accurately at Akron or at other museums? Is there a systematic process for collection of data, and if so, what does it reveal? Akron has a significant problem in visitation that the comparative analysis can only point out.

Admission charges do not appear to be a matter of signal policy concern. To price admission is to do so for one or two reasons, or both: One prices to gain revenues and/or to ration use. Pricing to ration use is irrelevant for the Akron Art Institute. Obviously, pricing of general admission is not apt to be successful for this museum. On the other hand, pricing of special events has in the past been useful. The extent to which the museum subsidizes some group visitors, such as school children with no financial support from the school districts, is a policy question of some particular concern.

This chapter has compared and described differences and similarities between Akron's museum and other museums in cities of similar size. The analysis is primarily suggestive, but certain basic policy issues are raised that need the attention of the museum's board and its staff. Success of programmatic elements of the museum will be affected by these organizational and structural characteristics of the museum. Whatever the result of policy discussions, it is clearly true that the policy questions raised here are important ones, to develop, and should be systematized and linked to programmatic areas of museum services in regard to exhibition, education, and development.

NOTES

1. Edward W. Hanten, William Hendon, and Alfred Papa, *The Akron Art Institute Study, Vol. 1* (Akron: Center for Urban Studies, University of Akron, 1973), p. 31.
2. Ibid.
3. Ibid. pp 31 32.
4. Ibid. p. 43.
5. Ibid.
6. Ibid. p. 48.
7. Ibid.
8. Ibid. p. 86.
9. Ibid. p. 87.
10. Ibid. p. 97.

Chapter Four

THE ART PUBLICS OF THE MUSEUM

As a multiple-function institution, the Akron art museum provides educational and curatorial services and stages numerous shows, displays, exhibits, and performances. In most museums the services are diverse. This diversity is simply an effort by museums to provide the activities and events that art publics demand. Yet who are these art publics? Why do they join and why do they quit? Are they mostly captive school children brought to the galleries by bus? Are they elite members of the local 400 who, between fox hunts, drop in for a bit of cheese and wine at an exhibition opening? Or are they students copying a work of art? Are they middle-class parents pushing their children and their visiting aunts in front of them? Are they moralists who dote on biblical themes?

The purpose of this chapter is to develop and demonstrate a method for identifying art publics from among a group of art-museum members. By being explicitly aware of the diverse art publics it serves, the museum should be more capable of planning and offering services that meet the needs of its membership. In the case of most local museums, the art publics served may be thought to be quite diverse. Assuming this point, then it is also clear that the demand for art exhibitions and other services will likely vary widely among these publics.

THE SAMPLE

A sample of some 550 members of the Akron Art Institute was selected randomly and asked, in a mail questionnaire, to respond to (among other things) a series of Likert-type value-judgment statements regarding their perceptions of art and art publics (see Appendix D at the end of the book). One hundred thirty-seven responded to the survey. Since one aspect of the

survey was an effort to detail the diverse values and attitudes that various art publics hold, a typology was used that separates responding art publics according to whether the values they hold are internally or externally derived. But before getting to questions of values and attitudes, let us briefly describe the responding members.

Basic Economic and Social Characteristics of Members

Of the 137 respondents, 119 (88 percent) of the members have lived in the Akron area for more than five years. Eighty-five of the respondents are natives of Akron. Educationally, only eight of the 137 respondents had only a high school diploma or less, whereas 103, or almost 80 percent, had a bachelor's degree or more (see Table 4.1).

Aside from their stable location patterns and their higher-than-average educational levels, the members had an average age considerably in excess of the average age of the Akron population. Members who are over the age of 40 represent 67 percent of total membership (see Table 4.2). Naturally enough, 85 percent, the vast majority (116 out of 137) are married, and their average number of children is nearly three per household.

Since they are relatively older, well educated, and mostly married, unemployment for this group is not a problem. In fact, 104 out of the 137 (76 percent) are heads of household engaged in professional or managerial careers. As one would expect, total family income among the members of the Akron Art Institute is quite high. Seventy-seven of the 137 respondents, or nearly 56 percent, had incomes in excess of $25,000 per year (see Table 4.3). Only seven of the respondents had incomes of less than $10,000 per year. Given the employment status of the head of household, and the large total family incomes of the membership, members of the Art Institute can be characterized as upper middle-class residents of the community.

TABLE 4.1

Akron Art Institute Member Survey: Number of Years of Schooling

Years of Schooling	Number of Members	Percent of Members
0-8	0	0
8-12	0	0
High school diploma	8	6
12-16	26	19
B.A.	44	32
Beyond B.A.	59	43
Total	137	100

Source: Compiled from sample data.

TABLE 4.2

Akron Art Institute Member Survey: Age

Age Group	Number of Members	Percent of Members
Under 20	0	0
20-30	16	12
31-40	27	20
41-50	27	20
51-60	36	26
61 and over	29	21
No response	2	1

Source: Compiled from sample data.

As members of the upper middle class, the membership represents a diverse interest group, active in civic and church affairs; they are frequent travelers, and widely engaged in a series of sports and hobby activities (see Table 4.4). As expected, they eschew indicating a reliance on television as a major activity. Characteristic of their participation in other activities within the community, they tend to participate in at least one community organization in each of the categories of organizations—recreational, cultural, social, religious, business, and civic. They can be characterized as regular participants and joiners in locally available organizations.

Their participation in the institute includes a variety of interests. They can be characterized as regular, if not frequent, visitors to the Art Institute (see Table 4.5). But, 15 percent of the respondents had not been to an exhibition within the previous year, and 7 percent had never attended an exhibition.

A substantial number of members surveyed, 48, indicated that they have had membership for more than ten years (see Table 4.6). In fact, 75 of

TABLE 4.3

Akron Art Institute Member Survey: Total Family Income

Income Group	Number of Members	Percent of Members
Under $5,000	1	1
$5,000-$10,000	6	4
$10,000-$15,000	16	12
$15,000-$25,000	31	23
More than $25,000	77	56
No response	6	4

Source: Compiled from sample data.

TABLE 4.4

Akron Art Institute Member Survey: Main Hobbies, Activities

Activity	Total Responses by Activity	
	Number	Percent
Sports	87	20
Gardening, homemaking	35	9
Crafts, hobbies	28	7
Collecting	15	4
Civic/church	37	9
Travel	31	8
Active in art, or art hobbyist	49	12
Collector, museum visitor	71	17
Television	12	3
No response	45	11
Total	410	100

Source: Compiled from sample data.

the respondents have belonged to the Art Institute for five years or more; 62 of the respondents have been there for four years or less.

While the responses vary widely, typical reasons for joining the museum have been, first, that members wish to support the Akron Art Institute or, second, they are generally interested in the arts. Ninety-one of the 137 respondents, or about 66 percent, gave one of those two reasons for joining the Akron Art Institute. Six of the respondents indicated a primary interest arising from art collecting, while eight indicated that they were professional artists, and only three indicated that they were art educators.

TABLE 4.5

Akron Art Institute Member Survey: Last Time You Attended an Exhibit

Most Recent Visit	Number of Members	Percent of Members
Within last 30 days	42	31
1-6 months ago	42	31
6 months-1 year ago	17	12
More than 1 year ago	22	15
Don't remember	5	4
Never	9	7
No response	0	0
Total	137	100

Source: Compiled from sample data.

TABLE 4.6

Akron Art Institute Member Survey:
How Long Have You Been a Member of the Art Institute?

Years of Membership	Number of Members	Percent of Members
Less than 2	31	23
2-4	31	23
5-10	27	20
More than 10	48	34
Total	137	100

Source: Compiled from sample data.

When asked to rank their secondary reasons for joining, reasons which were mostly commonly given were the same as the primary reasons, namely, support of the arts and support of the institute. A third reason given seemed to be the advantages that the Art Institute provided for children and a fourth was the fact that respondents have friends who are members. Since respondents were asked to give three reasons, an excess of 400 responses was gained. Only 63 of the responses, or roughly 15 percent, indicated that reasons for joining the Art Institute had to do with a member's interest as an art collector, a professional artist, an art educator, or an art hobbyist. In the main, the reasons for joining are not connected to a personal involvement in the participatory aspects of art. Rather, one would class the members as art viewers, consumers of art, persons who take part in a civic responsibility; and, finally, they join for social reasons.

Whatever their reasons for joining the Art Institute, they tend to be somewhat positive toward it, in that 89 of the 137 respondents had recommended membership in the institute to their friends; but only 80 percent indicated they definitely planned to join the next year, 7 percent said they would not, and 13 percent were uncertain.

About 9 percent of the members also hold membership in the nearby Cleveland Art Museum. The majority, 114 of the 137 respondents, indicated that they did not belong to any other art museum. However, association with other museums is evidenced by the fact that 46 percent of the respondents indicated that they had been to the Cleveland museum within the past year. Of that 46 percent, about half had been to the Cleveland museum two or more times within the past 12 months.

In spite of their regular support of the museum, members do not participate in, nor do they know much about, the operation of the museum. While the majority of the members are acquainted with some members of the board of the Akron Art Institute, only eight of the 137 respondents had attended the last annual meeting of the board. Further, only about 15 percent of the respondents serve on any committees of the Akron Art

Institute. Their explanations for not serving on a committee range from having no time to being too busy to never having been asked. As to growth or lack of it, 32 percent of the respondents believed that use of the Art Institute was on the increase, when in fact it was not. Fifty-nine of the 137 said that they did not know whether memberships in the Art Institute were increasing. Likewise, members were not intimately familiar with the major sources of financial support. When asked to rank in order of importance the major sources of financial support for the Art Institute, they accurately cited membership fees as the number one source, while rating industrial and commercial contributions as number two. Forty-one of the respondents indicated that they did not know how the institute was supported, and eleven did not respond to the question.

Members were asked a number of questions about the museum's location, its programs, etc. Ninety-one of the 137 respondents (or about 66 percent) thought that the present location of the Akron Art Institute was convenient for their use of the institute. When asked if they would like to see the Art Institute move to a new location, the majority of those responding saw no need to relocate the Art Institute. When asked what location they would like to see the Akron Art Institute move to, the 69 respondents to that question indicated a preference which was pretty much equally divided between prosperous northwest Akron, or a location elsewhere in the central business district or anywhere in the community with better parking (see Table 4.7). One gets no clear impression that the members of the Art Institute see any great need for it to move to another site.

TABLE 4.7

Akron Art Institute Member Survey: What Location Would You Like to See the AAI Move to?

Location That Members Prefer	Number of Members	Percent of Members
Other locations downtown	20	15
Anywhere with better parking	19	14
Near Akron University	4	3
West Akron, western suburbs	13	9
Stan Hywet Hall*	4	3
A park environment	4	3
Satisfied with present location	3	2
Other	4	3
No opinion	11	8
No response	55	40
Total	137	100

*A Tudor mansion, open to public view, the former home of Frank Seiberling, founder of Goodyear Tire and Rubber Company.

Source: Compiled from sample data.

Extending the hours of a museum is a common question regarding operations. Asked about the advisability of having regular evening hours in which the institute is open, 39 of the 137 respondents (28 percent) indicated that they would come more frequently if the institute were open in the evening. When asked how they found out about the Akron Art Institute prior to joining, the majority of the respondents indicated that they came to the Art Institute through some form of personal contact with friends or associates.

Are staff and board members responsive to members? Seventy-two of the 137 respondents indicated that they had at some time in the past sought assistance from the Akron Art Institute staff. The response of the membership was very favorable in regard to the staff. Only three of the respondents indicated that the staff had not been either courteous or helpful to them. On the other hand, 98 of the respondents (72 percent) indicated that the staff was courteous and helpful. One hundred three of the 137 respondents (80 percent) indicated that they could not make a judgment about the extent to which the board was responsive to the membership, suggesting that there is no clear working relationship between the board of the Akron Art Institute and the membership.

Even if it were within their power to do so, most respondents said they would make no changes in the museum. Eighty of the 137 (60 percent) either expressed no opinion or made no response to the question. Members showed no overwhelming desire for changes in the institute, although they have expressed interest in higher quality and greater variety in exhibits, the need for better representation of local artists, the need for better parking, the need for a capable director, and a need to deemphasize modern art (see Table 4.8). None of the changes that was suggested represented a view held by more than five of the respondents; thus one finds no great interest in changing the Art Institute in a consistent or particular manner.

Similarly, when respondents were asked to indicate activities or programs that they would like to see added or expanded, the results were somewhat mixed. Again, the majority of persons did not respond. But among those who did, there seemed to be some interest in expanding craft programs, programs involving local artists, and the classes offered.

As to questions of preference, the activities of the Akron Art Institute that members liked most were the exhibitions, followed, in a distant second position, by the members' previews, and then by social functions. On the other hand, when asked which activity they liked the least, the most frequently cited activity was, again, exhibits, with none of the other activities offered at the museum generating considerable response. It would appear, therefore, that the principal interest the membership has in the Akron Art Institute lies in exhibitions, and there seems to be some disagreement as to what those exhibits should properly present. None of the other activities of the institute can be said to play a prominent role in the minds of most members.

TABLE 4.8

Akron Art Institute Member Survey:
If You Were President of the Board of Trustees of AAI,
What Would You Do To Change the Institute?

Change Suggested by Members	Number of Members	Percent of Members
Broader representation of board members	3	2
Bigger-name exhibits, improved exhibits	4	3
Provide parking	2	1
Find a capable director	3	2
Relocate the museum	3	2
Deemphasize modern art	5	4
Add accredited courses, improve educational programs	2	1
Interest people in art, make them feel welcome at AAI	2	1
Emphasize local artists	5	4
Provide more variety	5	4
Advertise more	3	2
Other (one suggestion given in each case)	20	15
No opinion	13	9
No response	67	50
Total	137	100

Source: Compiled from sample data.

In sum, art-museum members are generally older, better off financially, better educated, and have a greater diversity of activities than the general population. About two-thirds of them appear to be regular visitors to the museum, but few come more frequently than once a month. They have interest in the museum's exhibitions but express widely varying preferences. In addition, most of them know little of the operation of the museum. Art-museum members pose something of a problem in that their interests appear vague, not sufficiently consistent, nor very strong in particulars. They support the museum, but their support may be considered in the main to be based on a mix of pleasure, perceived social value, and only a modest knowledge and interest in art. In order to better understand them, a typology of art publics was applied and analyzed.

A TYPOLOGY OF ART PUBLICS

Throughout the history of art and art study, a universally acceptable definition of what constitutes an art public has been elusive. Many of the early works of art mirrored the artistic tastes of the upper class, who were

the "spokesmen" for the general art public.[1] This minority concerned with the arts has traditionally represented a governing or controlling class in a spiritual and intellectual sense, and served as a cultural elite.[2] They were, in large part, then, the art public.

But with the advent of public museums, and the application of democratic ideals to art, art appreciation, and art education, art in various forms is now available to the vast majority of individuals who choose to participate. The arbiters of taste are not necessarily the wealthy, but the art-museum directors, curators, and trustees, those people responsible for the quality and the organization of their respective museums. To make effective policy decisions concerning issues such as the future direction of a museum (what programs to offer, what types of facilities should be used and where, and who should participate), the planners must initially identify who it is they serve.

Various attempts have been made to define what an art public is, but these have usually been rather general in nature. According to Harold Rosenburg, "we are a public of educated people. Yet it is not an educated public," in terms of art.[3] He notes further:

> These phenomena suggest that the public for each art activity and each organization of taste is the mass of those who have not yet identified themselves with it. From this point of view, what makes the public the public is precisely the inadequacy of its appreciation of the matter placed before it. When an artist or a scholar says "the public" he means persons ignorant of his specialty. . .[4]

Since the availability of art to all classes of people is relatively new, it is not surprising that the majority remain uneducated in regard to art, but this definition does not actually describe the art publics to any degree.

The problems involved in the conceptualization of a particular art public, and their motives for participation in art, are probably paralleled by the idea of the mass public, discussed by Roger Clausse.[5] Clausse points out that the mass public never remains the same, but is continually shifting, as a result of "demographic concentration, urbanization, functional isolation, anonymity, social conformism, leisure, etc.";[6] his discussion centers on the relationship between the mass public and mass communications. Public art, as found in museums and other public places, is experienced by a public that is constantly changing, perhaps never obtaining a sense of togetherness or mutual identification as a group. The art public on any one day is partially determined by the value of the art exhibit as perceived by various individuals, and by external circumstances that are totally unrelated to the art experience, such as work responsibilities, family duties, and leisure time available. Thus, simply providing public art is not the same as identifying and serving an art public.[7] As stated, individuals conceivably could have infinite reasons for participating in the arts. The dilemma of whether art-

museum policies serve only the relatively small number of educated art enthusiasts, or serve all levels of interest and sophistication, is a continuing one. For example: "The most prominent of the snobberies—democratic snobbery—seems to imply that only what attracts great masses is good, and conversely, what is good does attract great masses, and finally, if it does not seem to, it must have been insufficiently advertised.".[8]

Art-museum directors often attempt to satisfy various levels of taste and sophistication in their general public by offering various types of exhibits. These museum directors tend to organize their programs and plan their exhibits to satisfy three levels of interest: They have a section for children up to approximately 12 years of age, which tends to be simple and colorful; a section specifically for adults who (like the vast majority) have no specialized education or training in the arts and are therefore provided a great deal of factual information; and a section of their exhibits for art specialists, or those people who can compare and appraise works of art.[9] The question arises as to whether this is the most logical method of categorizing their art publics. The implied assumption in classifying the publics only by education and expertise is that within each category, the fundamental reasons for participating in an art experience are the same, leaving no room for the various individual motives of those who choose to visit a museum.

Another method of dealing with the growing numbers of people involved in art development and education has been to provide specific programs for specific interests, as opposed to a general program for the entire art public. In this concept, museum exhibits would not be provided for universal appeal, but different programs and activities could be made available on a communitywide basis. This method of organization has provided the opportunity for an art experience for people at all levels of interest and degrees of sophistication, and has, in essence, decentralized the control of art by the museum and enabled increased participation. Arts and crafts in senior-citizen centers, films and literary programs in local libraries, art festivals at teen centers, and neighborhood art shows at community neighborhood centers are all examples of efforts to provide a varied art experience.[10] But again, the question arises: Do programs such as these simply increase the supply of public art, or are they chosen to fill a void for a particular art public? The latter alternative is possible only if various art publics have been identified, a difficult task at best.

The typology used in this study was developed by Bruce Watson. It is worthwhile to briefly review the characteristics of Watson's six-cell typology, as shown in Table 4.9. Rows in the table reflect the value dimension of art, while columns reflect an attitude toward art. The "intrinsic-value, positive-attitude" category (cell I) represents an "art-for-art's-sake" public, and, of all of the six value and attitude perceptions noted by Watson, reflects the most intimate interaction with the artist and with art. This public has a high degree of commitment to art, yet they are not patrons in the historic sense.

TABLE 4.9

Watson's Art Publics: A Six-Cell Typology

Value Dimension	Attitude Dimension and Cell Number			
	Positive	Cell	Negative	Cell
Intrinsic	Art for art's sake	I	Pseudocritical	II
Intrinsic-Extrinsic	Educational	III	Didactic	IV
Extrinsic	Recreational	V	Status seekers	VI

Source: Bruce Watson, "On the Nature of Art Publics," International Social Science Journal 20, no. 4 (1968) 675.

This public both buys the artist's work and serves to enlarge the artist's circle of contact so that he has a larger market for his works.

The second positive category (cell III) "intrinsic/extrinsic values, positive attitude," includes those who are interested in the educational aspects of art. This group is similar in some respects to the recreational art public, but differs in that although art is a means of attaining an educational goal, this does not preclude developing a high degree of commitment to art. Watson noted that membership in this public often results from some preexisting membership; this entails the possibility of membership being a disguise for other values and attitudes, including art for recreation and art for the satisfaction of belonging to an aesthetic elite.

The "extrinsic-value, positive-attitude" public is described as the recreational art public (cell V), and it originates among those who seek pleasurable recreational activities. In contrast to the first type of public, the art in this case is not an end in itself, but rather, is a means of establishing congenial recreational relationships and experiences. This public is the most diffuse and, therefore, the least likely to share either a common fellowship or perception of art; visits are simply a means of using time in a pleasurable and socially approved manner. Visits can also have the purpose of purchase and collection of art for investment purposes, even though this group enjoys art and values it for other reasons. The size and transient nature of this public probably diminishes the possibility of more intimate forms of interaction and communication with art.

Many art publics hold negative attitudes about art even though they find positive value in it. The next category, a negative one (cell II), "intrinsic value, negative attitude," represents those for whom art is defined by preconceived standards of taste. This relatively small group is composed mainly of persons for whom great art is exclusively a reproduction of nature. Watson argues that the falsity of this position lies in this public's refusal or inability to understand the nature of artistic experimentation, and their misreading of the history of art. Also, because of the intense emotional appeal of their critical view, this public may develop a feeling of exclusive fellowship second only to that of the art-for-art's-sake public.

Cell IV, "intrinsic/extrinsic values, negative attitude," includes those who feel that art should reflect only certain kinds of subjects. This group's commitment is intensified by the feeling that art is a means of attaining a higher morality. They mix the attitudes of the pseudocritical art public with those of morality, the result being condemnation of art that, in their veiw, does not serve a moral purpose.

Cell VI, "extrinsic value, negative attitude," implies that the interest in art is merely a disguise for attaining goals that have nothing to do with art. The real objective of this group is not art but, rather, status, so that in feeling the need constantly to be among the avant-garde, they feel few artistic loyalties and constantly clamor for that which is new.

Using Typology

A typology in and of itself does not represent the end of the research effort, but is a means of organization and conceptualization of raw data.[11] The initial data, such as the answers to questionnaires submitted by the Art Institute sample, do not define the typology. Rather, the researcher derives the typology as being representative of a particular theory concerning uniformities within the data. As John C. McKinney states, "there is no such thing as a type of [of typology] independent of the purposes for which it was constructed."[12] What a typology can provide, then, is simply a higher level of understanding that is to some degree testable[13]—a fact especially important in any attempt to measure social behavior. Thus, Watson's typology can be used as a tool or device to initially organize the raw data in definable groups that can be systematically analyzed within his conceptual framework. This idea of "constructing the general" from the specific[14] is adequately summarized by the complementary thoughts of McKinney and of Howard Becker, respectively:

> Within this frame of reference we then define the constructed type as a purposive, planned selection, abstraction, combination, and (sometimes) accentuation of a set of criteria, a basis for comparison of empirical cases.[15]

> The construct may be a type of social organization, a type of personality, or the like. By implication, if not directly, this statement is made: . . . "under such and such circumstances, this type would probably behave thus and so." And then the researcher looks for cases that provide some kind of comparative checkup on his tentative generalization.[16]

Derivation of the Watson Typology

For Watson, the specific occurrences from which he derived his typological construct were the experiences of participants in an art exhibition held in 1913 at the New York National Guard Armory. Noting the

historical lack of consistency in describing art publics, Watson attempted to develop his theoretical framework from this particular event because of the tremendous public reaction to it. Attendance levels were high due to the fact that, for the first time, contemporary European art was displayed in a major exhibition in the United States.

Watson could easily divide the general attitude of the mass public into two critical positions, positive or negative, depending upon whether they responded in a positive or negative manner to the art exhibition. As stated by Watson, "The critical positions may be viewed as a dichotomy of attitudes in the sense that they represent internally aroused, but socially acquired, predispositions of an individual towards a class of objects."[17]

But Watson also realized that those who attended the exhibition, regardless of their attitude toward the art presented, participated in the experience for different reasons. For some, the art experience was an end in itself, so the value derived was of an intrinsic nature. For others, the value lay in obtaining more social benefits from the experience, such as recreation. The value for those individuals, then, was extrinsic to the actual works of art. Still others were motivated by a combination of the two sets of values, and so could hold an interest in the art (intrinsic), as well as being able to find external value from the entire experience (extrinsic).

Thus, two related, and certainly not mutually exclusive, dimensions provide the framework for a typology of art publics. Each individual has a critical-appraisal dimension, and, as previously stated, regardless of that appraisal, has some motivation for participation. It is the combination of these two dimensions that is the essence of the Watson typology.

Each of the six cells formed in the typology is representative of a distinctive art public, and each reflects a combination of the critical attitude toward, and the value of (or the motivation for), the art experience, as expressed by each public.

For example, cells I, III, and V reflect the positive appraisal of art (see Table 4.9). If an individual has a positive attitude toward art, and finds the value of the experience in the works themselves, he essentially accepts art for its own sake (cell I). If an individual does not perceive value from the works themselves, but does derive pleasure from the social contact at art exhibits, then he is receiving extrinsic value from the art, which still reflects a positive attitude (cell V). Acceptance of both extrinsic and intrinsic values, again reflecting a positive attitude, typifies those people interested in the educational facets of art (cell III)

Those who maintain a negative attitude toward art are still motivated by how they value the art activity, as illustrated in cells II, IV, and VI. Many are critical of art that does not imitate nature. To that particular public, the value is found in very specific and limited forms of representational art, and such persons reflect an inability to fully understand the nature of diverse art forms (cell II). If an individual carries a negative attitude toward art and

does not value the art itself, then the entire experience can become simply an opportunity to enhance one's image as part of a cultural elite (cell VI). Lastly, many individuals indicate an overall negative view of art, but feel there can be both an inherent value in art as well as external value, suggesting that art must serve a higher purpose. The higher purpose for this art public (cell IV) is that art should support and encourage moral progress, and that art forms that do not meet some arbitrary level of moral edification are inherently decadent and unacceptable.

Two characteristics of the various art publics described by Watson should be noted. First, both dimensions, the dimension of attitude toward art, and the dimension of the value derived from the art or art experience, are exhaustive. For example, there are no additional responses in terms of critical attitudes outside of the positive or negative dimensions. This can be assumed because these dimensions do not describe a specific level of intensity of attitude, but, rather, represent the entire range of positive and negative attitudes. These two dimensions, then, can be viewed essentially as polar opposites. This same assumption can be made concerning the value dimensions that are described in terms of intrinsic and extrinsic value. Thus, each art public (or cell) framed by the combination of the two dimensions does not serve to describe any one particular individual, but provides for a wide range of responses within any single dimension.

This description of the Watson typology is not meant to reproduce his explanation of his art-public theories. Of fundamental importance, however, is to note that these distinctive types suggested by Watson represent an effort to create some order in an area of human behavior that is very complex. Of course, not every individual must necessarily fit neatly into one specific category. There will always be exceptions to any type of theoretically based typology.[18] But if we can identify, in the Art Institute's membership, statistically significant groups of individuals who can be categorized within this framework, we have taken a big step in the identification of local art publics.

One important aspect of the typology is the heuristic nature of its origin and purpose, as opposed to the strictly empirical derivation discussed by R. F. Winch.[19] Watson's types were obtained from empirical evidence in the sense that he derives his conceptual framework from the views of participants in the 1913 art exhibition. But he creatively fit their reactions into neat categories that reflect his understanding of their similarities and differences. As Max Weber notes, the fit between the actual occurrence and the general classification scheme does not have to be a perfect one, but should be a logical one. The characteristics of a heuristic typology, then, according to Winch and as exemplified by Watson, are as follows:

1. It is deduced from theory.
2. It is constructed to enhance the vision of the researcher.

3. It is a voluntary distortion of empirical phenomena.
4. It stands between theory and the test of theory.[20]

This idea of classification of specific categories of the typologies themselves, according to their purpose, corresponds with the various types of typologies outlined by McKinney. A summation of the characteristics that can be attributed to the Watson typology might help define its usefulness.

For example, the Watson typology is probably closer to an ideal typology, as opposed to an extracted typology. The ideal type, generally accredited to Weber, who initially developed the conceptual framework for it, parallels the heuristic type described above. The major emphasis is not placed on simply restating the data, but upon constructing "conscious deviations from concrete experience."[21] This simply means that an individual researching the same art exhibit studied by a previous researcher could conceivably construct a totally different typology using the same information as that used by the other person, but approaching it from a different theoretical standpoint, and with unique perceptions and biases.

The typology developed by Watson is also of a general nature, as opposed to being of a specific nature.[22] Watson does not make an attempt to describe in detail all or most of the characteristics that those in each art public have specifically in common. He only makes a general statement of what attributes he perceives as cogent to his theory, and this approach allows for a great amount of flexibility in making the transition from raw data to the utilization of his typology. But this same flexibility can pose problems in the conversion process by leaving the transition open to subjective measurements, and raises the question of specifiic validity.

Additional characteristics of this particular typology reveal that it was not conceived as a tool to assist in the study of just that one specific art exhibit held in New York in 1913. Watson's typology takes a scientific approach[23] in that he is seeking to understand general and recurring phenomena. Through development of a theory from one body of research, Watson has made an attempt to transcend time and space[24] (the 1913 exhibit) and to make a universal statement concerning the nature of art publics. In effect, then, it paves the way for formal empirical research such as an analysis of the membership of the Akron Art Institute.

METHOD OF APPLYING THE TYPOLOGY:
STATEMENTS AND A SCALE OF RESPONSES

To apply the Watson typology to the Akron sample, value-judgment statements and a scale of responses were developed. (see Table 4.10). Once these were developed, a consistent method of interpreting the responses was required. One profitable way of viewing responses to these statements

TABLE 4.10

The Art Publics Test:
Statements and Scale of Responses

Some of the Statements, with Scale of Responses, That Sample Was Asked to Respond to	Attitude Category
1. Art should seek to improve the moral fiber of society. 1) strongly agree 2) agree 3) undecided 4) disagree 5) strongly disagree	Didactic
2. The best art is that art which realistically imitates nature. 1) strongly agree 2) agree 3) undecided 4) disagree 5) strongly disagree	Pseudocritical
3. I feel I profit personally from most art exhibitions because something can be learned from most of them. 1) strongly agree 2) agree 3) undecided 4) disagree 5) strongly disagree	Educational
4. Art for me is a way of life. 1) strongly agree 2) agree 3) undecided 4) disagree 5) strongly disagree	Art for art's sake
5. I think that people who appreciate art are really better than ones who do not. 1) strongly agree 2) agree 3) undecided 4) disagree 5) strongly disagree	Status
6. I would rather go to a movie, stay at home and watch TV, or go to a restaurant then attend an Art Institute exhibition 1) strongly agree 2) agree 3) undecided 4) disagree 5) strongly disagree	Recreational

Source: Compiled from sample data.

included in the membership questionnaire, in order to isolate the art publics, is in terms of cognitive dissonance theory.[25] It provides no automatic scheme to follow, but it does deal with consistency in behavior.

Underlying the theory is the consistency principle that is common to Freudian theories and to the conflict-resolution theories of Kurt Lewin and Neal Miller.[26] Associative bonds between objects or concepts exist in a person's mind when two objects are known to be like one another or bound together, and disassociative bonds exist when the objects are unlike one another or not bound together. Equilibrium exists when the consistency principle is satisfied: positively valued objects linked by associative bonds, and disassociative bonds existing between positively and negatively valued objects. The primary mechanism involved in this theory is the restoration of equilibrium, achieved by changing the attitudes between the persons involved or toward the object involved. Therefore, a simple resolution is effected by changing a single element—the attitudes between the persons involved or toward the object. More complicated resolutions are attained by shifting more than one element at a time.

Extreme responses to value-judgment statements can be inferred to indicate something about the individual's belief structure on an issue. The set of relevant cognitive elements, and the particular relations among them, define the content of this belief structure.[27] Because the response is extreme, the particular statement is salient to the individual, and therefore it is important that any inconsistencies regarding that question be eliminated.

The value-judgment statements can best be explained by reference to the individual's belief structure and to the question of whether the statement is inconsistent with that belief structure. For example, statement 6 relates to the recreational aspects of exhibits (see Table 4.10). An expression of strong agreement (response 1) or disagreement (response 5) with this statement indicates that this issue is salient to the respondent. However, for many statements, the more common pattern of responses seems to be one of responses 2 and 3; in other words, they do not pose particularly salient issues to most of the respondents.

Diagrammatically, an extreme response can be illustrated in the following manner (the minus sign represents an expression of strong disagreement, and the plus sign, one of strong agreement):

(+) (−)

-- statement 2

respondent's The best art imitates nature.
self-image

(+) (+)

——————————————————————————— statement 6

respondent's The person would rather go to a movie, etc.
self-image

The solid line represents associative bonds, and the broken lines, disassociative bonds. Cognitive-dissonance theory postulates that the above two situations are in equilibrium and will not change unless something outside this system impinges on it.

An unbalanced situation would be represented, for example, by the following:

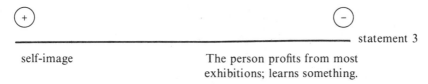

self-image The person profits from most
 exhibitions; learns something.

This situation is unbalanced only because we assume that the statement has a negative connotation and that the person has a positive self-image. This situation would be in balance if another element is added, to produce the following:

self-image The person profits from most
 exhibitions; learns something.

negative response to statement 4—art for me is a way of life

In other words, the individual can agree with the proposition that he doesn't learn much from exhibitions, because art for him is not a way of life. In this way, the individual attempts to resolve the initially dissonant situation. The above diagram represents an intermediary stage in a bolstering process. Bolstering means to relate one or the other of the two objects to other objects, thereby minimizing the relative imbalance in the structure. Dissonance refers to psychological expectations, not to any logical relationship between the two cognitive elements.

From the questionnaire itself, we do not know whether each respondent differentiates the cognitive elements; differentiation—splitting a cognitive element into two parts, with a strong disassociative relationship occurring between the two parts—represents a more sophisticated mode of conflict resolution than does bolstering. However, the questionnaire's choices are static in the sense that the person can react to the statement only as it is presented.

As a result, strongly positive responses to the items are probably more significant than negative responses, because a positive response indicates that the item is a part of the person's belief structure; a negative response, while indicating that the item is not a part of the person's belief structure, does not tell us what the person thinks of the item. At best, an extreme

negative response indicates that, by inference, the negation of the item is within the person's belief structure; it does not confirm the existence of the item. Using this logic, responses were analyzed to isolate those persons who could clearly be classified into one of the six cells of the Watson model, based on a judgment of all of their responses. The Appendix to this chapter illustrates the method of scoring that provides a scoring consistency.

Results

Once the data were collected and edited, the following tentative conclusions were reached concerning 92 of the 135 Akron Art Institute members responding to the questionnaire (see Table 4.11). Those question-aires not included (43) were considered incomplete or indeterminate. The large majority of the members fall into the cells of positive responses to art. About 87 percent of the members are in attitudinally positive categories, while 13 percent fall into what might be called negative attitude categories. The most common category of members is the educational—intrinsic/extrinsic values positive attitude—which contains 44 percent of the members. What may be somewhat fallacious about this category is that persons responding to the questionnaire might have answered the way they thought they ought to believe, rather than the way they actually think. Thus, while art is indeed educational and represents a mix of intrinsic and extrinsic values, there is some evidence to argue that many of the members listed in the educational category should have been classed in the recreational cell, the extrinsic-value, positive-attitude category. In spite of this cautionary point, there is every reason to accept the fact that greater numbers of members would be in the educational cell than in the recreational.

Turning to the 23 percent of members who represent those with close personal or professional interest in the arts, we find another very positive

TABLE 4.11

Application of The Typology to Akron Art Institute's Membership

| Value Dimension | Attitude Dimension and Cell Number | | | |
	Positive	Cell	Negative	Cell
Intrinsic	Art for art's sake 21 (23%)	I	Pseudocritical 6 (6.5%)	II
Intrinsic/extrinsic	Educational 40 (44%)	III	Didactic 4 (4.32%)	IV
Extrinsic	Recreational 19 (20%)	V	Status seekers 2 (2.2%)	VI

Note: Figure represent the number and percent of members in each category (cell).
Source: Computed from survey of members.

public, one which is apt to be relatively more involved with the internal activities of the Akron Art Institute, and more critical of the role and function of an art museum. Their needs and desires with regard to the Akron Art Institute are likely quite different from the needs and desires of those in the educational or recreational art publics.

With the negative categories, a small number (about 6 percent) of the members are identified with a desire for representational art—a public highly limited and specialized in its tastes. In this case, however, taste may arise as much out of ignorance or bias toward this chosen form of art as from a carefully thought-out position. Nonetheless, such people can be devout believers and do indeed strongly value representational art.

The didactic group numbers about 4 percent of the membership. These persons take an essentially negative and moralistic view toward art, as reflected in the idea that art should teach moral values. The needs and desires of this group are less easy to perceive because the group is likely to be characterized by negative views about certain kinds of art; much art may, for example, be seen as pornographic. One might imagine that religious art, and any art of didactic themes, would please this group.

The status seekers, an extrinsic-value, negative-attitude category, is one in which just more than 2 percent of the members likely fall. Only those who are willing to express status views and are somewhat proud of their unpopular views would likely respond positively to this category. Perhaps a number of these persons, if less candid, might well have classified themselves in the moralistic (didactic) group.

POLICY IMPLICATIONS

This type of analysis of art publics has implications for the planning of the Akron Art Institute and for the nature and composition of the programs it develops. The first point is that art publics are diverse—no single-purpose program in terms of collection, educational programs, and exhibitions is satisfactory. The activities at the institute must, by definition, be diverse because the membership is diverse. Educational programs and exhibitions are easily seen as diverse; but what about the third major function, collecting? The collection of the Akron Art Institute may continue to be diverse, but future acquisitions may be specialized. However, if the members perceive that diversity highlights other functions, then they are likely to favor a diversified collection policy.

While exhibitions represent probably the most important aspect (in the sense of most popular) of the institute's activities, there is little doubt that the educational activities of the Art Institute provide, both in classes and in enhanced teaching through exhibition, a basic means of generating a supportive art public. If one adopts this view, then one is impressed with the idea that local art museums may be primarily educational institutions, and

with the consequent necessity of ensuring intensive use of art-museum facilities by interested adults and public school children in the community.

Turning to the question of collection, since high art-market prices constrain what can be acquired for collection, and high-quality pieces can be obtained by most middle-sized museums only in the case of limited specialized collections (such as contemporary art, where market prices are not beyond the museum with a limited acquisitions budget), then members should be made to understand that scarce resources require that a very high quality collection can only be a highly specialized one. Yet, this strategy of scarce resource utilization comes in conflict with the diversity of art publics.

How can such a conflict be resolved? With limited resources, the middle-sized art museum cannot expect to have a collection which is both varied and of exceedingly high quality. Illustratively, if a museum owns but one Goya, and a poor one at that, and if the art public is largely educationally inclined, is the museum wise to have a second-rate Goya, given the fact that it will be used by people who wish to learn and understand the art of Goya? Having a second-rate Goya may be like having a second-rate textbook or a weak instructor in a class. It defeats the quality intent of the collection and the educational mission of the museum.

Obviously, it is easier financially for a museum to put together a first-class exhibition by borrowing and renting than it is to attempt to acquire and own the contents of a high-quality exhibition; thus the best-quality art in any modest museum will most likely be in its exhibitions, as opposed to its collections. The only real alternative possibility is to display only those parts of a collection that are of very good quality and dispose of, or store for student and scholarly use, the mediocre works in the collection. Concentration on exhibitions of quality, as opposed to collections, seems on balance to be a much more modest and efficient allocation of scarce resources, even though museum status is likely the result of what the museum owns, not of what it merely exhibits. The chapter on museum development gives more details concerning the role of a collection in the museum's overall programs.

The fact that members have a variety of possible values suggests that there will be essential membership conflicts in what museums ostensibly purport to do by their own statements of goals and conceptions of purpose, and in what the public demands of such institutions. For example, many members of the Akron Art Institute might criticize the purely social aspects of such practices as serving wine and cheese at openings, yet a few persons among the membership of the institute find a positive value in these status events.

Likewise, exhibitions which appeal to certain art publics of the Art Institute may well not appeal to the curatorial staff responsible for putting together exhibitions. The tastes and preferences of many members of the Art Institute may not be considered (in the minds of the staff) as representing any sort of good taste whatsoever. We have no evidence that applies to the Art Institute directly; yet there is reason to believe the professional staff

principally involved with administration and development might well have a broader view of the role and the function of an art museum than either a curator, with a single task involving exhibitions and collections, who might be more inclined toward art for art's sake, or the educational director who may also subscribe to the positive values of art for art's sake, but will have, as a major focus of interest, the educational aspects of art. Conflicts may occur among persons with different persuasions within the art museum's staff as well as among the publics they serve. Such conflicts might well occur not simply from the nature of the internal museum job per se, but from the diverse interests that staff positions in an art museum might typically represent, and from the fact that these positions are associated with the various art publics served by departments within an art museum.

No easy answer to these sources of potential conflict among members, among the staff, or between members and the staff can be given. Suffice it to say that any single view in regard to collection or exhibition, if it dominates all other views, will lead to misallocation of museum resources. Museum boards, committees, and staffs should work together to provide balanced activities within budgetary constraints. The appearance of a single individual running the museum defeats the purpose of an art museum as a local multipurpose institution.

The foregoing analysis does not suggest that an art museum should have a director of social status, an officer for fun and games, or a moralist in residence. Nonetheless, the activities pursued by the staff should properly include a recognition of the needs and the desires of the diverse publics served. Providing such a service means that within some limits, almost any sort of art or art-related activity is probably perfectly legitimate for an art museum to pursue. Care should be taken so as not to propose the trivialization of art, because to turn an art museum into a daytime nursery or circus would defeat its primary purpose, namely, the preservation, exhibition, and education activities of art. But recognize that many trivialization arguments tend to arise not from persons who represent broad, art publics, but from those who adopt the idea of art for art's sake as their number-one priority and, by so doing, discard other priorities.

Recall the premise of this chapter, that the art museum should aim to provide a multiplicity of services for a wide variety of people. Few people really expect an art museum to have a significant impact upon the majority of residents in a city, but for the person who can be encouraged to use it, the art museum provides needed services and satisfaction.

In assessing the activities of the Akron Art Institute, it is fairly clear that the aesthetic and educational priorities, from the standpoint of the people who are most intimately familiar with the museum, are of prime importance. The extent to which the aesthetic and educational priorities are shared by the membership is much less clear. The membership seeks a broader range of satisfying experiences, and one which tends to be somewhat less intense.

Intensity of experience is important as another possibility for the

Watson typology. One gains from that typology, whether rightly or wrongly, the implication at least that intensity of experience is probably greatest for those who have intrinsic values concerning art, seek the aesthetic experience, and are in the pseudocritical group; next in terms of intensity are those who seek the educational experience, and those at the didactic level; and finally, those who seek the recreational experience and social status. Perhaps this is true; at least it may well be true for the art publics at the art museum. For the artist or art educator, the art museum may be a primary focus for his purposes; but, for most viewers in the educational category or recreational category, one might perceive his experience as being perhaps more satisfactorily provided at other educational and recreational institutions within the city. Intensity of experience may, then, be associated with the Watson typology, but empirically the results only suggest this; they do not prove it.

But, such logic could be reversed. One might argue that the typology implies no intensity of experience, and that the subtle distinctions in the mind of the consumer between recreation at an art museum and recreation at another kind of museum are such that attendance at the art museum is a prima facie case for the consumer's preference, a lack of another kind of museum as a substitute for an art museum.

Finally, we must recognize that the majority of persons who are members of the Akron Art Institute are, while not truly indifferent, somewhat apathetic about the institute. As a result, it may be assumed that no matter what the primary interest of the art public in question happens to be, it is clear that the long tenure of membership that many members hold in the Art Institute creates a certain kind of traditional loyalty, support, and interest. So while we may not have intensity of interest, we have a kind of traditional loyalty to the institute, from people who have lived in the community for more than a few years.

FORMER MEMBERS OF THE AKRON ART INSTITUTE

To better understand art publics of the museum it is important to ascertain why people defected. Why did members quit?

After examining records of the Art Institute indicating past membership rolls, 200 persons were selected to constitute a sample of former members. These former members represented Akron-area residents who had in prior years been members of the Art Institute, but who had, for one reason or another, declined to renew their membership in the institute. A questionnaire (see Appendix A at the end of this book) was designed and sent to these 200 persons, and 46, or 23 percent of the total, responded. The purpose in surveying former members was to attempt to establish their perceptions of the Art Institute and to identify their reasons for failing to renew their membership.

Before going into the reasons for persons failing to renew, we should

recognize that a number of people would discontinue membership simply because they had moved. In the case of such persons, their views were not represented, and only those people who had remained in the area but did not renew were included in the survey. Persons were asked why they did not renew their membership; a number of possible reasons were given. The 46 respondents indicated a total of 123 reasons why they did not choose to renew (see Table 4.12). Thirty of the responses, or roughly 25 percent, were that persons were simply too busy with other things to want to continue the association. The next most significant reason was indicated by 25 responses (about 20 percent), revealing that these former members consider the location of the Art Institute inconvenient. Fifteen of the 123 responses (12 percent) suggested a general disenchantment with the museum's programs and operations. Only a few people pinpointed exhibitions and art classes as things they didn't like. A few people considered the annual dues too high. Some thought the board was unresponsive to members' requests, and several charged the museum with being a social club or cited it for failing to involve the whole community

TABLE 4.12

Former-Member Survey:
Reasons Given for Not Renewing

Reason	Number of Members	Percent of Members
The person was too busy.	30	24
The location is inconvenient.	25	20
The person was generally disenchanted, for various reasons.	15	12
The exhibitions didn't appeal to the person.	11	9
The institute does not involve all of the community.	8	7
The Art Institute is really a private social club.	7	6
The board is unaware of members' wishes.	7	6
All programs were not what the person had expected.	6	5
Annual dues were considered too high.	6	5
Educational programs were not to the person's liking.	4	3
Other The person forgot to send in dues. (2) Children don't like the education classes.(1) The person would rather go to a movie (1)	4	3
Total	123	100

Source: Compiled from sample data.

How is one to view such responses? It would seem that only a few people who were particularly interested in art and in the Art Institute had failed to renew because of disaffection with some of the current practices, programs, or policies of the institute. Persons who quit, usually did so because of locational disadvantage, parking inadequacies, or a general disenchantment, that is, convenience or casual-preference factors. Relatively fewer responses indicated some amount of criticism of the exhibitions; the fact that the institute does not involve a larger segment of the population in the community; that the location is fundamentally inconvenient; that, in some cases, annual dues were thought to be too high; a criticism of the Art Institute as being primarily a social organization; and criticisms of the board's lack of responsiveness to the membership. Throughout the survey of both members and former members, seldom do we encounter people who fall into the "avid sports fan" category. Many members and former members appear to have been only mildly interested in the museum to begin with.

When former members were asked to tell what they liked most about the Art Institute, seven of the 46 respondents (15 percent) indicated a positive view of the children's programs. No clear consensus was obtained that indicated a positive feeling toward the work of local artists presented at the museum, but no consensus was obtained regarding any particular exhibition. One would have to characterize the former members as being somewhat disenchanted with the Art Institute, but their reasons for disenchantment were quite diverse.

When asked what they liked the least about the Art Institute, former members again provided a variety of answers, but no clear consensus. Eleven of the 46 respondents (24 percent) indicated that the parking problem was the most disliked aspect of the Art Institute. Five of the respondents (11 percent) indicated that they did not like the location, and three of the respondents criticized the social atmosphere of the Art Institute.

When former members were asked about the kind of painting they preferred, 13 of the 46 (29 percent) indicated somewhat catholic tastes. Aside from these 13 respondents, there was a preference indicated for a variety of types of art; there was no clear consensus on the type of painting preferred. Another aspect worth mentioning is the extent to which these persons enjoy viewing the work of local artists. Forty-five of the 46 (98 percent) indicated that they did indeed enjoy viewing the output of local artists; only one of the respondents indicated that he felt that the Art Institute ignored local artists.

Characterizing further the former members of the Art Institute, the majority of those who failed to renew their memberships had been members for less than five years. Twenty-seven of the 46 (59 percent) had been members for four years or less; eight of the 46 who did not renew their membership had been members for eight years or more, some for as long as 20 or 30 years.

While they were members, the respondents indicated, their participa-

TABLE 4.13

Former-Member Survey:
When a Member, in What Did You Participate?

Participation	Number of Members	Percent of Members
Viewed exhibitions	39	30
Attended art classes	17	14
Attended concerts	13	10
Attended lectures	13	10
Attended films	11	11
Used the library	3	3
Attended special events	20	16
Other	8	6
Total	124	100

Source: Compiled from sample data.

tion in the Art Institute's activities included principally the attending of special events, the viewing of exhibitions, and the attending of art classes, lectures, concerts, and films (see Table 4.13).

SUMMARY

As a means of pulling together some of the various points about the art museum's diverse publics, the following summary should prove useful.

The Member Survey

The survey of members makes possible a general profile of their economic and social position as well as their attitudes toward membership in the Art Institute. One hundred thirty-seven members responded to the survey.

Economically and demographically, members can be characterized by the following points.

1. Eighty-eight percent have lived in Akron for more than five years; 62 percent are natives of Akron.
2. Eighty percent have at least a B.A. degree.
3. Sixty-seven percent are 40 or older.
4. Eighty-five percent are married; their average number of children is about 2.7.
5. Seventy-six percent are engaged in managerial or professional careers.
6. Fifty-six percent have incomes in excess of $25,000 per year.

7. Most of the members are actively engaged in professional, religious, civic, and cultural activities.

With regard to their behavior in relation to the Akron Art Institute, members may be characterized as follows:

1. Their attendance at the Akron Art Institute is less frequent than once a month; 22 percent of the members had not been to the institute within the past twelve months.
2. Most of their children had never been in an Art Institute education class.
3. Fifty-four percent had been members for five years or more.
4. Sixty-six percent indicated that their reason for joining the Art Institute was "to support the institute" or "a general interest in the arts." In the main, their reasons for joining are not related to a direct personal involvement in art as collectors, educators, hobbyists, and the like. About 80 percent said they would definitely join the next year.
5. Only 9 percent hold membership in other art museums; 46 percent had been to the Cleveland museum at least once within the past twelve months.
6. Only eight of the 137 respondents had attended the previous last year's annual board meeting.
7. About 15 percent of the respondents had served on committees of the Akron Art Institute.
8. Thirty-two percent thought the attendance at the institute was increasing, when in fact it was decreasing.
9. Sixty-six percent thought the present location of the institute was satisfactory.
10. The 40 percent of respondents suggesting changes in the museum's operations were not in agreement as to the changes desired; most prominent among the responses were statements about the number or content of exhibitions, but there was no agreement about the kinds of exhibitions.

In sum, the membership of the Akron Art Institute can be characterized as largely indifferent to change, as lacking in effective participation in the Art Institute, as peripherally interested in art but generally uninformed about operations, budgets, or policies of the institute. More positively, they respond well to the staff, and are much interested in the idea of art, if not art itself. Finally, one gains the impression that currently the mass of members are fairly well satisfied with the Akron Art Institute, and that this satisfaction arises more out of indifference than from regular and active participation in the institute.

The Members as Art Publics

The results of the application of the Watson typology to the institute's membership revealed that members could be sorted into positive and negative attitude categories. Members represent at least six art publics, ranging from positive categories including those who accept art for art's sake, or who see recreational value and educational value in art, to the negative categories, the moralistic, status–seeking, and pseudocritical publics. The major portion of the institute's membership has a modest educational orientation toward art.

The Former-Member Survey

An examination of the reasons why people failed to renew their membership in the Art Institute, and a more general survey of former members, revealed the following:

1. Twenty-five percent of the former members said that they did not renew their membership because they were too busy with other activities; about 20 percent indicated that they considered the location of the Art Institute inconvenient; 9 percent indicated that exhibitions were not appealing.
2. No clear consensus among former members could be achieved as to what they liked best about the Art Institute; 15 percent indicated that they liked the children's programs best.
3. When asked what they liked least about the Art Institute, 24 percent of the respondents cited the parking situation; 11 percent indicated they did not like the location of the Art Institute.
4. When asked what kind of painting they preferred, 29 percent of those responding indicated they had quite varied tastes.
5. Ninety-eight percent indicated they did enjoy viewing the output of local artists.
6. Fifty-nine percent of the former members had been members for four years or less. On the other hand, eight of the 46 who did not renew had been members for eight years or more.
7. While they were members of the Art Institute, respondents indicated, their participation principally involved attending (in order of importance) special events, exhibitions, art classes, lectures, concerts, and films.

Like the current members, former members of the Akron Art Institute tended, for the most part, to be somewhat supportive of the Art Institute, and yet, out of apathy, failed to renew their membership. Within the group that did not renew, however, a number of them obviously had long-term commitments to the institute that they were willing to give up. For such persons, matters of policy, location, and exhibition were of importance.

APPENDIX
Scoring the Art-Publics Test*

Value	Positive Attitude	Negative Attitude
Intrinsic	Cell I (art for art's sake) (#58) "Art for me is a way of life."	Cell II (pseudocritical) (#55) "The best art is that which realistically imitates nature."
Intrinsic/extrinsic	Cell III (educational) (#56) "I feel I profit personally from most art exhibitions because something can be learned from most of them."	Cell IV (didactic) (#54) "Art should seek to improve the moral fiber of society."
Extrinsic	Cell V (recreational) (#50) "I would rather go to a movie, stay at home and watch TV, or go to a restaurant than attend an Akron Art Institute function."	Cell VI (status seekers) (#59) "I think people who appreciate art are really better people than ones who do not."

*Prepared by Mark Riley

It is essential to construct a consistent scoring system (as illustrated above) for the responses given to the key statements included in the survey, to objectively place each respondent in the most appropriate art public. As discussed previously, Watson's six-cell typology divides the six art publics into three value dimensions (intrinsic, intrinsic/extrinsic, extrinsic); and each of these dimensions is subdivided into a positive and a negative attitude dimension. Since there are four alternative responses to each statement, two of which suggest a negative attitude about the art experience, as expressed by the respondent, and two of which indicate a positive attitude, it followed that a similar scoring scale could be applied to the attitude dimension, as illustrated below (example 1). As stated previously, the assumption has been made that since each of the three value dimensions has a positive and a negative cell, they can be viewed as polar opposites. (That is, the art-for-art's-sake attitude is the polar opposite of the pseudocritical attitude.) A score of 1 would indicate the strongest positive attitude, and a score of 4, the strongest negative attitude.

Thus, each individual response will fall into either the positive or the negative attitude category, under the value dimension appropriate to each

Example 1

Value	Positive Attitude				Negative Attitude
		1	2	3	4
Intrinsic	I (art for art's sake)				II (pseudocritical)
Intrinsic/extrinsic	III (educational)				IV (didactic)
Extrinsic	V (recreational)				VI (status seekers)

corresponding statement, and according to the following guidelines:

1. Agreement with a positive statement about the art experience reflects a positive attitude.
2. Disagreement with a positive statement about the art experience reflects a negative attitude.
3. Agreement with a negative statement about the art experience reflects a negative attitude.
4. Disagreement with a negative statement about the art experience reflects a positive attitude.

An example of scoring for all six statements is provided in the following sample scoring sheet and the corresponding table (example 2):

Example 2

Value	Positive Attitude				Negative Attitude
		1	2	3	4
Intrinsic	I (art for art's sake)	E	C		II (pseudocritical)
Intrinsic/extrinsic	III (educational)	D	B		IV (didactic)
Extrinsic	V (recreational)			A	VI (status seekers)

Interpretation

In terms of interpreting each set of six statements and responses, to place each respondent in the most appropriate art-public cell, an objective and systematic scheme was devised. This system would ensure that the transition from the raw scoring sheets to the characterization of each individual respondent as representing a particular art public would be consistent and reliable, no matter who scores the result. The importance of the mechanics of interpretation cannot be understated, because all potential statistical analysis is predicated upon how each individual is classified. Provided below are the guidelines utilized for each evaluation, with examples.

1. A minimum number of responses is necessary to provide adequate information: Each respondent must have answered at least five of the six critical questions to be considered in the analysis. Any number of responses less than five was considered insufficient information for analysis, and in such cases the respondent was not included in the statistical-base population. Three respondents were eliminated for this reason.

Example 3

Value	Positive Attitude	1	2	3	4	Negative Attitude
Intrinsic	I (art for art's sake)		X			II (pseudocritical)
Intrinsic/extrinsic	III (educational)		X		X	IV (didactic)
Extrinsic	V (recreational)		X			VI (status seekers)

2. Strength of conviction within the attitude dimensions: Since each end of the attitude dimension is a polar opposite, the strength of each response can be equally weighted, whether it be positive or negative. A strong positive response of 1 is weighted the same as a strong negative response of 4. If there is obviously no strong commitment to either a positive or negative overall view of the art experience, again that particular respondent is removed from the sample. Examples 4 and 5 illustrate the lack of a consistent response that would enable the member to be placed within a particular art public.

Example 4

Value	Positive Attitude	1	2	3	4	Negative Attitude
Intrinsic	I (art for art's sake)		X	X		II (pseudocritical)
Intrinsic/extrinsic	III (educational)		X	X		IV (didactic)
Extrinsic	V (recreational)		X	X		VI (status seekers)

Example 5

Value	Positive Attitude	1	2	3	4	Negative Attitude
		X				
Intrinsic	I (art for art's sake)	X				II (pseudocritical)
Intrinsic/extrinsic	III (educational)		X	X		IV (didactic)
					X	
Extrinsic	V (recreational)				X	VI (status seekers)

Sample Scoring

Designation	Statement	Type of Statement	Response	Attitude Dimension
A	Person would rather go to a movie, etc., than to the AAI.	Negative	Agree	Negative
B	Art should seek to improve the moral fiber.	Negative	Disagree	Positive
C	The best art imitates nature.	Negative	Disagree	Positive
D	Art can be educational.	Positive	Strongly agree	Positive
E	Art is a way of life.	Positive	Strongly agree	Positive
F	People who appreciate art are better.	Negative	Strongly disagree	Positive

If the respondent seems to have essentially a positive or a negative attitude toward art, then the weights of the respective answers are important. A strong response to a statement, such as "strongly agree" or "strongly disagree," is weighed heavier than a simple "agree" or "disagree," because the respondent places a substantial positive or negative value in that statement. Thus, if there is an overall positive attitude, such as that indicated in example 6, the respondent would be placed in the recreational art public because of the stronger attitude attributed to that particular public.

Example 6

Value	Positive Attitude					Negative Attitude
		1	2	3	4	
			X			
Intrinsic	I (art for art's sake)		X			II (pseudocritical)
			X			
Intrinsic/extrinsic	III (educational)		X			IV (didactic)
Extrinsic	V (recreational)	X	X			VI (status seekers)

In some cases the respondent is consistently positive, or consistently negative, and the strength of the attitude is the same, regardless of which value dimension is examined. Since the respondent equally weighs the intrinsic and the extrinsic value of art, the natural category for the respondent would be the public that supports both points of view equally. In the case of example 7, the didactic art public would be the appropriate choice.

Example 7

Value	Positive Attitude					Negative Attitude
		1	2	3	4	
				X		
Intrinsic	I (art for art's sake)			X		II (pseudocritical)
				X		
Intrinsic/extrinsic	III (educational)			X		IV (didactic)
				X		
Extrinsic	V (recreational)			X		VI (status seekers)

3. Consistency of response: The majority of the respondents indicated some overall ambivalence in terms of their positive or negative attitude toward art, and their responses could be found in both the positive and the negative attitude category. When this was the case, the key to interpretation was to find the most consistent responses at any level of the value

dimension. For example, in the case illustrated in example 8, the respondent has both a positive and a negative attitude toward the intrinsic value of art (the pseudocritical public and the art-for-art's sake public), and the same attitude is found toward the extrinsic value of art (the status-seeking public and the recreational public). The only consistent attitude is the positive attitude concerning the combined intrinsic/extrinsic values of art (the didactic public and the educational public); and so the appropriate category for this respondent is the educational public.

Example 8

Value	Positive Attitude	1	2	3	4	Negative Attitude
Intrinsic	I (art for art's sake)	X			X	II (pseudocritical)
			X			
Intrinsic/extrinsic	III (educational)		X			IV (didactic)
Extrinsic	V (recreational)		X		X	VI (status seekers)

Each of the preceding examples was illustrative of extreme cases that necessitated some type of interpretation. But many individual cases reflected a wide array of responses that did not nearly fall into any of the specific categories just discussed; example 9 and example 10 are provided as typical or common responses in these cases.

Example 9

Value	Positive Attitude	1	2	3	4	Negative Attitude
Intrinsic	I (art for art's sake)			X		II (pseudocritical)
Intrinsic/extrinsic	III (educational)		X	X		IV (didactic)
Extrinsic	V (recreational)	X	X			VI (status seekers)

In example 9, the respondent does not show consistency in attitude in the intrinsic/extrinsic dimension, so he will not be categorized as part of either the didactic public or the educational public. There is limited information on his attitude toward the intrinsic value of art, because both statements concerning that dimension had no response. Since the respondent does indicate a consistent positive attitude in terms of the extrinsic value of art, even if it is not particularly strong, he would be placed in cell V, or the recreational art public.

In example 10 the respondent again reflects neither a totally positive nor a totally negative attitude toward art. Within each category of the value

Example 10

Value	Positive Attitude	1	2	3	4	Negative Attitude
Intrinsic	I (art for art's sake)			X	X	II (pseudocritical)
					X	
Intrinsic/extrinsic	III (educational)				X	IV (didactic)
			X			
Extrinsic	V (recreational)		X			VI (status seekers)

dimension, he is consistent, so the key in this case is the relative strength of his attitude. Since he indicates the strongest attitude in cell IV, he would be designated as part of the didactic art public.

NOTES

1. T.R. Adam, *The Civic Value of Museums* (New York: American Association for Adult Education, 1937), pp. 18-20.

2. Kenneth Clark, "Art and Society," *Harpers Magazine* (August 1961), p. 74.

3. Harold Rosenburg, "The Vanishing Spectator," in *Arts and Public* (Chicago: University of Chicago Press, 1967), p. 179.

4. Ibid., p. 180.

5. Roger Clausse, "The Mass Public at Grips with Mass Communications," *International Social Science Journal* 20, no. 4 (1968): 630.

6. Ibid., p. 628.

7. For a listing of public places where art is typically displayed, see New York State Commission on Cultural Resources, *Cultural Resource Development* (New York: Praeger, 1976).

8. Ernest Van Den Haag, "Art and the Mass Audience," in *Museums in Crisis* (New York: George Braziller, 1972), p. 73.

9. Philip Adams, *The Organization of Museums* (Paris: Unesco Press, 1974), p. 267.

10. New York State Commission on Cultural Resources, op. cit.

11. Max Weber, *The Methodology of the Social Sciences* (Glencoe, Ill.: Free Press, 1949), p. 92.

12. John C. McKinney, *Constructive Typology and Social Theory* (New York: Appleton-Century-Crofts, 1966), p. 214.

13. Alfred Shvetz, "Concept and Theory Formation in the Social Sciences," *Journal of Philosophy* 51, (April 1954): 261.

14. Howard Becker, *Through Values to Social Interpretation* (Durham,: Duke University Press, 1950), p. 25.

15. McKinney, op. cit., p. 3.

16. Becker, op. cit., p. 31.

17. Bruce Watson, "On the Nature of Art Publics," *International Social Science Journal* 20, no. 4 (1968): pp. 674-75.

18. Becker, op. cit., p. 39.

19. R.F. Winch, "Heuristic and Empirical Typologies," *American Sociological Review* 12 (February 1947): 68-71.

20. Weber, op. cit., p. 98.

21. McKinney, op. cit., p. 23.

22. Ibid., pp. 26-32.

23. Ibid.

24. Ibid.

25. See Leon Festinger, *A Theory of Cognitive Dissonance* (Stanford, Cal.: Stanford University Press, 1957).

26. Kurt Lewin and Ronald Lippitt, "An Experimental Approach to the Study of Autocracy and Democracy: A Preliminary Note," *Sociometry* 1, (1938) 292-300; *Field Theory in Social Science: Selected Theoretical Papers by Kurt Lewin*, ed. Dorwin Cartwright (New York: Harper, 1951); and Kurt Lewin, "Decision and Social Change," in *Readings in Social Psychology*, 2d ed., ed. G. E. Swanson, T.M. Newcomb, and E.L. Hartley (New York: Holt, 1952). See also Neal E. Miller, "Theory and Experiment Relating Psychoanalytic Displacement to Stimulus-Response Generalization," *Journal of Abnormal and Social Psychology* 43 (1948): 155-78; N.E. Miller and R. Bugelski, "The Influence of Frustrations Imposed by In-Groups on Attitude Expressed Toward Out-Groups," *Journal of Psychology* 25 (1948): 437–42; and N.E. Miller, "The Frustration Aggression Hypothesis," *Psychological Review* 48 (1941): 337-42.

27. Robert Abelson, ed., *Theories of Cognitive Consistency: A Sourcebook* (Chicago: Rand McNally, 1968), and Robert Abelson, "Modes of Resolution of Belief Dilemmas," *Journal of Conflict Resolution* 3 (1959): 343-53.

Chapter Five

EDUCATION PROGRAMS AND ACTIVITIES

It is not easy to attempt an evaluation of a museum's educational programs and activities. The educational functions in our society are so diverse and so complex that any attempt to understand, much less evaluate, them is bound to be fraught with gross assumptions and tenuous conceptions. Yet, by building a construct of what we do know, a useful analysis can be made. Initially, one asks, descriptively, what educational programming is pursued at the museum. This leads to a contextual discussion of art and education, which sets the stage for the cost-benefit analysis in the next chapter. We then turn to some analytical results of a brief survey of teachers, examining their conceptions about the museum's educational role. Following the teacher survey, the results of a survey of students enrolled in classes are analyzed to ascertain their reactions to the class in which they participated.

EDUCATIONAL VISITS

During the fiscal year 1971-72, the Akron museum provided a wide variety of activities and classes that comprised its educational programming There were some 16 special one-class activities, including such programs as the making of paper airplanes for children. There were 13 films presented; 12 lectures, in a regular series; 12 concerts, presented in the museum's auditorium; and some 50 guided tours (conducted by docents). There was a variety of classes offered both at the museum and at a number of other places in communities in the Akron region. In all there were some 20,687 visits to the museum and its extension facilities for educational purposes, not counting the persons who came to the museum to view various exhibitions (see Table 5.1). These 20,687 include some 2,574 persons who attended extension

TABLE 5.1

Educational Visits to Akron Art Institute by Event, 1971 - 72

Event	Number of Events[a]	Visits per Event	Total Visits	Percent of Total
Special-education classes[b]	16	106	1,696	8.2
Films[c]	12	100	1,200	5.8
Lectures	12	131	1,572	7.6
Concerts	12	149	1,788	8.6
Special programs[d]	50	124	6,200	30.0
Formal-education classes	N.A.[f]	N.A.[f]	5,657	27.4
Extension classes[e]	N.A.[f]	N.A.[f]	2,574	12.4
Total			20,687	100.0

[a]Estimated from Akron Art Institute Calendar.
[b]Paper-airplanes, making, etc.
[c]Regular film series.
[d]Docent-conducted tours, etc.
[e]Formal-education classes.
[f]Not applicable since classes are so varied in structure; estimated from actual enrollments.
Source: Derived from AAI records and estimates.

classes in various neighboring communities. The data reveal that formal classes both at the AAI and extension units account for the largest attendance (39.8 percent), followed by special programs such as docent-conducted tours, which accounted for about 30 percent of total attendance at education activities. If special-education classes and formal-education classes are combined, they represent the largest attendance, at 48 percent of all education visits to the AAI.

Other events contribute to attendance. Concerts account for 8.6 percent of the visits, followed by lectures, at nearly 7.6 percent, and films, at 5.8 percent. These and the figures cited above indicate that the museum has a diverse set of educational programs that go far toward speaking to the needs of the educational visitor to the AAI.

The array of lectures, concerts, art classes, and special programming offered at the art museum in any one year is impressive. One wonders how such a rich variety of activities can be planned and carried out by the few staff persons involved. Indeed, each month there are lectures, concerts, and art classes covering a wide range of cultural interests.

Lectures

Exemplifying a museum trying diligently to make a contemporary impact upon its community, in 1971-72 the Akron art museum, through its then education director, Donald Harvey, made available to the citizens of Akron a regular series of high-quality lectures. For example, the museum sponsored a lecture by Barbara Rose, author and critic, who spoke on "Art in a Technological Society," in the AAI auditorium. Miss Rose is the author of *Readings in American Art Since 1900* and *Claes Oldenberg.* She is a contributor-editor for *Art Forum* magazine and for *Vogue*, as well as one of America's most knowledgeable and respected critics of the art of the 1960s.

In addition, Jan van der Mark, past curator of the Walker Art Center in Minneapolis, past director of the Institute of Contemporary Art in Chicago, and then public relations coordinator for the artist Christo, lectured on November 21, 1971. Mr. van der Mark spoke on Christo and his monumental wrapping projects.

Prior to that, on October 28, Michael Snow, a Canadian filmmaker and professor of advanced film at Yale University, showed and discussed his film "La Region Centrale" in the AAI auditorium. Mr. Snow was the winner of the Grand Prize at the Fourth International Film Festival in Brussels in 1967. Among the museums exhibiting his films are the Jewish Museum in New York City, the Museum of Modern Art, the Whitney Museum, and the Musee National d'Art Moderne, in Paris. In 1970 Snow represented Canada in the Venice Bienalle.

Robert Pincus-Witten, author and critic, spoke on "The Art of the 70's." Pincus-Witten was at that time a contributing editor of *Art Forum*

and lecturer in art history at Queens College of the City University of New York; he has established a reputation among artists, and gallery and museum people for his writing on contemporary art.

Charles Csuri, an experimental filmmaker, presented one of his short films done with the help of a computer, and talked on "Filmmaking and Technology." Csuri is a professor of film at Ohio State University.

In addition to lectures by persons not associated with the museum, the museum offered Wednesday evening programs in which the staff members of the Akron Art Institute offered free programs on such topics as Minimal art, printmaking techniques, contemporary directions in drawing, the sculpture of the 1960s, and museum collections.

Concerts

The 1971-72 concert program, heavily contemporary in its offerings, was billed as the finest in the institute's history; it was assembled by Nicholas Constantinidis, the AAI's curator of music.

Highlight of the fall programs was the Anniversary Celebration Concert given by violinist Sidney Harth, on Sunday, September 26, in the AAI auditorium. Harth was a concertmaster and first chair of the Chicago Symphony, and the Andrew W. Mellon Professor of Music at Carnegie-Mellon University in Pittsburgh. Included in Harth's concert were selections by Elwell, Grieg, Prokofiev, and Vladigerov.

On Sunday, October 17, soprano Elizabeth Unis Chesko presented a program of American contemporary music. A graduate of the Cleveland Institute of Music, she later studied and performed in Europe, before becoming a member of the music faculties of Hiram College in Hiram, Ohio, and Cleveland State University.

In November, Nancy Voigt presented a program of twentieth century music. Miss Voigt is a graduate of the Cleveland Institute of Music and has taught at Hiram College, the Cleveland Institute of Music, and Cuyahoga Community College in Cleveland. In 1968 she was awarded second prize in the Gaudemus Competition for Interpretation of Contemporary Music, in Utrecht.

Igor Kipnis, harpsichordist and CBS recording artist, gave a recital on January 30, 1972. Kipnis, who has performed throughout the United States, Canada, and Europe since his debut in 1959, is acclaimed not only for his virtuosity, but also for the entertaining quality of his recitals. Realizing that some listeners might be unfamiliar with his instrument or its music, he demonstrated how the harpsichord works and commented informally on some of the pieces.

In February, the University of Pittsburgh Electronic Ensemble gave a concert devoted to contemporary music, in the institute's auditorium, under the direction of Robert Snow, chairman of the Music Department at the

University of Pittsburgh. The group presented a program of contemporary electronic compositions.

The Kent State University Woodwind Quintet gave a concert in the institute's auditorium in March. Included in the program were both classical and twentieth century compositions.

In April the Early Music Consort gave a concert. The group consists of seven singers and instrumentalists who present music from the Middle Ages and the Renaissance, on such instruments as recorders, viols, krummhorns, rauschpfeife, the minstrel's harp, the portative organ, and the lute. The group was led by Earl Russel, professor of English at Mt. Union College in Alliance, Ohio.

Other Educational Programming

The museum has a regularly organized series of travel tours. For example, the Arts Council of the Akron Art Institute organized a three-week tour to Mexico and Central America for January 22-February 12, in cooperation with the Indianapolis Museum.

Also, the Akron Art Institute was invited to participate in a tour of the Metropolitan Museum of Art. The three-day tour included luncheon with the museum's staff, viewings of private collections, a cocktail party with selected trustees of the Met, dinner at a private club, and tours of selected exhibits and collections of the Met.

The Through the Eye Series was a series of lecture seminars dealing with exhibitions at the Akron museum. The series included a seminar entitled "Alan Sonfist—Ecological Systems," featuring projects and experiments dealing with ecological systems such as those used by Sonfist in creating the works in his exhibition. The program was aimed at getting the audience involved in the projects. Later the same month, Don Dedic and Dennis Adams held a seminar on their art and their ideas about art. This seminar was also intended to get participants involved with the artists' ideas and sources.

Film programs at the museum included a Children's Film Series, a free program of children's films held on the second Saturday of each month. The films included classic and experimental films geared to the children's interests and curiosity. Each program included one feature film and accompanying shorts.

Another novel feature of the museum was its Artmobile, a neighborhood traveling art gallery, opened to the general public on July 22, 1972. That first day, over 400 visitors entered the 35-foot air-conditioned trailer to view an exhibition of tribal art selected from the permanent and educational collections of AAI. The facility and the exhibition proved so popular that before the second week of the exhibition was over, the Artmobile had been scheduled for locations throughout the city as well as several places in the

greater Akron area. Exhibitions are changed periodically throughout the year and are designed to present a variety of artists and media to citizens.

Classes

Classes at the museum take a number of forms. One important class activity was the free Saturday arts program for children 6 to 11 years old. The classes met afternoons on the first and third Saturdays of each month, beginning October 2, 1971. The classes were led by members of the regular instructional staff, intermixed with guest instructors on a rotating basis. Each session presented an experience in which the child created a work of art and learned how others created art, through drawing and painting, writing, and acting. Because of the great popularity of these programs during that fall, the museum doubled the number of classes offered in order to allow more children to participate. Beginning January 15, 1972, two sessions were held each Saturday.

Further, in each season of the year, classes of two types were offered; studio classes met for five- or ten week sessions, and several four-week workshops were held.

Studio classes were as follows:

Jewelry—Instructors: Mary Ann Scheer, Cindy Gard
Meetings: Wednesday, 7-10 p.m.
Tuition: 5 weeks—members, $12.50; nonmembers, $14.00;
 10 weeks—members, $25.00; nonmembers, $28.00
Materials fee: 5 weeks—$3.00; 10 weeks—$6.00

Painting and Drawing—Instructor: Tim App
Meetings: Wednesday 7-10 p.m.
Tuition: 10 weeks—members, $25.00; nonmembers, $28.00
Materials fee: Students provide their own materials.

Preschool Workshop—Children 3-5
Instructors: Ramona Smith, Joan Thompson
Meetings: Thursdays 9:30-11:30 a.m.
Tuition: 10 weeks—members, $20.00; nonmembers, $24.00

The four-week workshops for the winter included the following:
1. Abstraction in American Art—The Sixties and Seventies—Wednesday, 8-9:30 p.m., January 19-26, February 2-9: These were four evenings dealing with problems posed by the work of the four California artists on exhibit in the Art Institute's galleries at that time. The workshop investigated trends in abstract painting in the last 15 years, from hard-edge painting to color-field painting to lyrical abstraction. These trends were discussed in relation to their historical precedents, both American and European, and to other contemporary movements such as pop art. The

workshop was conducted by Donald Harvey, director of education at the Akron Art Institute.

2. Art and Technology—Thursdays, 7:30-9:00 p.m., February 3, 10, 17, 24: This workshop was directed by John Pearson, a young Cleveland artist who teaches at the Cleveland Institute of Art. Classes were spent examining the history of the relationship between art and technology, and various approaches to using technology to create art. The third session of the workshop was held at the computer center of the Goodyear Tire and Rubber Co., where various pieces of equipment useful to the artist were demonstrated, and a class-prepared project was executed. The fourth session was conducted by Chuck Csuri, an artist from Ohio State University in Columbus, who showed one of his films made with the aid of a computer, and discussed his ideas concerning art and technology.

3. Andy Warhol and Pop Art—Wednesday, 7:30-9:00 p.m., March 1, 8, 15, 22; conducted by Orrel Thompson, director of the Akron Art Institute: This workshop investigated the sources and the concepts of the Pop art movement, and dealt specifically with the work of Andy Warhol, whose multiples were on display in the galleries at that time. The four sessions included an overview of the Pop art movement, a discussion of Andy Warhol's multiples, a printmaking demonstration, a chance to make silk-screen prints, and an evening of Andy Warhol's films.

4. Printmaking—Wednesdays, 7-10 p.m., March 29, April 4, 12, 19: Ian Short, printmaker at Kent State University, conducted this workshop, which included a demonstration of printmaking techniques, a brief history of printing as an art form and of its use by contemporary artists, and two evenings of studio experience in making prints, using selected techniques.

5. Artists and Ecology—Thursdays, 7:30-9:00 p.m., March 2, 9, 16, 23: This workshop was based on the works of Sonfist and Sam Richardson, on exhibit at that time. The four evenings began with an exploration of microecological systems such as those used by Sonfist to create some of his works, and were expanded to consider macroecological systems. Considerations of the workshop were the artist's use of ecological systems as a medium, the artist's responsibility to ecological and environmental planning, and precedents from which this type of art has derived. All phases of the workshop involved the participation of those enrolled in projects dealing with ecological systems and art. The workshop was conducted by institute staff members, and by guest artists and speakers. Tuition for the four-week workshops was: members—$9.00; nonmembers—$10.00. A $3.00 materials fee was required for the Printmaking and Artists and Ecology workshops.

A further illustration of art-class activities is provided by the program schedule, for the summer season, shown in Table 5.2; the diversity of contemporary-art offerings is obvious.

A common problem in museums has been the very question of the considerable variety of its offerings. That is, as Theodore Low points out:

To a certain degree variety in approach and method, when it is based on conviction, is essential. Without it the inevitable result would be stagnancy. And yet, variety for variety's sake can be as detrimental as complete uniformity. . . . Diversity becomes the excuse which veils an innate resistance to change and to the concentrated thought which would lay a sound basis for the future.[1]

While variety may create problems, such is not the case here, because the Akron museum, having committed itself to contemporary art, has undertaken a specific direction; the rich variety of its offerings in educational programming and in exhibitions aims in this direction. The offerings are not simply a potpourri, but a concerted effort at diversity. By the same token, look at the obvious problem this direction creates in satisfying the diverse art publics of the museum, people who in many cases have actively supported the Art Institute for many years, but who do not find great value in this role. Further, the diversity of the larger citizenry points up what has to be a conflict between a more general collection and exhibition practice and the role which the museum's staff and board have selected.

But, should a museum attempt to be everything for everyone and do so in a distinctly mediocre way, or should it attempt to do exceedingly well for the benefit of a few? To the museum's staff, there is little point in attempting to compete with the Cleveland Museum as a large general-purpose museum when resources in Akron do not warrant that choice. The city must be made aware that the museum should, as an educational institution in the community, continue to try to do well those things which it has some prospect of being able to accomplish. In this light, the choice of specializing (although not necessarily in contemporary art) appears to be a wise one.

But if in fact a wise one, then this choice does shift the possible basis of the museum's support, and by so doing, may call into question future public support. Will the city, through its citizens, be willing to support a contemporary museum or will it only be willing to support a general museum, albeit a mediocre one?

ART AND EDUCATION: THE PROPER CONTEXT

The previous sections of this chapter reveal the offerings of the museum in directing its efforts toward contemporary art; classes, lectures, workshops, and special events are so focused. But what is the proper context for these activities? Obviously, the contemporary direction is not merely to serve some internal ends of the museum's staff. Rather, the effort is based on the premise that art enriches lives, and that this museum should concentrate on the quality of art that it can reasonably expect to represent to its audiences in order to enrich the lives of these consumers.

TABLE 5.2

Educational Programming

Paper Airplane Flying Contest—
Saturday, May 20, 1:00 p.m.

A contest conducted according to the rules of the International Paper Airplane Competition. Contest categories will be: aerobatics, distance plane is flown, time it is aloft, and origami. Contestants may enter one or all categories; there will be children's and adult divisions in each category. Prizes will be given to divisional winners in each category.
Registration fee—50¢

Free Programs
Paper Airplane Clinic—Saturday,
May 13, 9:30 a.m.–11:30 a.m.

A workshop in the construction and flying of paper airplanes, according to rules of the International Paper Airplane Competition conducted by *Scientific American* magazine. Workshops will be held on construction of planes to fly in each of the following categories: aerobatics, distance plane is flown, time it is aloft, and origami.
Members only. Open to children and adults.

Children's Classes

There will be six one-week sessions of children's classes. Children may be enrolled in a single week of classes or for as many weeks as desired. Classes will be held Monday, Wednesday, and Friday; children may be enrolled in either the morning session, 9:30 a.m.–12:00 noon, or the afternoon session, 1–3:00 p.m.

Discovery Series—Children 6–12
June 19, 21, 23—Found-Object Art.
 Children will use found objects in three different types of experiences: collage, sculpture, and silkscreen printing.

June 26, 28, 30—Photographs and Films.
 Experiences for this week will include photography without a camera (photograms), animated films, and a light show from handmade slides.

July 5, 7, 10—Construction Projects.
 Sculpture and 3-dimensional construction will be done from wood, clay, cardboard, and plastic.

July 17, 19, 21—Soft Art and Inflatable Art.
 Experiences in making art from papêr-mâché, sheet plastic, cloth, and helium-filled balloons.

July 24, 26, 28—Drawings and Paintings of People and Places.
 Drawing and painting experiences ranging from self-portraits, to field trips downtown to sketch the city.

Table 5.2 (continued)

July 31, August 2, 4—Body Ornamentation.
Jewelry making, tie and dye, batik, and costume making with a variety of materials.

Tuition for the Discovery Series—Children 6–12
Members' children—$6.00, nonmembers' children—$7.00 per week

Adult Classes
There will be two three-week sessions of adult studio classes open to anyone thirteen years of age or older. Dates are:
Session #1: June 19–July 10 (no class on July 3).
Session #2: July 17–August 4.

Painting and Drawing—Meetings: Monday, Wednesday, Friday
9:30 a.m.–12:00 noon
Tuition: see below
Materials fee: 3 weeks—$2.00; 6 weeks—$3.50. This covers basic materials such as paper, charcoal, etc.; paints, brushes, and other major items must be supplied by the student.

Jewelry—Meetings: Monday, Wednesday, Friday
9:30 a.m.–12:00 noon.
Tuition: see below
Materials fee: 3 weeks—$3.50; 6 weeks—$7.00 (includes basic materials). Most projects will require additional materials, such as precious metals, which may be purchased at the class.

Photography—Meetings: Monday, Wednesday, Friday
9:30 a.m.–12:00 noon.
Tuition: see below
Materials Fee: 3 weeks—$2.00; 6 weeks –$3.50. This covers basic darkroom materials. Film must be purchased by the student.

Printmaking— Meetings: Monday, Wednesday, Friday
9:30 a.m.–12:00 noon.
Tuition: see below
Materials fee: 3 weeks—$3.00; 6 weeks–$6.00. This covers inks and other basic materials. Plates and papers must be purchased by the student.

Ceramics—Meetings: Monday, Wednesday, Friday
12:00 noon–2:00 p.m.
Tuition: see below
Materials fee: 3 weeks—$2.00; 6 weeks—$4.00, plus cost of clay used.

This class will be held in the neighborhood arts center at 532 West Bowery St.

Tuition for all Adult Classes:
3 weeks—members, $18.00, nonmembers, $20.00
6 weeks–members, $31.00, nonmembers, $35.00

Source: Programs and publication of the Akron Art Institute.

Without attempting to define enrichment, it is still possible to elaborate the skills that the art consumer should be directed toward in the process of becoming educated in regard to art. Those skills center around the idea of art codes and the consumer's ability to use them and thereby better respond to the enjoyment possibilities of the art experience. Sophisticated art codes are required for the consumer to aspire to higher levels of comprehension of art; therefore, it is the learning of codes that is the most important aspect of art classes or lectures. Since the majority of viewers of art lack systematic decoding ability, the knowledge acquired in the art class is fundamentally valuable both in its creative-production elements and its enhancement of the sophistication of art perception.

The Art Code

Art perception involves a conscious or unconscious deciphering. As Pierre Bourdieu points out, codes are essentially cultural. He noted:

> Immediate and adequate comprehension is possible and effective only in the special case in which the cultural code which makes the act of deciphering possible, is immediately and completely mastered by the observer and merges with the cultural code which has rendered the work perceived possible.[2]

In this restrictive view, a completely mastered perception of art necessarily demands that both the artist and the viewer come from the same culture.

This culturally based view is supported by Jean Paul Weber's theory that perception derives from infantile vision, which in turn leads to an understanding of the essence and the various structures of the graphic work considered as such.[3] Weber's argument centers around the idea of infantile as opposed to adult vision. He discusses the difference between near vision and near visual space, and how objects seem at a distance. Adult vision can be understood by the sense of near vision, while infantile vision can be somewhat akin to the adult seeing something at a considerable distance. The point is that adult vision takes into account a great number of specific characteristics of the objects viewed and the clear representations that arise from this familiarity and recognition. On the other hand, the child's vision develops slowly during the first few weeks of its life; at first, light and dark images appear; then color develops, but is still essentially fuzzy in image; and finally, color develops with clear outlines and perceptions of the objects in view.

Weber's ideas suggest that what is essentially aesthetic is the result of infantile vision recollected through adult perceptions. Visual development can be thought of as a continuum with perception improvements made through improvements in deciphering in adult life. We may think in terms of visual development as growth in an ever-decreasing rate to some peak in later life or at the end of life.

The necessary conditions for deciphering a work of art, in Bourdieu's terms, are

> completely adequate and immediately effective only in the case where the culture that the originator puts into his work is identical with the culture ... which the beholder brings to the deciphering of the work: in this case everything is a matter of course and the question of meaning, of deciphering of the meaning, and of the conditions of this deciphering does not arise.[4]

Whenever these specific conditions are not fulfilled, some degree of misunderstanding is almost inevitable; thus we have the illusion of immediate comprehension of art, based on what can be called a mistaken code. One reason why many less-educated beholders of art in our society so strongly demand realistic portrayal is that, being devoid of specific categories of perception, such beholders cannot apply to scholarly works any code other than that which enables them to view objects as having a meaning in their everyday environment.[5] If such is the case, the beholder may view art as devoid of significance because he cannot decode the work of art or, in other words, reduce it to an intelligible form.[6]

A deciphering operation requires a complex code that has to be mastered. Works of art may reveal significance at different levels. As Bourdieu points out, the most naive beholder, first of all, distinguishes "the primary or natural subject matter or meaning which we can apprehend from practical experience."[7] He notes further:

> To reach the secondary subject matter which presupposes the familiarity with specific themes or concepts as transmitted through literary sources and which may be called the sphere of the meaning of the significate, we must have approximately characterizing concepts which go beyond the simple designation of sensible qualities and, grasping the stylistic characteristics of the work of art, constitute a genuine interpretation of it.[8]

A work of art as a symbolic asset exists only for a person who has the ability to understand it, or, in other words, to decipher it. The degree

> of art competence of an agent is measured by the degree to which he masters the set of instruments for the appropriation of the work of art, ... that is to say, the interpretation schemes which are the prerequisites for the appropriation of art capital ... or the prerequisite for deciphering a work of art offered to a given society at a particular time. Art competence can be provisionally defined as the preliminary knowledge of the possible divisions into complementary classes of the universe of representations: a mastery of this kind of system of classification enables each element of the universe to be placed in the class necessarily determined in relation to another class, constituted itself by all the art representations consciously or

unconsciously taken into consideration which do not belong to the class in question.[9]

More specifically, artistic competence can be defined as the previous knowledge of principles of artistic division, which enables the viewer to classify works of art unambiguously, and yet in a sophisticated way. The degree of artistic competence depends upon the degree to which the available classification system is mastered by the viewer, and also upon the degree of complexity of the system of classification.[10]

The system of classification to which we refer can be called an art code, or a social code, a system of possible principles of artistic division offered to a particular society at a given time—historically constituted and founded on social reality at a particular point in time. It does not depend upon individual wills and consciousness, and, as a social institution, it forces itself upon individuals many times without their conscious knowledge and determines the distinctions that viewers of art will make.[11]

A chief concern of codes lies in the idea of the readability of the work of art and, as such, the deciphering of art offered in a particular society at particular times calls for a given code of varying complexity and subtlety. The readability of a work of art for a particular individual depends upon the divergence between the level of emission (the degree of intrinsic complexity and subtlety of the code required for deciphering the work) and the level of reception (the degree to which this individual masters the social code), which may be more or less adequate in relation to the code required for deciphering the work.[12] When the code established for the work, or the code required to understand it, is more complex than the code as perceived and developed by the individual, then the viewer loses interest in what appears to him to be an unsortable and insignificant confusion.[13]

A disturbing possibility about the codes necessary for deciphering art is that, in theory, the code required to comprehend certain forms of new art, or indeed any art, may not be available to individuals, given the fact that each work of art, or each classification of works of art, demands a particular code of its own. Such a divergence between the code required to understand the work and the individual's prospects for mastering the code is more apparent during times of social disruption and rapid change than in relatively quiet periods of social history. Further, the comprehension of the codes demands a rather full mastery, such that the codes do not become habits of mind or pigeonholes of the worst sort.

Yet how do we classify the need for the perception of art? Art perception gratifies human beings, and it is therefore of value to them. It is not in the same dimension as a primary need; rather, art as a cultural need is really a kind of derived need that increases in proportion to its satisfaction, because each new understanding tends to strengthen the mastery of the instruments of appreciation and, consequently, this satisfaction attached to the new comprehension. Perception of art, therefore, can be seen as a

creative need arising out of a broader conception of the need for gratification. The mastery of codes, of such instruments of understanding, is acquired by slow familiarization, "a long succession of little perceptions."[14]

The entire question of codes inexorably brings us back to a critical policy question, the question of the Akron museum's charted move into contemporary art. If the museum continues to move in this direction, then perhaps it can enhance the citizen's perception of the art codes necessary to appreciate contemporary art. Certainly, as difficult as it is to believe that many persons can appropriate works of art through art codes, it is also tempting to say that by specializing, the museum can do a partial job but do it better. By specializing, the museum leaves out the potential for the development among Akron's citizens of art codes for deciphering other specific types of art; but can it, by specializing, hope to make the citizens more responsive to contemporary art? Unfortunately, no unqualified answer can be given to this aspect of the question of appropriate museum policy, even though there is a strong logic favoring it.

Scitovsky argues that the consumer of cultural goods and services cannot make a fully rational choice. Prospective satisfaction is satisfaction that one may gain from consuming most goods and services, a situation in which the consumer knows cognitively that satisfaction will occur. Retrospective satisfaction suggests that the consumer cannot know the value of a choice until it has already been made. Obviously, if art codes are necessary to enjoy art, then codes must be learned before the choice moves from a retrospective to a prospective situation. Cultural consumption will therefore usually be forgone in preference to consumption of things, where satisfaction can be rationally chosen, as opposed to those situations where one must spend time and energy reaching a point where consumption is valued.

Returning to perception of the art work, repeated contact with the work is absolutely essential, and just as the student or disciple can unconsciously absorb the rules of art, including those which are not explicitly known to the master himself, so the art lover, in some way, by abandoning himself to the work, interiorizes the principles and rules of its design and construction without them ever being brought to his consciousness and formulated as such.[15] A museum may provide this for a person who is already sophisticated, but since museums seldom figure prominently in the way in which people learn art, it is not likely that museums can expect to teach art codes to the totally uninitiated child, and certainly not to the uninitiated adult. Schools and families are institutions more important to the learning of codes than are museums.

Art, Schools, and Social Class

The slow familiarization brought about by conscious or subconscious experience with works of art is a necessary part of comprehending the

principles involved in art. But, as Bourdieu points out, school education tends to encourage conscious reflection on patterns of thought or expression that have already been mastered unconsciously by an explicitly formulated creative language. The danger of heavy pedantry is inherent in any rationalized teaching involving one body of precepts, prescriptions, and formulas that is explicitly described in the patterns of thought, more often negative than positive, that traditional education imparts.[16]

When the school does not make provision for proper art training, it nonetheless tends to inspire a certain familiarity, a feeling of belonging to a cultivated class through works of art. Schools can also inculcate not only a cultivated attitude that implies recognition of the value of the works of art, but an inclination to admire works of art approved by the school, and, in some sense, a duty to admire certain works or classes of works that seem to become linked to educational and social status.[17] The educational process works rather poorly in art appreciation not, perhaps, because of the absence of social codes required to decipher art, but because individuals lack the knowledge of such codes.

Less-educated viewers of art tend to prefer the most famous paintings and those sanctioned by school teachings. If one is to have discerning personal opinions, one must have education that is of sufficient quality to throw off the habits of mind taught by the school, and freely develop his or her own judgments about culture. Unless able to do so, people become the victims of what might be called routinized culture. The number of students who are freed from this kind of routinized culture is probably a small minority of educated people. Further, art education can be of full benefit only to those who owe to their family circle a competence for the comprehension of art, acquired by long, slow, and imperceptible familiarization.[18] Unless this familiarization occurs on a regular and consistent basis through the family (since, obviously, such intensive familiarity is not possible through the schools), individuals may fail to develop the necessary comprehension of art. In this sense, too, art may become a very class-oriented part of the larger culture.

The class divisions of art found among social groups are enhanced and indeed elaborated in many cases by art connoiseurs and critics. An ideology which derives from the value of art as a kind of affection of the heart, acquired through long familiarity with art and through the educational process, makes works of art and their understanding a kind of silent self-seeking. The result is that what is essentially a social privilege is made legitimate for a particular class in the society merely by the view which says that the appreciation of art is based on a natural human conception.[19] Culture then becomes class conscious, and the right of enjoyment of particular aspects of culture is reserved for members of particular classes. To close the logical circle, it is essential to partition the society into barbarians and civilized people. This justifies the civilized people and their right to conditions that make the possession of culture a kind of state of nature.[20]

If art is used to produce cultural classes and to divide society into the cultured and uncultured, then art museums are in a peculiar position. Their true function may be to strengthen the feeling of belonging in some people and the feeling of being excluded in others.[21] The works found in these civic temples in which bourgeois society deposits its most sacred possessions are relics inherited from a past that is not its own. In these holy places of art, the chosen few come to nurture a faith in virtuosity, while conformists and bourgeois devotees come and perform a class ritual. Everything combines to indicate that the world of art is as contrary to the world of everyday life as the sacred is to the profane. The visitor to museums detects the religious silence forced upon visitors; the puritan aestheticism of the facilities, always sparse and uncomfortable; the almost systematic rejection of any instruction, the grandiose solemnity of the decoration and the decorum; colonnades, vast galleries, decorated ceilings, monumental staircases, both outside and inside;

> .. everything seems done to remind people that the transition from the profane world to the sacred world presupposes, as Durkheim says, a genuine metamorphosis, a radical spiritual change, that the bringing together of the worlds is always in itself a delicate operation which calls for precaution and more or less complicated initiation, that it is not even possible unless the profane lose their specific characteristics, unless they themselves become sacred to some extent and to some degree.[22]

The art museum may give to the public a legacy of monuments of a splendid past; yet this may be false generosity, because while entrance to museums is usually free or inexpensive, it tends to be reserved for those who are endowed with the ability to appropriate the works, who find themselves with a legitimatized privilege. What Weber called a monopoly of the holding of cultural wealth and of the institutional signs of cultural salvation becomes the keystone of a system that can only function by concealing its true position in the mystifying words of a democratic language.[23]

Such an analysis of a class-oriented culture and of an inward-turning group of zealots is perhaps unfair. At least it is onesided. Art as a social institution has neither the strong social nor economic supports that many other social institutions exhibit in the society. Like recreational institutions, art institutions tend to be second-class citizens among other institutions within the society. Thus it is easy to see how their very exclusion from a larger society sets up a reaction in those who value art and the culture of art and leads them to create small enclaves of culture apparently exclusive to themselves. They are exclusive to some considerable degree, and exclude many citizens in the society, but in truth this arises in part because art as an institution within the society is fairly well excluded itself.

One must conjecture that social institutions of art have done a relatively poor job in educating large segments of the population in the use of higher codes of art perception. One need not argue that the failure is due to lack of

effort, because it is easy to recognize that since the art institution is a secondary social institution, it does not usually have the opportunity to compete with other social institutions for a voice in educating the children and adults of the society.

Limits to Educational Success

It should also be recognized that to expect an entire public to achieve highly sophisticated levels of art perception is to expect a society to devote much of its time to art. The question then remains as follows: Since art codes are complex (when sophisticated), and difficult to comprehend, and take a long time to master, can we ever expect the society to achieve a sophisticated level in the comprehension of art? The answer to this question must unfortunately be no, yet the functional illiteracy of the public with regard to art is clearly unacceptable when society values culture even to a limited extent. One must then observe that the education of the public to art in this society will continue to be meritorious, but an essentially losing effort for large numbers of people.

However we view education and its role in the making of art and in the appreciation of art, it is also clear that a spontaneous ruboff in an educational sense may be of little value. We recognize that repeated contact with a work of art is absolutely essential, and casual education in art, therefore, may well have no carryover value. One may then question the educational emphasis placed on art in elementary school systems today. One may question whether there is anything like an efficient level of such education to have significant impact upon the aesthetic development of citizens of the society. Given the prevalent tastes of much of society, we can suggest that whatever has been fundamentally attempted in art education, toward developing individuals aesthetically, is, for the majority of citizens in the United States, utterly unsuccessful.

If we accept Bourdieu's point that school education tends to encourage a particular aesthetic language that is class oriented, then any kind of adequate comprehension of art cannot be expected. Likewise, if the family is not strongly involved with art, there is no reason to expect that the family members will develop sophisticated aesthetic tastes.

Another impediment to effective education comes from a dimension of public school education in art that tends to routinize culture through the development of less-cultivated values pursued by schools and the society generally. A talented teacher of art is not so apt to fall into a routinized culture, but art in the lower grades of public school is not usually taught by art professionals. If children learn their first cultural expressions from society's representatives (elementary school teachers), then some aspects of the culture will undoubtedly suffer—in particular, the cultural institutions of art and music. Except in those rare cases where there is significant professional training among teachers of art in the lower grades, it is unlikely that a

proper foundation can be established for the student to move beyond routinized culture. If this point is accepted, then it suggests that the difficulty of developing higher levels of culture is made even greater.

In education we should further recognize that the art publics that the museum must attract to educate and please are quite diverse. First, we note the fact that there is no direct relationship between value and attitude orientations, leading to a community of interest felt by members of various art publics. Second, a sense of community of interest will be greater within those art publics whose members develop a high degree of commitment to art, irrespective of value and attitude orientations. Third, the greater the sense of community and commitment to art, the greater will be the possibility of a more formal organization emerging from the amorphous structure of the art public. Fourth, there is no necessary relationship between the satisfaction of immediate goals such as recreation; thus the degree of fellowship and community interest felt by the members of the art public will be very, very low.

Basic research into the art publics of the museum must focus on the art-publics typology, with due recognition of the fact that other elements of society must also be included. There is no one model consisting of six types of art publics; rather, there are at least six types of the art-publics model developed in Chapter 4, which relate to ethnic characteristics, income levels, social status, work status (blue collar-white collar), and age levels. Age levels may mean differing art-public memberships for a single person over a period of time. Even sex differences among art-public memberships may occur. In the case of education, basic research is required to establish some level of expectation of sophistication in art appreciation for various persons characterized by the art-publics model, but also including the other social and economic variables indicated above. What should an educational activity of a particular type be expected to accomplish among a group with particular characteristics?

The difficult task of speaking to a series of amorphous art publics cannot be approached from the standpoint of merely saying that we will provide programs for those interested in education, recreation, or any other specific dimension of art. The art public's diversity demands the most imaginative kind of educational efforts toward teaching art codes at levels appropriate to the level of the public's comprehension. An education program at an art museum must therefore be involved in testing; it must be very experimental and quite varied to be effective.

In summation, given all the limits and problems elaborated above, it is the height of silliness to imagine that a small local museum can have much impact in bringing in new initiates to art in any substantial number. The museum's role in education is, therefore, limited, narrow, and may not be of relatively great social value.

But even given the problems, education goes on apace. To better understand the role of art classes, an analysis of class work at the Akron

museum was undertaken. Although they are included in the cost-benefit analysis of the next chapter, special events, films, concerts, and other educational activities are not individually analyzed. Total lectures were studied, as were films and one-time special programs; but the next section focuses on an analysis of the perceptions that participants and teachers had concerning individual classes in which they were active. Note that we deal with perceptions, not any standard of evaluation in an absolute sense.

Most art museums have educational departments, some offer formal degrees, and some are associated with degree-granting art schools. Most middle-sized museums offer formal instruction, at least to a limited number of adults and children. The purpose of these classes is to try to instruct the student in the production of art objects in one or more mediums, that is, to help the student produce art and thereby intelligently consume art. Although it is a production-oriented activity, few participants ever go beyond mere art-hobbyist levels and the personal satisfaction they may so derive. Practice in art processes and techniques seems to extend the participant's knowledge toward an understanding of art codes; thus, enhanced consumption skills are a major aim of these class activities. Indeed, art-appreciation or art-history classes are frankly consumption oriented. But, with both production and consumption elements included, the classes offer participants the opportunity to enhance their asthetic perceptions, even if few artists are produced in the process.

ENROLLMENT AND ATTENDANCE IN ART CLASSES

Like most art museums, the Akron Art Institute conducts a regular series of courses in art during particular seasons of the year. Catalogs or announcements are published. Enrollments are taken, and scheduling of classes (just as in a university) is done largely on an experimental and somewhat hit-or-miss basis. Looking into classes that were offered by the insititute during a particular winter term (including two carry-over photography classes), we asked students about their experiences with the courses and their general impressions of the museum.

The selected sample from the year's offerings was considered reasonably representative of the classes offered for the entire year. The analysis presents some descriptive data on individual courses, but the primary aim is to gain an impression of the general run of class offerings. Certainly, if an instructor is poor, then it means the class will be poor, or if an instructor is exceptionally good, this will show up in the quality of the class, but such results are merely a managerial problem for the museum. What is sought is an overall impression of all the courses, with the recognition that good and poor instructors will tend to offset each other in such an impressionistic analysis. A sample of seven courses was investigated.

Table 5.3 shows the title of the course, the number of meetings for each course, the total attendance for each course, and the total official enrollment, for each of the seven courses offered during the winter term of 1972. The entry under total enrollment for photography was for a ten-week period, which covered two separate sessions; the enrollment for the first five weeks is listed above that for the second five weeks. Few central attendance figures are kept; thus attendance figures were obtained from teachers of the classes.

The most heavily attended courses were the jewelry and metals courses; two of the three listed in the table were created because of over-enrollment for the first. The preschool class taught at the Art Institute had the least enrollment and attendance. Students in the three jewelry courses were a mix of teenagers and adults. Enrollees in the photography course were all 17 or older. The extension class was comprised of 11-and 12-year-olds. Each of the teachers reported a relatively steady average attendance.

Costs of Supplies and Tuition

Table 5.4 shows for each course the estimated total cost of supplies provided by the Art Institute, the estimated total cost of art supplies provided by students, and the tuition cost. The cost of Akron Art Institute supplies is in each case an estimate and refers to the supplies kept in a central storage place and used during the course; it does not refer to machinery, tools, or sunk-cost items. Student-provided supplies ranged in cost from zero to $30 per student. Museum-provided supplies ranged in cost from $2 to $25 per student, with lax record-keeping making some supply costs unallocable.

The tutition figure for the photography course is higher than tuition for the other courses. The tuitions for the other courses cluster around $20. Fees varied according to the number of class meetings and averaged from about $2.80 to $4.00 per session.

As an added note, jewelry teachers generally felt that the students were undersupplied—that it, they did not have a sufficient set of tools to progress as well as could have otherwise been expected.

Characteristics of Teachers

To have a better notion of the actual class activities, we held discussions with the teachers. Museums seldom have full-time instructors for programs such as those offered here. All of the teachers worked part time, as one would expect in the case of a museum of this size, but all of the teachers had significant training in their respective art fields both as practicing artists and from the standpoint of formal college education. Two of the teachers held master's degrees, and one held a bachelor's while the others had had some formal college education. Considering the fact that the wages they received

TABLE 5.3

A Sample of Museum Courses

Course	Days Offered	Dates Offered	Total Attendance	Total Enrollment	Number of Course Meetings
Photography I & II	Thurs., PM	Oct.-March	85	8 (I) 9 (II)	10
Jewelry and Metals I	Wed., PM	Jan.-March	100	20	5
Jewelry and Metals II	Thurs., PM	Jan.-March	75	20	5
Jewelry and Metals III	Sat., AM	Jan.-March	55	11	5
Preschool	Thurs., AM	Jan.-March	35	7	5
Extension	Sat., AM	Jan.-March	65	13	5

Note: The Roman numerals after each jewelry and metals course refer to the different sessions offered; they are not used as official designations, nor do they refer to the level of instruction or student expertise.

Source: Compiled from sample data, records of the museum and interviews with teachers.

TABLE 5.4

Cost of Course Supplies and Tuition

Course	Cost of AAI Supplies	Cost of Student Supplies*	Tuition Cost	Supplies That Are Returned
Photography	$2 per student	$10 per student*	$28 if member $32 if nonmember	Chemicals
Jewelry and Metals I	$25 per student	$9 per student	$17.50	Tools
Jewelry and Metals II	Not known	$6 to $15 per student	$17.50	Tools
Jewelry and Metals III	Not known	$10 to $30 per student	$17.50	Tools
Preschool	Not known	No cost	$18 for child	Not known
Extension	Not known	No cost	$20	Not known

*This figure does not include cost of student's camera.

Source: Compiled from sample data.

for teaching were small ($120 for each course), one would not expect to have the most highly qualified persons in the formal-education sense. On the other hand, excellence in art is not as closely associated with formal education as would be the case in other fields, so that evaluating art teachers on that score would be a suspicious procedure.

As to experience in teaching, some of the teachers were new to museum classes, while four had been teaching for about five terms, and one had been teaching museum classes for more than 20 years.

Since the main purpose of each course is its own internal focus, the absence of a regularized curriculum means that the teachers could not be considered part of a unified teaching staff. They taught their own courses, but had little intercourse with each other. Each teacher's general evaluation of the museum was based rather exclusively on his or her own individual perceptions, as opposed to any well-stated common goal.

Teacher Perceptions of the Museum

We asked each teacher several questions regarding his or her perceptions of the Art Institute in general. Their responses to the question, "What do you like best about the Akron Art Institute?" had to do either with the general purpose of the institute or specific programs. Two teachers specifically mentioned the previous director of the institute in their answer to this (Orrel Thompson had by this time left the museum), while two others mentioned the museum's role in the community. One said that the museum's atmosphere for work was its prime attraction, while two mentioned the opportunity it gives local artists.

In describing what they liked least about the institute, two of the artists said that they liked everything equally. Two others mentioned either the "upper-class attitude" of the institute's staff and the institute's being unaware of, and out of touch with, most of the city's population. A fifth artist mentioned the stifling effect of budgetary troubles caused by the lack of support from both the city and from the big money in Akron.

Changes which they would like to see at the institute ranged from making the museum more aware of, and integrated with, the community to assuring a large and steady flow of income to support a viable program. One artist suggested centralization and better organization of supplies, and another suggested more advertising so that the city would be more aware of what the institute offered. One other artist suggested an increased emphasis on exhibits and activities that are participative in nature.

Two of the five teachers want the institute to continue its emphasis on collecting twentieth century art. The other three mentioned their own specialties—photography and crafts—when asked what kind of permanent collection the institute should have. Two of the five felt that the present types of exhibitions were satisfactory, while the other three emphasized the importance of crafts. One of this latter group suggested a return to juried

shows of area artists as one method of increasing participation in, and support of, the institute.

All of the respondents felt that the institute's primary purpose is education, exposure of the public to contemporary art. At the same time, none of the five teachers felt that the institute is performing this function well. All mentioned the lack of consistent public support as the main problem; two mentioned elitism on the part of the institute as the primary cause, while one simply said that it was the "public's fault."

Survey of Institute Students

There were 35 of a possible 39 responses (87 percent) to our random telephone survey of former Akron Art Institute students. Of these students, 11, or 28 percent, attended extension courses in Bath and Hudson, two Akron suburbs. The remainder attended courses conducted at the Art Institute.

To develop elements of the economic analysis we surveyed the travel time consumed and the distances traveled by students in getting to the classes. The shortest distance traveled to class was a half mile; the longest was 14 miles. The travel times estimated by the students ranged from less than five minutes to 35 minutes. One student went to class directly from work at Akron University, which is less than one mile away, and traveled 12 miles to get home. The mean travel time was 13.57 minutes and the mean distance traveled was 5.87 miles.

All of the students traveled to class by car. Children were usually driven by their mothers; one mother mentioned that they car-pooled on occasion.

The students ranged in age from young children to those between 40 and 50 years old. Twenty-seven students were under 19. The mean age was 15 and the mean number of students per class was five.

We asked the students to judge the effectiveness of the teachers; the comments registered disappointment, absolute delight, and many points between those two extremes (see Table 5.5). The adult photography students were all positive about the effectiveness of their teacher. One said

TABLE 5.5

Students' Reaction to Teachers

Comment Regarding Teachers	Number of Students Commenting
Disappointing	4
Effective enough	9
Pretty good	9
Very good	5
Marvelous, superb, fantastic	7

Source: Compiled from sample data.

simply that she "learned a lot from him." Another felt he "learned more from him than anyone else." The painting and drawing students were all at least moderately positive about their teacher. Some comments were that the teacher was "good," "helped me better my style," and was "effective enough." When asked if they would take another course at the Art Institute, 28 students (80 percent) answered yes and six (20 percent) said no.

When asked what they believed to be the primary purpose of the Akron Art Institute, most participants seemed to view it as an educational organization (13 or 23 percent), or as a means "to widen the horizons of people in Akron" or to "enrich lives" (eight, or 23 percent). Some comments were as follows: the museum's purpose is "to serve Akron as an art facility in general," "to get you to like art more and appreciate it," "to make art and various aspects of art available to the Akron community"; and the museum "should be community related as well as a museum—serve both people and artists."

When asked what they liked best about the class they took, respondents provided mixed answers. Positive reactions were expressed toward other persons in the class, the teacher, the variety of materials, and class flexibility, while the 20 percent who indicated that they would not take another course were generally negative about the experience.

Specifically, what students liked best about classes was as follows:

Response	Percent of Respondents
Teacher	23
Variety of Materials	20
Flexibility	12
Imaginatively presented	9
Small class	6
Cannot answer, nothing	12
Coming home	6
Something to do while mom is in jewelry class	3

In summary, the teachers got relatively good reviews from the wide age range of participants; their perceptions in each case paralleled how they felt about their success in the course undertaken. Most of the students (about 88 percent) rated teachers as "effective enough" or better. Teachers, like students, seemed positive about the museum and its services.

Other Data on Classes

Students' responses also indicated the following significant data:

1. Mean number of students per class was five.
2. Forty-six percent of the students were enrolled in children's classes.

3. Mean number of class meetings was 8.6.
4. Mean number of classes attended by each student was 8.1.
5. There was a 95 percent attendance rate.
6. Mean cost of supplies was $2.84.
7. Mean cost for tuition was $6.61.
8. Eighty-eight percent of students said taking a particular course achieved their purpose.
9. Fifty-seven percent of the students, or their parents, were members of the Akron Art Institute.
10. Forty-three percent could not think of any particular thing they liked least about the course
11. In regard to the purpose of the museum, 77 percent view it as an educational orgainizatıon

For all of the fine comments and elaborate claims made about the educational role of art museums, there is little evidence that this particular museum has met many of its high goals in regard to classroom activities, except for a very modest number of cases. In a large midwestern city like Akron, the museum was only able to draw some 88 persons as enrollees in its courses for the winter term— not a distinguished enrollment. It is fairly clear that there is a gap between hopes for education and the effective outcomes of this museum's array of course offerings. Certainly, costs for the interested person were not generally prohibitive, yet either substitute activities in art or other pursuits render the class activities of the museum less attractive to would-be enrollees.

In essence, perhaps the museum is simply faced with a small market for its classroom services or is in direct competition with schools in the area where art offerings are considerably broader and better attended. The limited-market idea is related to the museum's relative lack of consequence for most citizens in the city. If the museum seeks quality, then perhaps all it has achieved in this sense is the previously suggested elitism, an impression about art that is widely held by most citizens anyway. In comparison to public school activities, some would call into question whether or not the museum was justified in channeling a considerable amount of its resources into formal classroom education. On the other hand, perhaps it is through education in the production of art that the young consumers of art learn art codes that enable them to find permanent satisfaction in consuming art. Certainly, the student in an art class makes a greater commitment of time and resources to art than does the casual visitor to the museum. Even if the experience in the class is not greatly satisfying, there can still be positive elements and satisfaction for the participant, in his or her efforts to develop sophistication in the art codes that are necessary to permit highly satisfying consumption. But, no matter how one argues, it is obvious that formal classes in this museum generate insignificant benefits, when the entire Akron community is considered, even though formal classes amount to about 40

percent of educational visits as defined in this chapter, and even though the education classes have value for certain participating individuals.

NOTES

1. Theodore Lewis Low, *The Educational Philosophy and Practice of Art Museums in the United States* (New York: Bureau of Publications, Teachers College, Columbia University, 1948), pp. 162-63.

2. Pierre Bourdieu, "Outline of a Sociological Theory of Art Perception," *International Social Science Journal* 20, no. 4 (1968): 589.

3. Jean Paul Weber, *The Psychology of Art,* trans. Julius A. Elias (Paris: Delacorte Press, 1969), p. 139.

4. Bourdieu, op. cit., p. 590.

5. Ibid., pp. 590–91.

6. Ibid., p. 591.

7. Ibid., p. 592.

8. Ibid.

9. Ibid., pp.594-95.

10. Ibid., p. 596.

11. Ibid., p. 597.

12. Ibid., p. 598.

13. Ibid., p. 598.

14. Ibid., pp. 601-2.

15. Ibid., p. 602.

16. Ibid.

17. Ibid., pp. 603-4.

18. Ibid., pp. 604-6.

19. Ibid., p.608

20. Ibid., p. 610.

21. Ibid.

22. Ibid., p. 611

23. Ibid., pp. 611-12.

Chapter Six

ECONOMIC BENEFITS OF
EDUCATIONAL PROGRAMS

The economics of education details the possible benefits to the individual and the society derived from participating in the schooling process. A period of schooling, usually a year, is the economic process with which economists normally work. One may criticize such a limited concept of an educational process, but the broader aspects of education are so diverse that they do not lend themselves well to formal analysis.

Schooling, in comparison to education, is a more clearly defined idea, and one in which it is not difficult to perceive a classroom situation where an instructor and a group of students undertake particular tasks or missions. The outputs of the educational process are periods of schooling, even though inherently we know that what the student gains from that process is in the form of skill, products, and satisfaction. If museums produce art, or an artist whose later art has value in the market, then the usual discounted future earnings streams would be a valid economic benefit—that is, the value of the schooling is the net difference over time in a stream of income to the artist, with the schooling or without it.

Our particular interest, however, is in the training of adult and child hobbyists in art and art-related activities. In this form of education, it is possible to argue that the output of the educational or schooling process is, in economic terms, related to consumer satisfaction derived from art and only occasionally to the production of art for art markets. We assume in the analysis of Art Institute education programs that the principal component of the schooling output is the satisfaction derived from the skills that accrue to the individuals who take part rather than some ultimate market test in years ahead, which might result in the sale of a particular produced work of art. The student who goes on to be an artist in the market is rare. On the other hand, an analysis of participants in the casual art classes of some museums might reveal numerous persons who become notable producers. Such is not ususally the case in Akron, however.

Educational programming as we define it includes all formal and informal classes, both extension classes and those held at the museum's building, all films, lectures, concerts, special educational programs, and guided tours of exhibitions and/or the museum in general.

THE MEASURE OF BENEFITS

The conception of economic benefits of the museum's art-schooling program is based on evidence of the value that the participants place upon their experience. Let us not consider away possible economic returns to the individuals in years to come and concentrate the focus on costs that the participant is willing to bear in order to participate in education. The amount of cost that the participant is willing to bear becomes a statement of the value or esteem in which he or she holds the educational or schooling experience.

Aside from the fact that the proposed benefit is a gross measure including cost elements, this conception of willingness to pay as a statement of value to the consumer should be further qualified, principally in that the consumer has no opportunity to evaluate the process—that is, to know the satisfaction possible before going through it—yet must pay the costs prior to entry. A second kind of qualification comes from the indirect nature of the expenditure. Many children take art classes and do not pay directly for either their fees for admission or the tools and materials that are employed; nor do they pay for the transportation costs that are required in order to place them at the class at the proper time. With these qualifications in mind, we should recognize that the value to be placed upon museum classes for children is, in large part, an estimate of the value that the parents, who actually pay these costs, place upon the experience for the child.

Costs that will be measured in this analysis of the educational programs of the Akron Art Institute include the to-and-from-the-class travel costs, the enrollment or admission fees, and a participant's expenditure for materials and tools required for a class. The sum of these three types of expenditures indicates a willingness to pay, that is, an acceptance of the educational experience being worth at least the amount expended.

In order to express the benefits in economic terms, Figure 6.1 shows the demand curve for education programs at the various prices that people are willing to pay. Price in this sense includes travel cost, fees, and tuition. Persons pay, as shown in the figure, an average of OP for OX services from the Art Institute, and the lined area indicates the amount of economic value measured in this study. Since the area under the demand curve (ODB) represents the total value of the resource (education) in a short-run sense, we are not measuring all elements of the total value. The value represented by the lined area OP-AX is what is measured. The triangle immediately above the lined area is what we call consumer surplus, or that surplus value that

FIGURE 6.1

The Demand for Educational Activities of the Akron Art Institute

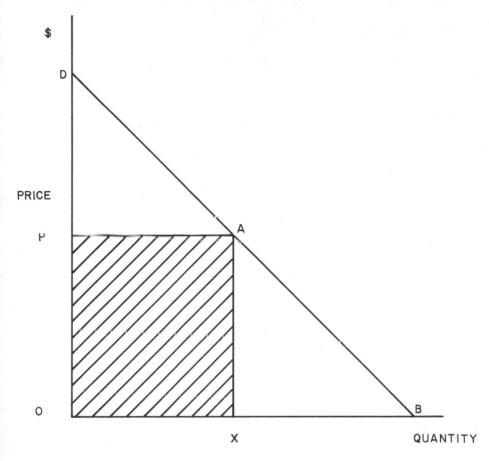

Units of Education

Source: Constructed by the author based on general information.

accrues to persons who did not have to pay as much as they would have been willing to pay. The consumer surplus (DPA) must remain an unmeasured element, but it is one we know exists. But what is consumer surplus? In evaluating normal economic goods, the consumer-surplus valuation is based on the maximum price that the consumer is willing to pay for the goods, not the price the consumer actually has to pay. Since the present analysis measures only what the person actually pays rather than what the person would be willing to pay, it should be recognized that estimates of the value of

the activity are in this view essentially conservative (that is, the consumer-surplus triangle DPA is not measured). But classroom activity is only part of the total educational programming of the museum. While estimates of the economic value of classes are attempted, estimates of the value of all educational activities including classes must also be attempted.

Assigning total benefits to educational programs for a year is different from assigning total benefits to an educational class. We can assign benefits to a class by considering the to-and-from-class travel costs, materials fees, and enrollment fees as evidence of what the participant is willing to pay. In effect this means that the experience, if continued, is worth at least the estimated amount, and thus is a minimum statement of the economic value to the participant. Grants, endowment income, and membership-fee allocations cannot be seen as benefits assigned to any one class or any other program, but along with the class benefits, these other elements, along with admission fees (for films, lectures, etc.), are an expression of the total annual benefits for total educational programming. Total benefits, therefore, are an expression of class benefits, annual membership-fee allocations based on what proportion of members gave education as their prime reason for joining the museum, an arbitrary allocation to education of the museum's endowment income, certain private grants and scholarships (as opposed to any public grant that would merely be a transfer payment), and admission fees for films, concerts, or lectures.

MEASURABLE COSTS

On the cost side, the concern is primary with the direct costs incurred by the Art Institute in providing the program or class. In addition to these direct costs, estimates of the value of acquired or loaned space and other imputations to cost are included.

In addition to dealing with the direct costs and benefits that are allocated to the Art Institute and to the classroom participants, it is recognized in economics that there can be significant external effects of almost any kind of economic transaction. External benefits and costs to society arise that are not part of the individual participant's costs and benefits or the institutional cost. The impact of one's education on one's friends is an external effect of one's being educated. Externalities are unanticipated outcomes of a transaction (or activity) that have impacts on a third party or on society in general. No measures are attempted for either external benefits or external costs.

Another limitation must be mentioned. Because of incomplete personal data on all enrollees in the 1971–72 courses offered, we used, as representative examples of the 1971–72 courses, seven classes offered during the summer and fall of 1972 to gain travel-cost estimates, while aggregate costs to the Akron Art Institute were developed from fiscal 1971–72 (ending July

1). We used some of the later classes for detailed student-cost data because of the ready availability of both current students and teachers. Using these classes as examples provides a model that can be applied to these courses and to some offered earlier by the same teachers and, in many instances, drawing the same student clientele. Thus, there is overlap between cost and benefit data in this chronological sense, but the only result would be a slight change in cost data if we were to update for the calendar year 1972. Benefits would not likely change since behaviors are thought not to change significantly during this overlapping year. Before turning to the analysis of the seven courses, an examination of educational data in the aggregate is in order.

Educational Visits to the Akron Art Institute

Looking again at the total visits to educational events at the Akron Art Institute, we estimate there to be approximately 20,687 education-related visits to the institute during the fiscal year 1971–72 (see Table 6.1). This number includes some 2,574 persons who attended extension classes in various neighboring communities, but who did not attend classes at the Akron Art Institute. The data reveal that formal classes both at the Akron Art Institute and at extension facilities account for the largest attendance (39.8 percent), followed by special programs, such as docents offering guided tours, accounting for about 30 percent of total attendance at educational

TABLE 6.1

Educational Visits to Akron Art Institute by Event, 1971-72

Event	Number of Events[a]	Visits Per Event	Total Visits[h]	Percent of Total
Special-education classes[b]	16	106	1,696	8.2
Films[c]	12	100	1,200	5.8
Lectures[d]	12	131	1,572	7.6
Concerts[e]	12	149	1,788	8.6
Special programs[f]	50	124	6,200	30.0
Special-education classes	N.A.[g]	N.A.[g]	5,657	27.4
Extension classes	N.A.[g]	N.A.[g]	2,574	12.4
Total	—	—	20,687	100

[a]Taken from Akron Art Institute Calendar.
[b]Paper-airplane making, etc.—single events.
[c]Regular film series.
[d]Includes lecture-films.
[e]All types.
[f]Docent-conducted tours, etc.
[g]Not applicable since classes are so varied in structure.
[h]Data from actual enrollment and attendance records.
Source: Derived from Akron Art Institute records and estimates.

activities. If special-education classes and formal-education classes are combined, they represent the largest proportion of all educational visits to the institute, 48 percent.

Other events contribute to attendance. Concerts account for 8.6 percent of the visits, followed by lectures, accounting for nearly 7.6 percent, and films, 5.8 percent. These, and the figures cited above, indicate that the institute has a diverse set of educational programs that go far toward speaking to the needs of the educational visitor. Varied art publics are served by the wide range of educational offerings.

There may be variance in the numbers given for attendance, and this fact should not be overlooked. The formal-education classes represent relatively good estimates of attendance; sufficient data were available to use several means of estimating this category of events. Less certain are the other categories, because they depend upon the head counts taken daily at the institute, numbers that we cannot verify fully. Thus attendance data for the formal-education classes may be taken as more reliable than attendance figures for the other events cited in Table 6.1.

Actual estimates for the other categories were made by comparing mean daily attendance, excluding special events, to days in which a particular event occurred; nighttime visits were taken to indicate some form of special event.

AGGREGATE COST ANALYSIS

Table 6.2 represents the estimates of total costs which we ascribe to education as we have defined it. Total educational costs for the fiscal year 1971–72 are estimated to be $70,930.85. Such a figure bears some elaboration. First, the total does not correspond to what the Art Institute budget would list as educational costs, because the educational budget is done strictly in terms of accounting costs, and the table presented here is done in terms of economic costs. Thus, we allocate on the basis of the economic value of such things as space, which the accountant might carry at the price paid of $1. The fact is that the building has economic value, and we would be remiss in not including a portion of that value in the educational costs.

Other differences occur. Note that we have allocated, in addition to the educational director's salary and the class instructors' salaries, a portion of salaries of other members of the Art Institute staff; the educational director, for example, had one-third of his annual salary allocated to education, as is the case for the director of development. The allocation is justified on this basis: we perceive the institute as having three functional aspects: education, exhibition, and development (and collection). The education functions are important outputs of the Art Institute and take certain amounts of the work time of certain higher administrators, and account for some amount of the work of other related staff members. Thus, salaries are allocated on a time-

TABLE 6.2

Total Educational Costs, July 1971-June 1972

Item	Cost	Percent of Total
Salaries expenditures		
Director of education	$11,000.00	15.5
Instructors	6,374.50	9.0
(Assessed salaries)		
Director of institute (33% of $23,000)	7,666.67	10.8
Director of development (33% of $17,000)	5,666.67	8.0
Business manager (33% of $9,200)	3,066.67	4.3
Bookkeeper (25% of $5,400)	1,350.00	1.9
Maintenance (33% of $5,700)	1,900.00	2.6
Executive secretary (25% of $5,500)	1,375.00	1.9
Registrar/security officer (10% of $7,400)	740.00	1.0
Total salaries allocation	39,139.51	55.2
Operations expenditures		
Total supplies cost to AAI	2,278.04	3.2
Total overhead, business		
assessment (33% of $38,573.62)	12,729.29	17.9
Total operations expenditures	15,007.33	21.1
Assessed value of fixed equipment (10% of $26,995.72)	2,699.57	3.8
Assessed value of AAI class space (@ $1.00 per sq. ft.)	7,980.00	11.3
Assessed value of extension-class space (@ $6.50 per sq. ft.)	877.50	1.2
Assessed value of auditorium space (@ $2.50 per sq. ft.)	5,227.00	7.4
Total educational costs	70,930.85	99.8

Source: Compiled from AAI records and estimates of economic value.

percentage basis, which suggests a salary-percentage allocation done according to Table 6.2. In total, salary allocations account for an excess of 55 percent of educational costs.

In addition to salary allocations, we estimated that in 1971–72, one-third of the general operating expenditures ($12,729) was spent on educational functions, including general office work, postage, supplies, and services. The final addition of costs comes in a variety of valuations placed upon the space used for education, including third-floor space estimated at a value of $1 per year, per square foot; extension space valued (though not charged) at $6.50 per year, per square foot (office-space rates); and finally, the basement auditorium valued at a good first-floor warehouse space rate of $2.50 per square foot, per year. While the institute does not have out-of-pocket expenses in the amounts indicated for space, the fact is that such space has economic value and should be counted as an economic cost. The appendixes at the end of this chapter detail the methods of cost allocation and estimation.

SEVEN ILLUSTRATIVE CLASSES

Recognizing that the largest segment of attendance for educational activities is represented by art classes (both special one-time and regular courses), we analyzed a sample of formal classes by the application of benefit-cost analysis. The basic methods used are indicated in the worksheets in the appendixes at the end of this chapter. The programs selected included jewelry classes, classes in printmaking, ceramics, painting and drawing, and photography; and two children's classes, preschool and the Discovery Series. These programs, offered during calendar 1972, represent the largest amount of total educational enrollments.

Using allocations of the cost data developed in Table 6.2, costs for the seven programs were estimated as revealed in column 2 of Table 6.3. Costs for the various programs ranged from $913 to $3,388. Benefits were generally lower, as revealed in column 3 of the table, ranging from $519 to $4,360. The benefit-cost ratios in column 6 indicate that three of the seven programs generated benefits in excess of cost. Ratios of more than 1 indicate greater benefits than costs, while a ratio of 1 would be a breakeven point. Ratios below one reveal higher costs than benefits.

The benefits measures include the travel-benefit method, which measures the willingness of the consumer to bear costs of transportation as evidence of a price he or she is willing to pay for the service. Other benefits, in the form of willingness to pay for materials, fees, tuitions, and the student-borne costs of equipment or materials used in the class, are added. These basic ideas of benefit represent the sum of willingness to pay, or the price which the consumer pays for the service.

The economics of schooling usually applies a method which enables the

TABLE 6.3

Total Economic Costs and Benefits of Selected Educational Programs, 1972

Program	Total Costs	Total Benefits	Total Costs Per Person	Total Benefits Per Person	Benefits-to-Cost Ratio	Number of Enrollees
Jewelry	$3,388	$3,979	$34.57	$40.61	1.175	98
Ceramics	724	519	51.78	63.52	.717	14
Printmaking	923	1,070	40.15	46.56	1.159	23
Painting and drawing	3,377	4,360	46.27	59.73	1.291	73
Photography	1,393	1,246	42.23	36.66	.895	33
Preschool (children)	1,459	1,125	45.59	35.76	.771	32
Discovery Series (children)	913	540	17.91	10.59	.592	51

Note: Some benefits which in the aggregate can be counted for all education program; cannot be allocated on a per-class basis. These estimates are conservative.

Source: Computed from sample data.

economist to estimate the additional amounts of income that the educated person generates over a lifetime, a benefit which obviously is quite large. In this case, however, the principal means of estimating benefits becomes a matter of immediate consumer demand and the expenditures which this demand creates, not an investment which one makes in one's future, as in formal education.

Looking at specific programs, it would appear that the adult classes generally are valued more highly than are the children's classes; the Discovery Series and the preschool programs were both somewhat lower in benefit than the adult programs. This difference may arise because the child's demand for the course is in part set and valued by the parent. The parent may not be as aware of the precise benefit of the art class as an adult would be who directly participates. Generating positive benefits over costs were the painting and drawing class, printmaking classes, and the jewelry classes.

Column 7 of Table 6.3 reveals the number of persons enrolled in the courses. Although little is to be gained from speaking of benefits and costs relative to larger or smaller classes, it is certainly true that larger classes would have reduced the high fixed costs (plant, equipment, salary) of the education program. Normally, the addition of other persons to these same classes would have enlarged the benefits and reduced the total costs per person.

In sum, the analysis reveals that the museum's costs in undertaking a class were greater in some cases than the value which participants placed upon the class. In the absence of further information, one might suggest that fees for participating in the classes should be raised to more nearly approximate the difference between what the consumer pays and what it actually costs the museum to offer the class. If there are significant consumer surpluses, then demand might not be much reduced. If on the other hand, the consumer is indeed paying what he or she perceives as the value of the course, then a rise in tuition would result in a fall in demand.

The question of raising tuition is an interesting one. If the consumer is enjoying a surplus (that is, paying less than he would be willing to pay), the museum's policy decision would be whether to continue to subsidize this consumer or to attempt to bring the museum greater revenues, that is, stop the subsidy. Undoubtedly, it is more efficient, for the economics of the museum, to raise its prices somewhat to appropriate a portion of a possible consumer surplus. Again, however, if raising prices drops demand, then a loss of revenues would likely occur, and efficiency would not be as well served. As it is, the museum is offering a service which is apparently more costly to produce than the price consumers are expected to pay.

A related question arises as to whether or not Art Institute classes have to generate a profit. Service may be more important than breaking even on events and activities. If service is paramount, then minimizing loss becomes the policy criterion instead of maximizing benefit, and we look to see which

programs minimized cost relative to other programs. Clearly on this basis, among those in which costs exceed benefits, photography, and the preschool classes appear to serve the public the best. Ceramics lags, as does the Discovery class, even though unit cost in the Discovery Series was lowest of all classes—$17.91.

Another interesting question arises. Can we compare the children's classes to the adult classes? Obviously different, these two forms of class activity may serve purposes so different that a comparison is meaningless. This is a question not for the analyst but for the policy makers of the Art Institute.

Further disaggregating the benefit-cost data, we examine per-user visit costs and benefits in the classes studied (see Table 6.4). The classes served 2,400 persons, with an average per-visit benefit of from $3.48 to $8.49 per participant. To provide these benefits, the Akron Art Institute incurred a range of costs of from $3.56 to $9.16 for each class visit.

Since the principal purpose of benefit-cost analysis is to aid in planning, the evidence is rather clear. Some classes appear inefficient, at least on the basis of our estimates of immediate benefits, and, even though there may be carryover benefits or long-term benefits, we have no means for measuring them. If officials at the institute decide that service is of most importance, and that profit is not their most important product, then clearly they opt for a cost-minimizing criterion of efficiency of operation, with the result that

TABLE 6.4

Economic Costs and Benefits per User Visit for Seven Selected Educational Programs, 1972

Program	Per-User Visit Benefits	Per-User Visit Costs	Benefit-Cost Ratio Per User Visit	Number of User Visits
Jewelry	$6.58	$5.60	1.175	605
Ceramics	4.36	6.08	.717	119
Printmaking	8.49	7.32	1.159	126
Painting and drawing	4.59	3.56	1.291	949
Photography	8.20	9.16	.895	152
Preschool	3.70	4.80	.771	304
Discovery Series	3.48	6.27	.592	145

Note: Average benefit = $5.63; average cost = $8.52; average benefit = cost ratio = .626; total visits = 2,400.

Source: Computed from sample data.

classes which have a poor record of benefits relative to costs will either be dropped and the resources used elsewhere, or reconstituted in an attempt to operate them more efficiently.

On a class-by-class basis, the Discovery Series failed miserably to draw a sufficient number of participants. Less notable ones, but still failures, were the preschool class and the ceramics class. The Discovery Series would need to increase its enrollments from 51 to 85 to break even, assuming that costs did not go up too much. The preschool group would need an increase of only about 10 students to break even, and might be able to do so at minimal cost. The ceramics group would need to move from about 14 to 19 participants to break even. If the photography class could have had only four more participants (37 as opposed to 33), it would have come close to break-even efficiency.

Note that uses of benefit-cost analysis are not like uses of accounting controls. Benefit-cost analysis is really more like performance budgeting in that it permits the policy maker to ascertain which programs generate what benefits relative to costs, and to make plans and adjustments to programs accordingly. Note also that a one-year benefit-cost computation is insufficient to arrive at a final determination. The cost-benefit procedure lends itself to regular and periodic evaluations of what various programs are doing; it is an ongoing evaluation process for examining the institutions's programs and functions. As a monitoring system, it is invaluable for efficient planning of activities.

ESTIMATED COSTS AND BENEFITS OF OVERALL EDUCATION PROGRAM

When estimating benefits and costs for the overall education program, data problems increase and small computational or conceptual errors make great differences in final results. Easing into the assessment of total educational benefits and costs, we take cost data from Table 6.2 and include them in Table 6.5. Total educational costs are $70,930.85.

Estimated total benefits based on the measures of transport costs, allocations of members' fees, and other expenditures and fees result in total benefits of $83,314.38. The excess of benefits over costs suggests that education programs are produced relatively efficiently at the Akron Art Institute. Positive net benefits accrue for participants. Benefits per visit (an education-oriented visit) amount to $4.02, costs are $3.43, and the benefit-to-cost ratio is 1.172.

In examining various elements of benefits, note the large amount of benefits estimated for the round-trip travel that visitors make to classes. In addition, membership fees were allocated to education. This was done by analyzing the membership and allocating to education those fees from members who indicated that education was their primary reason for joining

TABLE 6.5

Estimated Costs and Benefits of Educational Programs, 1971-72

Cost/Benefit Item	Amount
Total estimated costs:	$70,930.85
Estimated benefits[a]	
Travel	
nonformal classes	22,431.13
regular classes at AAI	4,104.03
regular extension classes	1,972.39
Membership-fee allocations[b]	14,721.84
Tuition and admission fees	17,832.25
Endowment income (33% of $24,474)	8,076.42
Donations and grants (12% of $18,536)	2,224.32
Special fund raising (12% of $44,100)	5,292.00
Material fees for classes (over and above formal	
tuition for class)[c]	6,660.00
Total	83,314.38
Benefit-to-cost ratio[d]	1.172
Benefit per user visit[d]	$4.02
Cost per-user visit[d]	$3.43

Note: Data include all educational activities—classes, guided tours, lectures, films, concerts.

[a]Total benefits based on willingness to pay, a price paid for the service.

[b]From analysis of members' reasons for joining the AAI. If education is the first reason, the allocation is $20; if it is the second reason, the allocation is $13.33; third, $6.67; these allocations are 12 percent of total.

[c]Materials costs include capital costs for equipment and materials used by participant. Estimates based on seven classes analyzed. Mean = $10 per enrollment.

[d]Includes extension class as visit.

Source: Computed from sample data.

the museum. We allocated some weighted proportion based on a certain weight for education as the first reason, a lesser amount when education was the second reason, and so on. Tuition fees for courses are obviously evidence of educational benefit, as are fees paid for films and concerts, and materials fees paid to the museum for supplies and materials for art classes. In addition, there would be the unmeasured consumer surplus arising for the recipient of the scholarship, as being logically distinctive from the other possible surpluses that lie above the stated figures.

Another way to look at education benefits and costs is to consider the costs and the benefits that accrue to the individual and those that accrue to the museum directly. In reality, while total benefits exceed total costs, the museum bears the costs of $70.930, but gains only the membership-fee allocation ($22,431), the tuition fees ($17,832), the endowment income ($8,046), the grants and scholarships ($7,454), the admission fees ($6,538), and the materials fees ($6,660), for a total of $61,274, to offset the higher

costs. From a purely accounting-cost standpoint, education does not break even, but from the standpoint of economic analysis, it creates benefits in excess of costs, benefits which represent economic value for citizens of the community.

EDUCATIONAL PROGRAMS: AN ASSESSMENT

How do we assess the picture of the economic benefits of education programs as compared to economic costs? In total, the immediate benefits of these programs are greater than their cost. Among classes, those which are small are expensive, and the children's classes appear less economic than the adult classes.

On the other hand, remember that not all the benefits of education are gained in the short run; indeed the long-run effects of education may be more significant. Unfortunately, economics is unable to speak well to the long run or to the question of quality of the educational experience. We do not know how well the programs are planned and pursued, or what degree of quality is gained by students who are enrolled. We do not know if education in art and the making of art creates a more productive, more balanced, or more socially astute individual. However, sophistication comes from education, and sophistication of taste in the aesthetic development of individuals and society must come from educational efforts. The effectiveness of the class activities of the Art Institute in these terms is not estimated, but logically art education enhances the aesthetic experience. The student in an art class may not, at the time he or she enrolls, have a clear impression of the value the class may subsequently hold. Most respondents to the student survey indicated that they would take another art class, so there is little doubt that the response of students (adults and children) to the classes is favorable.

Another kind of economic value is evidenced in the reasons members gave for joining the institute. A major reason given by the respondents was the selection of classes offered. One cannot discount this kind of value. In economics we speak of the option value, that value which states that people may positively value a place for the option of being able to go there even if they do not exercise that option. The option value was measured by the membership fees attributable to those who find the classes a significant reason for joining the Art Institute.

The employment that may result from art classes, while not investigated in this study, could be considered. The extent to which art-related occupations are generated by art classes offered at the institute is probably slight, but intuitively, we know that formal education in art does stimulate the interest of a number of persons in works of art and in art as a profession. Such values cannot be measured in the present study, but while the number

of persons so stimulated may be small, they do logically exist. Surely the institute's classes have, somewhere along the line, helped produce a future art teacher, an art therapist, or an artist.

In conclusion, we have measured the immediate and short-run economic effectiveness of the art classes and other education activities at the Akron Art Institute, and they have generally been found efficient in the economic sense. But note that we have found only partial value in the art class. Tentative though the conclusion may be, classes in the making of art are in fact of sufficient value currently to warrant continuation if fees can be raised and/or numbers of participants increased.

If the number of students were increased, the rather high cost per student, a fixed cost, could be reduced; indeed, every time the institute brings in a new student to a class, the average fixed costs are reduced and actual benefits increased. Illustratively, if there is currently an average fixed cost of $10 per person, and there are ten persons in a class, and then one person is added to the class, the fixed costs decline to about $9 per person. At the same time, with an average benefit of $10 per person and the addition of an eleventh person, we still have an average benefit of $10 but a total benefit of $110, instead of $100, and total fixed costs are still $100. There is not much question but that the classes suffer in precisely this way. Similarly, lectures, films, and concerts need a full house or as near to a full house as is possible.

Elaborating this illustration somewhat, if we contend that fixed costs are the major cost item in conducting the education program, additional visitors and students could be served with no additions to fixed cost and only slight increases to variable costs. Unfortunately, aside from variable costs such as the salaries of the instructors, and materials costs, which are the chief variable costs, education programs are characterized by very high fixed costs. Costs of the permanent staff, the administrative costs, and costs of equipment and the building are fixed and relatively high even if there are no students and no classes.

The central point, therefore, is that if education is to be pursued as an immediately efficient and economically viable operation, educational efforts ought to be expanded. More education may be the answer rather than less; the problem right now is essentially a problem of economics of scale.

The fee paid for classes represents a significant benefit or value statement from the consumer. Perhaps the upward revision of some fees would be in order, along with the elimination of some free programs in education. If the Art Institute chooses to subsidize certain members of the community (low-income groups, for example), then it should do so specifically and discriminate against the larger public.

Another alternative is to drop education altogether. By so doing, the institute can, over time, reduce significantly some of its fixed staff costs and all of its variable costs. To do so would mean elimination of the education director's position, plus expenditures related to his activities. Unfortunately,

unless the space were used more efficiently for other purposes, the large loss attributable to the third-floor class area and other space would not be recovered in fixed costs merely by dropping educational programming.

Finally, when estimating costs and benefits for educational activities, note that the classes are the least efficient aspects of the overall educational program. The main reason is the staff time they take, the equipment investments they take, and the fact that all third-floor classroom spatial costs must be attributed to them. Other educational activities are less expensive. Among these less expensive activities are special programs of various kinds, such as concerts, films, lectures, and other activities related to the educational process at the Akron Art Institute.

APPENDIXES

Cost and Benefit Tables: Art Classes, Summer 1972

Program Name: Discovery Series (for Children)

Number of classes per course: 3
Number of courses: 6
Enrollment data:

Members	Nonmembers	Total
12 (24%)	39 (76%)	51 (100%)

Total number of sessions 18

Benefits

1) Tuition and materials fees
 Members $6.00 x 12 = $72.00
 Nonmembers $7.00 x 39 = $273.00
2) Extra materials cost - 0 = 0
3) Travel costs: for 145.4 visits
 11.04 miles for 51 participants = 563.04 miles x 3 sessions = 1,689.12 miles @ 13.5¢ per mile = $228.03 ÷ 1.6 persons per car = $142.52 x .95 absentee factor = $135.39
4) Member-fee allocation: (25% of fee) x 12 = $60.00
 Estimated total value of benefits $540.39

Costs

Costs to Art Institute

Value of space: @ $9.41 x 18 sessions =	$169.38
Materials costs to Akron Art Institute: total	174.42
Operational costs	
Administrative, utilities, security, janitorial, etc.: total	363.50
Salaries for instructors: total for courses	206.25
Estimated total cost to AAI	$913.55

Total estimated value of benefits $540.39
Total estimated value of costs 913.55
 Cost per person $17.91
 Benefit per person 10.59
 B/C ratio .592

Spatial Distribution of Students: Discovery Series (for Children)

ZIP Code	Distance in Miles
44240	15.00
44303	3.03
44303	3.03
44320	3.80
44223	7.00
44310	3.41
44302	1.52
44302	1.52
44303	3.03
44223	7.00
44223	7.00
44223	7.00
44305	3.41
44303	3.03
44223	7.00
44223	7.00
44313	4.55
44223	7.00
44303	3.03
44303	3.03
44303	3.03
44303	3.03
(Barberton)	9.00
44312	9.00
44312	9.00
44312	9.00
44312	9.00
44312	9.00

Σ (sum) = 160.45 miles
n = 28 ZIP Codes
\bar{x} (mean) = 5.73 miles

Program Name: Preschool

Number of classes per course: 10
Number of courses: 2
Enrollment data:

	Members	Nonmembers	Total
10 weeks	13 (41%)	19 (59%)	32 (100%)

Total number of sessions 20

Benefits

Direct Costs to Students
1) Tuition and fees
 13 members @ $21.00 = $273.00
 19 nonmembers @ $24.00 = $456.00
2) Materials and costs other than fees: 0 = 0
3) Travel costs: for 304 visits
 11.76 miles per trip x 10 trips = 117.6 miles @ 13.5¢ per mile = $508.03 ÷
 1.6 persons per car x .95 absentee factor = $301.64
4) Member-fee allocation: (25% of fee) x 19 = $95.00
 Estimated total value of benefits $1,125.64

Costs

Costs to Art Institute

Value of space: @ $9.41 x 20 sessions =	$188.20
Materials cost to Akron Art Institute: total	109.44
Operational costs	
Administrative, utilities, security, janitorial, etc.: total	760.00
Salaries for instructors: total for courses	401.50
Estimated total costs to AAI	$1,459.14

Total estimated value of benefits	$1,125.64
Total estimated value of costs	1,459.14

Cost per person $45.59
Benefit per person 35.76
B/C ratio .771

Spatial Distribution of Students: Preschool

ZIP Code	Distance in Miles
44256	20.00
44223	7.00
44313	4.55
44306	6.06
44308	0.50
Maiden Ave.	3.80
44307	2.46
44302	1.52
44221	7.00
44313	4.55

44223 7.00

44306 6.06

Σ = 70.50 miles

n = 12 ZIP Codes

\bar{x} = 5.88 miles

Program Name: Photography

Number of classes per course: varies as to summer or winter

Number of courses: 2

Enrollment data:

	Members	Nonmembers	Total
5 weeks	1	11	12
10 weeks	2	2	3
3 weeks	1	13	14
6 weeks	2	1	3
Total	6	27	33

total number of sessions 20

Benefits

Direct costs to students

1) Tuition and fees

 5 weeks: 1 member @ $14.50 = $ 14.50

 11 nonmembers @ $16.00 = $176.00

 10 weeks: 2 members @ $29.00 = $ 58.00

 2 nonmembers @ $32.00 = $ 64.00

 3 weeks: 1 member @ $20.00 = $ 20.00

 13 nonmembers @ $22.00 = $286.00

 6 weeks: 2 members @ $34.50 = $ 69.00

 1 nonmember @ $38.50 = $ 38.50

2) Materials and costs other than fees

 short term: $10.00 per person x 26 persons = $260.00

 long term: $20.00 per person x 6 persons = $120.00

3) Travel costs: for 152 visits

 a) 5 weeks: 12 persons @ 7.3 miles per trip for 5 trips = 36.5 miles x 12 persons = 438 miles @ 13.5¢ per mile = $59.13 ÷ 1.6 persons per car = $36.96

 b) 10 weeks: 4 persons @ 7.3 miles per trip for 10 trips = 73.00 miles x 4 persons = 292 miles @ 13.5¢ per mile = $39.42 x .95 absentee factor (but not persons per car) = $37.45

 c) 3 weeks: 14 persons @ 7.3 miles per trip for 3 trips = 21.9 miles x 14 persons = 306.6 miles @ 13.5¢ per mile = $41.39 ÷ 1.6 persons per car = $25.87 x .95 absentee factor = $24.56

 d) 6 weeks: 3 persons @ 7.3 miles per trip for 6 trips = 43.8 miles x 3
 persons = 131.4 miles @ 13.5¢ per mile = $17.74 x .95
 absentee factor (but not persons per car) = $16.85
4) Member-fee allocation: @ (25%) x 5 = $25.00
 Estimated total value of benefits $1,246.32

Costs

Costs to Art Institute:

Value of space: @ $9.41 x 48 sessions =	$ 451.68
Materials costs to Akron Art Institute: total	116.28
Operational costs:	
Administrative, utilities, security, janitorial, etc.: total	380.00
Salaries for instructors: total for courses	445.50
Estimated total costs to AAI	$1,393.46

Total estimated value of benefits	$1,246.32
Total estimated value of costs	1,393.46

Cost per person	$42.23
Benefit per person	36.66
B/C ratio .895	

Spatial Distribution of Students: Photography

	ZIP Code	Distance in Miles
Half-session	44313	4.55
	44203	8.00
	44314	4.92
	44304	2.00
	44302	1.52
	44301	2.65

Σ = 23.64 miles
n = 6 ZIP Codes
\bar{x} = 3.94 miles

	ZIP Code	Distance in Miles
Full session	44313	4.55
	44304	1.00

Σ = 5.55 miles
n = 2 ZIP Codes
\bar{x} = 2.77 miles

Total

Σ = 29.19 miles
\bar{x} = 3.65 miles

Program Name: Painting and Drawing

Number of classes per course: 9 or 18
Number of courses: 1
Enrollment data:

	Members	Nonmembers	Total
3 weeks	3 (4%)	32 (44%)	35
6 weeks	9 (12%)	29 (40%)	38
Total	12 (16%)	61 (84%)	73 (100%)

Total number of sessions 54

Benefits

Direct costs to students
1) Tuition and fees
 members 3 for 3 weeks @ $20.00 = $ 60.00
 nonmembers 32 for 3 weeks @ $22.00 = $ 704.00
 members 9 for 6 weeks @ $35.00 = $ 315.00
 nonmembers 29 for 6 weeks @ $39.00 = $1,131.00
2) Materials other than fees
 3-week course $10.00 for 35 persons = $350.00
 6-week course $20.00 for 38 persons = $760.00
3) Travel costs: for 949 visits
 3-week participants: 9.04 miles x 9 sessions = 81.36 miles x 35 persons =
 2,847.6 miles @ 13.5¢ per mile = $384.43 ÷ 1.6 persons per car =
 $240.43
 6-week participants: 12.82 miles x 18 sessions = 230.76 miles x 38 persons =
 8,768.8 miles @ 13.5¢ per mile = $1,183.80 ÷ 1.6 persons per car =
 $739.87
4) Member-fee allocation: (25%) x 12 = $60.00
 Estimated total value of benefits $4,360.30

Costs

Cost to Art Institute:

Value of Space @ $9.41 x 54 Sessions =	$ 508.14
Materials cost to Akron Art Institute: total	249.66
Operational cost:	
Administrative, utilities, security, janitorial, etc.: total	2,372.50
Salaries for Instructors: Total for Courses	247.50
Estimated total costs to AAI	$3,377.80

Total estimated value of benefits	$4,360.30
Total estimated value of costs	3,377.80

Cost per person $46.27
Benefit per person 59.73
B/C ratio 1.291

Spatial Distribution of Students: Painting and Drawing

	ZIP Code	Distance in Miles
Half-session	44313	4.55
	44301	2.65
	44320	3.80
	44224	7.00
	44313	4.55
	44313	4.55
	44313	4.55

Σ = 31.65 miles
n = 7
\bar{x} = 4.52 miles

	ZIP Code	Distance in Miles
Full session	44223	7.00
	44302	1.52
	44696	20.00
	44272	11.00
	44313	4.55
	44302	1.52
	44240	15.00
	44313	4.55
	44303	3.03
	44310	3.41
	44313	4.55
	44303	3.03
	44302	1.52
	44304	1.00
	44313	4.55
	44312	9.00
	44321	4.55
	44320	3.80
	44321	4.55
	44320	3.80
	44321	4.55
	44281	20.00
	44262	10.00
	44203	9.00
	44313	4.55

Σ = 160.30 miles
n = 25 ZIP Codes
\bar{x} = 6.41 miles

Total
Σ = 191.95 miles
n = 32 ZIP Codes
\bar{x} = 5.99 miles

Program Name: Printmaking Activities

Number of classes: 30 (class meetings)
Enrollment data:

	Members	Nonmembers	Total
6 weeks	4 (17.3%)	19 (82.7%)	23 (100%)

Total number of sessions 30

Benefits

Direct Costs to Students
1) Tuition and fees
 4 members @ $31.00 = $124.00
 19 nonmembers @ $34.00 $646.00
2) Materials-costs estimate
 23 persons x $10.00 = $230.00
3) Travel Costs: for 126 visits
 6.98 miles x 23 participants = 160.54 x 5.5 trips = 882.97 miles @ 13.5¢
 per mile = $119.25 ÷ 1.6 persons per car = $74.50 x .95 absentee factor
 = $70.78
 Estimated total value of benefits $1,070.78

Costs

Costs to Art Institute:

Value of space: @ $9.41 times 30 sessions =	$ 282.30
Materials costs to Akron Art Institute: total	78.66
Operational costs:	
Administrative, utilities, security, janitorial, etc.: total	315.00
Estimated salaries for instructors	247.50
Estimated total costs to AAI	$ 923.46

Total estimated value of benefits	$1,070.78
Total estimated value of costs	923.46

Cost per person $40.15
Benefit per person 46.56
B/C ratio 1.159

Spatial Distribution of Students: Printmaking Activities

	ZIP Code	Distance in Miles
Half-session	44320	3.80
	44307	2.46
	44313	4.55
	44320	3.80
	44313	4.55
	44320	3.80
	44320	3.80
	N. Howard St.	2.00

$$\Sigma = 28.76 \text{ miles}$$
$$n = 8 \text{ ZIP Codes}$$
$$\bar{x} = 3.595 \text{ miles}$$

	ZIP Code	Distance in Miles
Full session	Ashwoòd Drive	2.65

$$\Sigma = 2.65 \text{ miles}$$
$$n = 1 \text{ ZIP Code}$$
$$\bar{x} = 2.65 \text{ miles}$$

Total

$$\Sigma = 31.41 \text{ miles}$$
$$n = 9 \text{ ZIP Codes}$$
$$\bar{x} = 3.49 \text{ miles}$$

Program Name: Ceramics

Number of classes per course: 9 or 18
Number of courses: 1
Enrollment data:

	Members	Nonmembers	Total
3 weeks	2 (14%)	12 (86%)	14 (100%)

Total number of sessions 22

Benefits

Direct costs to students
1) Tuition and fees
 3 week: 2 members @ $20.00 = $ 40.00
 12 nonmembers @ $22.00 = $264.00
2) Materials and costs other than fees
 3 weeks: $10.00 per person x 14 persons = $140.00
3) Travel costs: for 119.7 visits
 3 weeks: 6.18 miles x 9 sessions = 55.62 miles x 14 persons = 778.68 miles
 @ 13.5¢ per mile = $105.12 ÷ 1.6 persons per car = $65.70
4) Member-fee allocation: (25%) x 2 = $10.00
 Estimated total value of benefits $519.70

Costs

Costs to Art Institute
Value of Space @ $9.41 x 27 sessions =	$ 254.07
Materials costs to Akron Art Institute: total	47.88
Operational costs:	
Administrative, utilities, security, janitorial, etc.: total	299.25
Salary for instructor: total for courses	123.75
Estimated Total Costs to AAI	$ 724.95

Total estimated value of benefits	$ 519.70
Total estimated value of costs	724.95

Cost per person $51.78
Benefit per person 63.52
B/C ratio .717

Spatial Distribution of Students: Ceramics

	ZIP Code	Distance in Miles
3 weeks	44313	4.55
	44304	1.00
	N. Canton	16.00
	44303	3.03
	44320	3.80
	44303	3.03
	44304	1.00
	44302	1.52
	44313	4.55
	44303	3.03
	44307	2.46

Σ = 27.97 miles
n = 11 ZIP Codes
\bar{x} = 2.54 miles

	ZIP Code	Distance in Miles
6 weeks	44303	3.03
	44303	3.03

Σ = 6.06 miles
n = 2 ZIP Codes
\bar{x} = 3.03 miles

Total
Σ = 34.03 miles
n = 13 ZIP Codes
\bar{x} = 3.093 miles

Program Name: Jewelry

Number of classes per course:
 short term: 5
 long term: 10
Number of courses: 3 (each with five- and ten-week sessions)

Enrollment data:

	Members	Nonmembers	Total
5 weeks	17 (17%)	58 (58%)	75 (75%)
10 weeks	5 (5%)	18 (19%)	23 (24%)
Total	22 (22%)	76 (77%)	98 (99%)

Total number of sessions 15

Benefits

Direct Costs to Students
1) Tuition and Fees
 5 week: 17 members @ $16.00 = $ 272.00
 58 nonmembers @ $17.50 = $1,015.00
 10 week: 5 members @ $32.00 = $ 160.00
 18 nonmembers @ $35.00 = $ 630.00
2) Materials and costs other than fees (estimated—each student proceeds at own rate)
 short term: $10.00 per person x 75 persons = $750.00
 long term: $20.00 per person x 23 persons = $460.00
3) Travel costs: for 605 visits
 a) 5 weeks: 75 persons @ 15.5 miles per trip for 5 trips = 5,812.5 miles
 @ 13.5¢ per mile = $784.69 ÷ 1.6 persons per car x .95
 absentee factor = $465.91
 b) 10 weeks: 23 persons @ 11.67 miles per trip for 10 trips = 2.684.56 miles
 @ 13.5¢ per mile = $362.41 ÷ 1.6 persons per car = $226.51
 Estimated total value of benefits $3,979.42

Costs

Costs to Art Institute:

Value of space @ $9.41 x 15 sessions	$ 141.15
Materials costs to Akron Art Institute: total	335.16
Operational costs	
Administrative, utilities, security, janitorial, etc.: total	1,512.50
Salaries for instructors: total for courses	1,399.50
Estimated total costs to AAI	$3,388.31

Total estimated value of benefits	$3,979.42
Total estimated value of costs	3,388.31

Cost per person $34.57
Benefit per person 40.61
B/C ratio 1.17

Spatial Distribution of Students: Jewelry

	ZIP Code	Distance in Miles
Half-session	44302	1.52
	44223	7.00

44313	4.55
44303	3.03
44321	4.55
44303	3.03
44320	3.80
44303	3.03
44313	4.55
44305	3.41
44313	4.55
44313	4.55
44221	7.00
44313	4.55
44302	1.52
44313	4.55
44278	6.00
44302	1.52
44278	6.00
44240	15.00
44313	4.55
44313	4.55
44240	15.00
44301	2.65
44310	3.41
44240	15.00
44709	20.00
44313	4.55

Σ = 163.420 miles
n = 28 ZIP Codes
\bar{x} = 5.836 miles

	ZIP Code	Distance in Miles
Full session	Cleveland Heights	25.00
	44320	3.80
	44320	3.80
	44260	9.00
	44307	2.46
	44313	4.55
	44240	15.00
	44313	4.55
	44312	9.00
	44320	3.80

Σ = 77.54 miles
n = 10 ZIP Codes
\bar{x} = 7.75 miles

Total
Σ = 240.96 miles
n = 38 ZIP Codes
\bar{x} = 6.34 miles

Method For Allocating Education Costs, July 1971–June 1972

The allocation of costs for educational purposes was derived from costs incurred in the fiscal year beginning July 1, 1971, and ending June 30, 1972. The areas covered in expenditures allocation are salaries, operations expenditures, the value of equipment, and assessments of the value of space.

The salaries expenditures allocated to educational costs are of two types: a 100 percent allocation and an assessed percentage of salary applicable to education. The salaries that were assessed were based on interviews with staff members pertaining to their functioning within the institute's overall operations. The assessment of salaries includes a 100 percent allocation of the director of education's salary and a 100 percent allocation of the part-time instructors' salaries. There is no allocation of the assistant director of education's salary since he did not begin until after June 30, 1972.

Operations expenditures were based on two factors: total class materials and supplies costs absorbed by the Akron Art Institute, and total general overhead costs assessed to the education function of the Art Institute. The total class materials and supplies cost ($2,278.04) was obtained from the institute's business records. However, in its bookkeeping system, there is no delineation as to which course a particular supply expense is to be charged to; therefore, the supplies cost is an aggregate figure. The total overhead figure ($38,573.62) was obtained by adding the audited cost figures for the following areas: office supplies, postage, telephone, maintenance, heat and steam, electricity, gas and water, insurance, part-time security, and part-time receptionists. The cumulative total ($38,573.62) was divided by one-third, based on the assumption that the Akron Art Institute's functions are as follows: one-third educational, one-third exhibition, and one-third development and general administration of day-to-day operations. The final assessment of overhead was $12,729.29. Including the allocated staff salary cost of $39,139.51, one gains a total annual overhead and salary cost of $51,868.80. Courses are allocated a proportion of that cost for educational visits per year (20,687), or a cost of $2.50 per visit.

The total replacement value of the fixed equipment used for educational functions was arrived at by an inventory check, by checking equipment catalogs for prices, and through interviews with education staff persons, and instructors. The total replacement value of fixed equipment ($26,995.72) was divided by ten. This is representative of an average life expectancy of ten years for the fixed equipment; the final derived figure of $2,699.51 represents an annual consumption cost of the fixed equipment.

The assessed value of classroom space was determined by multiplying the total square footage of the third floor of the Art Institute's building by $1.00 per square foot. The factor $1.00 per square foot is representative of the fair market value of commercial loft space. The square footage assessed to the third floor was 7,980 square feet; the entire third floor (57 x 140) is

available exclusively for education usage, including stairwells and storage areas. The total space allocation of $7,980 was divided by 4 to gain a summer-space value of $1,995. The total number of education sessions for all summer-class programs equaled 212 separate class meetings. Dividing $1,995 by 212 equals a space cost per session of $9.41. The assessed value of extension-class space was based on the factor $6.50 per square foot, per year; this is representative of the fair market value of good location property for commercial use. The initial factor of $6.50 per square foot per year is multiplied by a hypothetical 25 x 25 classroom (625 square feet), equaling $4,062.50. Multiplying 23 working days per month by 12 months equals 276 days. Per-day cost equals $14.72. For extention space, the charge is estimated at $14.72 per session. The assessed value of auditorium space was based on 2,091 square feet (the basement area), multiplied by $2.50 per square foot, per year. The derived figure was $5,227.00.

By adding each of these groups of calculations, the total assessed cost of the educational function of the Art Institute for the fiscal year 1971–72 is $70,930.85.

Estimated Replacement Value of Fixed Equipment, by Educational Purpose

Purpose	Value
General	
36 chairs—replacement cost, taken from University of Akron catalog, is $25.85 for each	$ 930.60
36 chairs—replacement cost is one-half of cost of the chairs, or $12.92 each	465.12
4 8-foot work tables—replacement cost, from University of Akron catalog, is $140.00 for each	560.00
1 etching press—replacement value, from equipment catalog	3,000.00
Jewelry	
The replacement value assessed was arrived at through inventory analysis, checking jewelry-equipment catalogs, and consultations. This figure is representative of what is involved in equipping a new jewelry shop to a modest degree.	3,000.00
Print shop	
2 printing presses, several stones, and assorted necessary hand tools—fair market replacement value	6,000.00
Photography studio	
3 enlargers, assorted supporting equipment tables, booths, etc.— total replacement value	3,000.00
Video-tape equipment shop	
This replacement total includes: a monitor, a study recording deck, an editing deck, a portable camera with recorder, a studio camera, and assorted supporting equipment; it is a fair market replacement cost.	9,000.00

Painting and drawing
 21 easels (replacement value of $21.00 each) 315.00
 assorted drawing boards 15.00
Audio-visual equipment
 2 slide projectors (replacement value of $280.00 each) 560.00
 2 extra lenses (at $150.00 each) 300.00
 1 16mm projector 550.00
 1 8mm projector 200.00
 6 super 8 cameras at $75.00 each 600.00
 Total replacement value $26,995.72

Chapter Seven

EXHIBITIONS AT THE MUSEUM

Each year, the Akron Art Institute plans and conducts a series of exhibitions covering a wide range of artistic subjects. Choice of exhibitions is determined by the director, with the assistance of the curator, and is limited by gallery space, budget size, the availability of works of art from other museums, as well as the availability of traveling shows for rental by the museum.

THE YEAR'S EXHIBITS: WHAT WAS OFFERED

During the fiscal year 1971–72 the museum presented seven major multiple exhibitions to an estimated 21,500 viewers. From the standpoint of popularity, the "Celebrate Ohio" and Gary Bower exhibits, in combination, attracted the largest number of viewers (see Table 7.1). Least popular among the exhibits was the combination of the "Drawing Invitational," "Richardson Sculpture," and "Ceramics," presented in June and July of 1972.

Both in its collecting and in its exhibitions, the Akron Art Institute had made a firm commitment to contemporary art. Illustratively, the education director, Donald Harvey, stated that if the direction of the museum changed, he would "quit." The direction of the museum was an issue not without some conflict as various board members disagreed with Director Orrel Thompson's planned move to create a nationally recognized contemporary art museum. Nonetheless, the direction was explicit, and obvious in the museum's choices of its few purchases, and in the views and aspirations expressed by the museum's staff members, just as it had been in the choice of educational-program content.

Exhibitions were varied, and there was never only one exhibit planned for the galleries at any one time (usually there were four), but the contemporary direction was strongly present, dominating museum programming.

TABLE 7.1

Multiple Exhibitions Presented at the Akron Art Institute during the Fiscal Year July 1971-June 1972

Name of Multiple Exhibition	Dates		Total Museum Attendance Figures[a]	Estimated Exhibition = Only Attendance	Mean Daily Computed Attendance[b]
	From	To			
1. Constructivist Tendencies	7-17-71	8-22-71	4,797	3,167	85.6
2. Celebrate Ohio, Gary Bower	9-27-71	11-07-71	6,313	4,287	99.7
3. Twentieth Century Sculpture, O'Neil Collection, Mary Ann Scherr Retrospective	11-20-71	1-02-72	4,720	3,040	72.4
4. Four Artists	1-16-72	2-20-72	4,984	3,241	87.6
5. Alan Sonfist, Warhol Graphics, Haitian Serigraphs	3-04-72	4-16-72	5,656	3,764	85.6
6. FTD Collection, Print Invitational	4-29-72	6-04-72	4,099	2,657	71.8
7. Drawing Invitational, Richardson Sculpture, Ceramics	6-18-72	7-31-72	4,243	1,352	27.6
Total computed attendance	—	—	34,812	21,408	—

[a]Total visitation figures also include people who came to the museum for classes, concerts, lectures, etc. To use these figures for the subsequent cost-benefit analysis could create a serious double-counting problem. Figures refer to the same time periods as exhibitions, not the entire year.
[b]During exhibitions.
Source: Computed from Akron Art Institute attendance figures.

Starting with a late-summer show by Alice Weston, in tandem with a show entitled "Constructivist Tendencies," a series of pieces from the collection of George Rickey, the museum moved into the fall season with "Celebrate Ohio." On September 27, the Akron Art Institute opened its fiftieth anniversary year with a major exhibition of 11 Ohio-born artists, covering a 50-year look at art in America. The 11 artists included George Bellows, Isabel Bishop, Charles Biederman, Charles Burchfield, Jim Dine, Robert Henri, Philip Johnson, Ronald Kitaj, John Kock, Robert Mallary, and Tom Wesselmann. It was one of the largest collections of art ever assembled at the institute.

The summer show proved moderately popular, with exhibition-only attendance of nearly 3,200 persons, but the "Celebrate Ohio" show, which consumed most of the gallery space, drew about 4,300 visitors. Planned around the museum's normal five-week exhibition period, this latter show proved to be the most popular of the exhibition year.

Opening in October and continuing through Christmas, the "Odyssey Bazaar" was a collection of junk items, jewels, art objects, and clothes from the Far East, the Near East, and Africa, offered for sale as special Christmas gifts.

On November 20, a show on twentieth century sculpture opened along with an exhibition of the work of Mary Ann Scherr, a popular local artist, and an exhibition of the collection of Mr. and Mrs. Rory O'Neil. The "Twentieth Century Sculpture" exhibition, organized in cooperation with Marlborough Gallery of New York, surveyed many of the twentieth century sculptors the gallery represents. A few of the artists included in this exhibition were Lipchitz, Lipton, Moore, Pepper, Rosati, and Hepworth.

The "Mary Ann Scherr Retrospective" was organized to exhibit the metal works of Scherr. The exhibition included both gold and silver jewelry and metal work. Many of her finest works, created during her career as artist, craftsman, and designer, were brought together for this retrospective exhibition.

The "O'Neil Collection" included paintings, drawings, sculpture, and prints by such contemporary artists as Albers, Motherwell, Shields, Trova, Rickey, Bowers, Diao, and Clarke.

In combination, these three exhibits attracted about 3,000 visitors. Parenthetically, it was not possible to divide the audience from the standpoint of which exhibit was the one attracting them to the museum. In most cases, it would have been the most publicized one, the sculpture exhibit in this case, but given that the museum is small, each visitor to the museum would view all of the exhibits, even though a taste and preference for one might have originally brought the visitor to the museum.

In January the "Four Artists" show opened. This exhibition, which was really four separate one-man shows, represented the institute's first organized look at California artists. The intent was to look at four talented

individuals noted for innovative use of materials and techniques. The following is a description of the works of the four.

Peter Alexander works with case-polyester resins that explore the visual transparency and luminosity inherent in these materials. His low-relief bars are installed in vertical series on the walls, creating a unique sculpture.

Billy Al Bengston, a prominent member of the Pop movement of the 1960s, is noted for his works that incorporate emblems and images from the hot-rod and motorcycle world. Included in this exhibit were new drawings on metal, and paintings that still make use of the emblem.

Edward Moses is considered the most mysterious artist of the four. His works are considered calligraphic and, according to observers, "may allude to magical signs and imagery." His exhibited works were painted, sewn, weathered and resin-soaked canvases.

Edward Ruscha's works evoke an almost Dada-like, surrealist image, which also casts him close to the Pop aesthetic of the 1960s. Dealing with popular imagery and insights into typography, he combines words and objects in visually sophisticated forms. Included in this exhibit was a series of "radio paintings," gunpowder drawings, prints, and books.

Combined with the work of these four artists, the museum also exhibited the work of Robert Horvitz, along with some prints from its own permanent collection.

Horvitz, a young artist originally from Akron and a 1969 graduate of Yale, made his debut in 1972. This exhibit featured highly personalized pen drawings and was held concurrently with a similar exhibit at the Institute of Contemporary Art, in Boston. The "Prints From the Permanent Collection" featured a selection of newly framed prints from the collection and included works by Robert Indiana, Alan Shields, David Diao, Brice Marden, Alan Cote, and others. "Four Artists" and the above shows attracted some 3,200 visitors.

The early March shows featured Andy Warhol's graphics, "Alan Sonfist Environments," works by Donald Dedic and Dennis Adams, Shula Salem's banners, and a collection of Haitian graphics. In excess of 3,700 visitors were attracted to these exhibitions.

Alan Sonfist, a young artist (born in 1946), uses physical, chemical, and biological processes to create his works. In his art he works with crystals, microorganisms, heat, aging, erosion, and gases.

"Andy Warhol Graphics" looked at the print history of Andy Warhol—"Marilyn," the flower series, tomato soup cans, cow wallpaper—all the vivid images that made Warhol the leader of the Pop-image artists.

Donald Dedic and Dennis Adams, two young Philadelphia artists, presented an exhibition entitled "Plants and Animals." The title was taken from the sources from which their work is drawn. The works in the exhibition included drawings, paintings, and constructions.

Salem was born and raised in Israel and educated at Balfour College in

Tel Aviv and at the Israeli Music Academy. She continually experiments in painting, jewelry, and sculpture. The banner paintings provide her the opportunity to experiment on a large scale in the manner of contemporary tapestries.

The Haitian graphics collection was the first American showing of a group of hand silk-screened graphics from Haiti's top artists. Under the auspices of the Haitian Center of Art, the artists of Haiti work with the silk-screen process. In this first collection, all of the prints were controlled and numbered.

Late April brought a show developed by the Florists' Transworld Delivery (FTD) Association, which had built a collection documenting the importance of flowers in the world of contemporary art, as a reflection of their importance in life. There exists a common misconception that contemporary art has turned its back on human sentiment and popular subjects, when in fact many of the younger artists use such themes. Included in the exhibit were works by Tom Wesselmann, Martial Raysse, Malcolm Morley, Ralph Goings, Alex Katz, Paul Van Hoeydonck, and Ellen Tanyon. The FTD show appeared along with exhibitions of four other artists and a "Print Invitational."

The "Print Invitational" was the first in a new series of invitational exhibitions organized by the Art Institute, surveying the talents of numerous area and regional artists in printmaking, drawing, painting, and sculpture. This print show featured two works each by the following printmakers: Jim Lenavitt, Donald Harvey, Linda Lyke, Ian Short, Jody Klein, Julian Stanczak, Dennis Kleidon, John Sokol, Carl Cassill, and Ralph Woehrman.

Another exhibit, the etchings of Sol LeWitt, had been presented at the Museum of Modern Art in New York. They included three portfolios containing six individual prints, published jointly by the Wadsworth Publishing Company, Atheneum, and the Parasol Press (New York). All works were for sale and could be purchased at the museum's shop. In addition to this exhibition, the etchings were later shown in Philadelphia and San Francisco.

Further, there was an exhibit of photographs by George Sumerak, then a student at the Cleveland Institute of Art. Sumerak exhibited images from his experiences as a young photographer, printmaker, and filmmaker.

Also, "Ceramic Sculpture," works by Jim Stahl, a young Akron artist, featured three-dimensional wall images of his generation; and photographs by Tom Simon were exhibited. Simon was then a photography student at Akron University; his camera reveals the worker in his own surroundings. This was a first exhibition for this young artist. These shows ran until June and attracted some 2,650 viewers.

The combined shows of June and July brought only 1,352 viewers to the museum's galleries. These final shows of the fiscal year ran over into the next fiscal year and featured the sculpture of Sam Richardson. Richardson, a

California sculptor, works in acrylics and molded plastics. His works involve images of the topography of the earth—mountains, icebergs, a slice of a hillside, a mountain pool. At the same time, the institute sponsored a drawing invitational.

In addition, the Art Institute, in its continuing program of exhibiting works by area and regional artists, installed an invitational exhibition of regional and area artists. The exhibition included one or two works by each artist and ranged over various stylistic considerations and media. The following artists were included in the exhibition: Robert Culley, Craig Lucas, Robert Morrow, Joseph O'Sickey, William Quinn, Bill Schock, Hazel Janicki Schock, Douglas Unger, Charlotte Hanten, Dennis Myers, Woody Nash, Harry Wheeler, Chris de Boshnick, Leroy Flint, and Ron Taylor.

The "Regional Crafts Invitational" featured ceramics, fabrics, jewelry, and other objects by area and regional craftsmen. Highlighting private collections, the museum also exhibited the Pengilly collection.

ATTENDANCE PATTERNS

When one looks at the museum's attendance patterns, it is obvious that daily attendance is small. Mean daily attendance does not exceed 100 persons, and for some exhibitions is as low as slightly over 27, hardly indicative of an important community event. The most frequently attended exhibitions did not far outstrip the modest figures for most other exhibits.

Shows which drew the greatest numbers were not notable in their seasonality. Shows in the late spring and summer drew the lowest attendance, but the sculpture show around Thanksgiving was also rather poorly attended. In general, one would have to argue that visits to the museum during the year were a modest number. Parenthetically, exhibition attendance for previous years had run higher, with as many as 36,000 persons for some recent years.

The range of ages of museum visitors was from eight to 70. The modal age was 20 years. With a mean age of 27.9 years and a standard deviation of 12.8 years, the distribution of museum visitors was heavily skewed. The modal range clustered in the range of 16 to 21 years, with a peak at 20, but a weak modal effect was also apparent in a smaller, flatter cluster of from 25 to 45 years, peaking at about 30.

The time which visitors spent in the museum viewing its exhibitions varied widely from a mere ten minutes up to two hours. No obvious mode appears, but there is a clustering between 10 and 20 minutes. Mean time of 36.3 minutes is drawn higher by those few who stayed up to two hours. The standard deviation was 27.1 minutes, indicating, again, a skewed distribution—in this case, of time spent in the galleries. What appears to

have happened is that either the visit was frankly casual, or visitors who came sampled the exhibition and left without finding it to their taste, or the exhibition captured their interest and they stayed long enough to absorb some of it.

If an average museum visitor spends from 10 to 20 minutes in traveling both to and from the museum, then 20 minutes in the gallery hardly seems profitable. Few people would regularly expend that kind of time and money for such a brief visit. Perhaps no single fact so strongly suggests the museum's lack of adequate gallery space or, perhaps, its failure to meet the demands of exhibition visitors, or indeed both problems. The relationship between travel time and gallery time is critical. Arbitrarily, one would hope to have a minimum ratio of at least four to one, that is, an hour of viewing for each 15 minutes of travel time. The higher the ratio, the more satisfactory is the exhibit. A clear measure of consumer satisfaction, this ratio should be regularly examined.

EXHIBITING ART: HOW SHOULD IT BE DONE?

Problems of exhibiting works of art have received considerable attention. An exhibit can be defined as a display of art plus an interpretation. Wittlin describes three types of exhibits based on interpretation. The first is an "underinterpretive" exhibit, in which each object is, for example, crowded on a shelf, a fact which may contribute to a reduction of uncertainty, that is, assist the viewer in understanding the art because of the total impression of the cluster.

The second type is the "misinterpretive" exhibit. This is an exhibit in which internal architecture or some other distraction diverts attention from the actual art objects and may give the viewer a faulty impression. The final type of exhibit Wittlin describes is the "interpretive" exhibit, in which an emphasis is placed on the flow of communication among the greatest number of people.[1] Exhibitions for the year 1971–72 at the Akron museum could have been classified as interpretive; that is, there was no evidence of crowding in any of the hangings to concentrate focus on a particular idea, and certainly, internal architecture as interference was absent.

G. Ellis Burcaw classifies exhibits as either systematic or ecological. Systematic exhibits consist of objects organized according to their similarity and their "genetic" relationship to each other; for instance, French impressionist paintings exhibited in the same gallery. Ecological organization requires that the objects be in an areal and living relationship to each other; for instance, paintings, drawings, and sculpture produced in the same milieu, representing a response to similar forces, but representing different media.[2]

Special appreciation is owed David Falconeri for his part in developing this section.

Using Burcaw's notions, the exhibitions at the Akron museum may be described as systematic.

Exhibits may also be classed as aesthetic—for enjoyment; or as factual—to convey information; or as conceptual—to present ideas. In short, there are many ways to exhibit art, and the method chosen may make a great deal of difference to the success of the exhibit as viewed by various art publics. Akron's tendencies appear more toward the aesthetic than toward the factual or conceptual, if by this notion is meant heavy amounts of educational information and materials, along with the art, that are more of informational than of artistic assistance.

It might be proper to pause here for a moment and assimilate what has been mentioned so far with regard to the ways in which exhibitions can be staged. Figure 7.1 provides a visual impression of the exhibition characteristics noted thus far. Such dimensions of exhibition represent a conceptual space in which the various categories indicated can be seen as not mutually exclusive, but as continuous. By that is meant that as an exhibit moves from one dimension to another—for example, from aesthetic to conceptual to factual—such distinctions need not be seen as discrete categories, but can be seen as a continuous schema on a kind of numeric scale, say, from one to ten. Similarly, moving from the ecological to the systematic may be seen as a

FIGURE 7.1

Dimensions of Exhibition

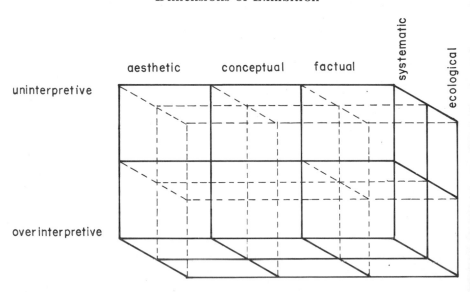

Sources: Adapted from Alma Wittlin, *Museums: In Search of a Usable Future* (Cambridge and London, MIT Press, 1970), and Ellis Burcaw, *Introduction to Museum Work* (Nashville: American Association for State and Local History, 1976).

continuous relationship, one in which exhibitions may be taken to be highly ecological, then less so, and then toward relatively more systematic in organization. The concept of interpretation suggested by the figure finds moving from uninterpretive to overinterpretive more useful than Wittlin's three-way concept; this two-way schema is similar to the concept she was leading to.

While no mechanism was developed to detail the conception of Figure 7.1 within the limits of this study, there is little doubt that scaling techniques could be used to gain impressions, from both expert panels and the ordinary visitors to the museum, that would permit museum administrators to have a better notion of what methods of exhibition were most appealing to, and most effective for, particular art publics of the museum.

The question of presentation may be as important as the question of what art is selected to exhibit, and that is the significance of developing a systematic approach to exhibition presentation. This is particularly true when one is dealing with an uninformed art public; tastes are not well formed, preferences not well developed—thus presentation may, for these people, be even more significant than the content of the exhibition, that is, the art itself. Whether one accepts this argument or not, it is still urgent to gain visitors' impressions of presentation and to use that knowledge to better serve art publics.

Exhibits have the basic problem of how to capture attention long enough to give the viewer the artistic message. Attention ought not to be enforced, or reinforced, by extraneous rewards like grades or credits, or by potential success in a competitive game. The experience of looking at the exhibit must, in theory, be reward enough. Illustratively, one is never completely sure that a busload of school children can truly enjoy a trip to the gallery, that is, purely in the sense of enjoying the art. One need not belabor the point, but observation suggests that while young children may quickly move to an interested examination of the art itself, teenagers often bring their strong self-consciousness with them to the gallery, and by thinking of themselves as viewers of the art, instead of simply thinking of the art, they may lose some aesthetic enjoyment. In any event, the theory behind capturing attention is to provide an opportunity for viewers to identify with a topic. This is usually a great deal easier to do with young children than with young or older adults, since children can readily identify with things.

A measure of complexity should also be added to the exhibit, providing a challenge for the observer. Quantity of objects in an exhibit is also an important consideration, but "quantity cannot be considered strictly by itself. A greater quantity of items presented in a structured way is a lesser information load than fewer items unstructured. One has only to think of the learning of nonsense syllables as compared with the learning of words or sentences."[3] Becoming skeptical for a moment, it might be suggested that complexity may not be enjoyable for some people who come to museums. If the obviousness and simplicity of their normal entertainments pass over into

their tastes in art, then even the slightest bit of complexity might elude them. Another view of quantity suggests that it may be better to show fewer objects in a number of contexts than many objects showing a narrow focus. This enables the viewer to conceive a subject from a number of different angles, thereby appealing to a diversity of possible visitors.

There is no one way to exhibit art, but, in addition to the concerns expressed above, it is generally agreed that the so-called good exhibit should also meet a number of other criteria. Arrangement should provide for the safety of the objects without sacrificing visibility. Visibility is one of the more important aspects; exhibits should be well lighted. Art objects, especially paintings, and sculpture can be extremely sensitive to light. By illuminating the art in a certain way, certain colors or features can be accented. Often, natural lighting produces a harsh glare. It is very important, therefore, that the correct lighting be used with each exhibit.[4]

Background distractions can be detrimental to the effect desired. The exhibit itself must catch the eye. In this respect, the art museum is at a bit of a disadvantage because it may be difficult for a painting, by itself, to attract a visitor. If it is a famous piece by a well-known artist, attraction is not a problem. The name Picasso on a painting will stop people automatically, if only for its fame. A lesser-known art object, however, must be skillfully exhibited to attract attention to it. Where, and with what other artifacts, an art object is exhibited is crucial to this consideration.

The good exhibit must not only attract, but should also hold attention. In order to convey the desired message, a certain minimum amount of time is required. The ability of the exhibit to entertain, educate, arouse emotion, and/or otherwise stimulate will enhance the possibility that the viewer will spend profitable time at the exhibit. At another level, as Kenneth Hudson reveals:

> It is a debatable point as to which of two kinds of museum the visitor finds most exhausting and frustrating—the small, crowded museum, in which he has to do very little walking but a great deal of peering and mental sorting; and the large, orderly museum in which everything is clear and regimented, but where room passes into room in an apparently never ending sequence and where one's brain, spirit and feet try to meet an impossible challenge. . . . The remarkable thing about professional museum visitors is their stamina. They never seem to tire. From about the 1820's onwards they begin to criticize the way the collection is arranged, or labelled, or lit, the inconvenience of the opening hours, the behavior of the attendants. What is very rare is any confession of physical weakness.[5]

In sum, how about a few more comfortable chairs?

Exhibitions are often unimaginative, poorly done. As James Gardner and Caroline Heller argue:

> There is a kind of sardonic justice in the fact that in most art treasures and permanent historical or scientific collections, the things that are really

worth looking at for their own sake, are displayed in a way that would not stand comparison with the temporary stand of a commerical firm at an average-size trade fair. With some distinguished exceptions museums and art galleries are outstanding for the shabby dreariness of their display. The most beautiful or interesting exhibits are as good as buried in the average setting of crowded showcases, yellowing labels, echoing marble galleries, dim overhead lighting from dusty skylights and a building whose very entrance frightens people away. This is not just a cause of distress to designers but a tragedy for the general public to whom these things are lost. Presentation is as relevant to a piece of sculpture as it is to shoes in a shop window, more so in fact: people need shoes, but they have no need to look at Rodin.[6]

They note further:

The important thing is *aim*. Objects for specialist reference will need to be accessible and in reasonable sequence. Objects for public exhibition will have to be given special treatment to attract interest and perhaps explain their importance. People can feel uncomfortable and inferior faced with well-displayed exhibits without a context. Interest is related to the objects' period, place, use or special craftsmanship and the public wants a lead as to how to think about them. A good museum display should be able to do this in much the same way as a good introduction establishes the atmosphere of a book or a good lecture on musical appreciation can help people to listen properly.[7]

Burcaw presents an interesting view of museum exhibits.[8] He equates a series of exhibits to a good novel. The exhibits must have structure, drama, suspense, a theme, and a climax, as well as some relief and humor, and whatever else a good storyteller might use. A museum with exhibits that use these elements can hardly help being a valuable experience to a visitor. Obviously, the small or middle-sized museum has less opportunity to be like a good novel; with problems created by episodic displays, incomplete fragments, small size, and other elements, such museums should consider themselves more like a good short story.

All told, an exhibit should be utilized as an effective means of communication between art and the viewer, keeping in mind that human beings are both the source and the target of the process. An effective exhibit should generate a chain reaction—output-input-output of knowledge.[9]

Perhaps one of the more difficult aspects of an exhibit is the evaluation of its success. Beyond the time ratio indicated earlier, it is problematic to figure out how much one has gained from an exhibit, the extent to which a certain exhibit has stimulated a visitor.

Parenthetically, questions of quality versus quantity of viewers can be dealt with at least indirectly. There are quality dimensions of the art itself to consider, that is, good art or better art. But given that the exhibition is museum-quality art, then, in general, the more visitors who are attracted to

the exhibit, the more successful it is likely to be. This does not take into account the question of strong as opposed to weak stimulation of viewers, but if the added dimension of time spent at the exhibition is clearly measured, one can at least tentatively say that on an ordinal scale, one exhibit is more successful than another if the number of viewers is greater, if more time per viewer is spent at the exhibit, and if the exhibitions are of similar size and complexity.

At the present time, one of the most useful techniques for evaluation is to simply observe visitors going from exhibit to exhibit. It will soon become obvious which exhibits are getting the most attention. If it is discovered that a particular display is being passed by, the curator may wish to discover whether there is a problem. According to the criteria noted above, this exhibit would be a failure. Here again, however sheer numbers may not always be fairly indicative of the worth of a particular exhibit, if it is compared to a very dissimilar exhibit. In the Vatican Museum, for instance, literally thousands of visitors spend considerable time in the Sistine Chapel, but probably not because of Michelangelo's arrangement of paintings. Instead, they more likely spend time there because of the novelty of the chapel. Michelangelo could have arranged these frescos in many ways, and thousands would still flock to the Sistine Chapel and spend little or no time looking at the rest of the very well arranged exhibits in the museum, of which there are many. For most art museum visitors, there is an optimum amount of time that viewers will spend in a museum in one visit, no matter how good the exhibits are. Therefore, many factors must be considered in an evaluation of an exhibit. A certain amount of weighing the novelty of the art and fame of the artist against numbers of viewers and time spent in front of an exhibit must be done, however.

In candor, one would have to argue that the rather sparse and uninformative exhibitions at the Akron museum for the period in question probably failed from the standpoint of stimulating many viewers. But the alternative may be to educate the viewer through exhibition blurbs, special decor, or handouts written by either eager curators or dreary academics. Does one exhibit art in its bare essentials or openly provide insights into the art for the viewer? The Akron museum seems to be following the notion that most anything except the art itself interferes with the art. Whether this is appropriate is open to question, but in a small museum it would seem to be a poor choice not to offer a comfortable gallery with ample material to assist the viewer. By such means, gallery time per visitor would likely increase; visitors would view the art not just read the labels.

AN EXHIBITION PREVIEW: VISITORS TO THE MUSEUM

Prior to each exhibition opening, there is an exhibition preview offered to members of the museum and their guests. One such members' preview was

analyzed in detail to gain a deeper picture of the museum's, varied art publics. The preview chosen for analysis was the one held before the opening of the very popular Whitney quilt show in February of 1973, an exhibition which drew over 8,000 visitors, Aside from the popularity of this show, the preview provided a good opportunity to have at one location, at one time, the various art publics who make up the museum's membership, and other regular consumers of museum shows. One obvious limit to the analysis is that school children are not represented; nor are many art students from high schools and universities. Otherwise, it is a good mix.

The exhibition involved, entitled "Abstract Design in American Quilts," was held at the Akron Art Institute from February 11, 1973 to March 18, 1973. The members' preview (opening night) was held Saturday, February 10. The exhibition of quilts was originally to have been titled "The Whitney Quilt Show," but was changed when the exhibition was expanded to include other collections. The exhibit was originally held at the Whitney Museum in New York and toured Europe for a year, with the Akron Art Institute being the first museum to exhibit the quilts since their return to the United States. The exhibitions consisted of 42 quilts from the Joseph Holstein collection, being circulated by the Smithsonian Institution, 15 quilts from the Goodman Gallery of New York, and four collages and two sculptures by Joseph Cornell.

As noted, on the night before the opening of the exhibition to the general public, a members' preview was held. On this particular Saturday night, there were 270 persons in attendance, and 135 completed a survey questionnaire—92 of the respondents were members of the Art Institute and 43 were not; thus about 68 percent were members while 32 percent were not.

How frequently do people attend openings? It would appear that the majority of members who did come to the opening night are not regular participants in openings of new exhibitions. Only about one-third of the members had attended half or more of the openings of the exhibitions presented during 1972 (see Table 7.2). Over one-third of the members present that evening had been to either one or none of the openings in 1972.

In accounting for this differing response, one may point out several possibilities. First, since art publics differ in taste, many who came to this opening might not be interested in art exhibited at other openings. An earlier opinion survey of members conducted for the museum had revealed that there was considerable diversity in member preferences, and that about three-quarters of the members had visited one or more exhibits in a 12-month period, (see the questionnaire in Appendix B at the end of the book). Second, many of these same members who did not regularly attend openings may have seen the previous exhibitions at other times than the opening-night previews. Third, the opening night is a social event as much as it is an art event, and reasons for coming are associated with preferences for various social events in the community. A fourth possibility, correlative to the third point, and that explains some aspects of the pattern of members' attendance

TABLE 7.2

Responses of Members and Nonmembers on the Number of Openings Attended in Calendar Year 1972 (number and percent of respondents)

Membership Status	Number of Openings Attended in 1972										Total Respondents
	0	1	2	3	4	5	6	7	8	10*	
Member	18 (13.3)	14 (10.4)	9 (6.7)	11 (8.1)	9 (6.7)	6 (4.4)	7 (5.2)	7 (5.2)	9 (6.7)	2 (1.5)	92 (68.1)
Nonmember	18 (13.3)	8 (5.9)	6 (4.4)	6 (4.4)	1 (0.7)	0 (0.0)	0 (0.0)	2 (1.5)	2 (1.5)	0 (0.0)	43 (31.9)
Column total	36 (26.7)	22 (16.3)	15 (11.1)	17 (12.6)	10 (7.4)	6 (4.4)	7 (5.2)	9 (6.7)	11 (8.1)	2 (1.5)	135 (100.0)

*The number of openings attended in calendar year 1972 goes from eight to ten, skipping nine. This is because no one attended nine openings during the period questioned.

Note: The numbers in parentheses are percentages of each group attending the indicated number of openings. Chi-square = 16.7; significance = 0.05.

Source: Compiled from sample data.

at openings, is simply that art is not a high-priority activity, even for many members.

While only a small number of the members regularly attend the openings, nonmenbers, as invited guests, are even less likely to regularly attend openings (See Table 7.2). Five of the nonmembers (about 20 percent of nonmembers surveyed) had been present at more than three openings during 1972. The nonmember group may be thought to be relatively large for an opening night, but the same people are not always present at other openings during the year. The question of membership as opposed to nonmembership in regard to the number of openings attended was subjected to correlation analysis. The correlation coefficient of .292 was significant, validating the statement that members attended more openings than non-members.

The Purpose of the Opening.

The opening-night preview is not a family affair. With the majority of couples who come, the absence of children is obvious. The opening-night preview is designed to provide an exclusive kind of thank-you to regular supporters of the Art Institute, an aspect similar to the department store's creating a private sale event for its better credit customers.

Previews suggest that many things which happen at art museums are not exclusively aesthetic events. Many activities that encourage groups of persons to attend particular functions are therefore extraaesthetic for either social, promotional, or educational purposes. The exhibition opening, in the minds of the institute's staff members, may well be educational or promotional; that is, it may be the showing of works of art to educate the public or to promote other aims of the museum. To the viewer it may be an aesthetic experience, but it is quite likely to be principally a social event.

Space and Time Patterns of Museum Use.

Residence location is important relative to the total number of openings attended. Economics posits that the facilities for producing goods or services are efficiently located either near a market or near a significant resource used in the production of those goods or services. Clearly, an art institute should be located near its market, since it is producing a mix of services for the community. Unfortunately, in large communities, museum location cannot be effectively optimal, particularly if there is only one site for exhibition. Banks have built branch banks; restaurant franchises are scattered widely over the urban landscape. Service stations, department stores, and public institutions like libraries, parks, and schools are distributed throughout the urban area. The Akron Art Institute, located as it is on a single site, loses some potential clientele. The opening-night response tends to bear this out. As the time of the trip that people must make to get to the museum

TABLE 7.3

Responses of Members and Nonmembers on the Number of Minutes Taken for the Trip to the Art Institute (number and percent of respondents)

Membership Status	Minutes per Trip							Total Respondents
	0-4	5-9	10-14	15-19	20-24	25-29	30 or more	
Member	1	8	28	27	13	14	1	92
	(0.7)	(5.9)	(20.7)	(20.0)	(9.6)	(10.4)	(0.7)	(68.1)
Nonmember	2	1	14	11	10	4	1	43
	(1.4)	(0.7)	(10.3)	(8.1)	(7.4)	(2.9)	(0.7)	(31.9)
Column total	3	9	42	38	23	18	2	135
	(2.1)	(6.6)	(31.0)	(28.1)	(17.0)	(13.3)	(1.4)	(100.0)

Note: Chi = square = 18.0; significance = 0.35.
Source: Compiled from sample data.

increases, the number of persons in attendance declines (see Table 7.3). Up to a total trip time of 19 minutes, there is no significant decline in attendance, but once the trip takes 30 minutes or more, the number of persons attending drops radically. Only 1.4 percent of those attending spent more than 30 minutes to get to the opening. Twenty minutes was about as time-consuming a trip as most people were willing to make.

What would be optimal from the standpoint of people in the city would probably be to have exhibitions wherever a definable interested population lives; that is, a policy of decentralization. Since different parts of the city are populated by different kinds of persons (in terms of income, education, tastes), exhibitions, like other institute programs, might, where feasible, be conducted at sites other than the central one. The optimal number of exhibits is related to the size and kind of exhibitions developed and the sites where works can be exhibited, as well as other traditional demand factors.

An interesting exception to the trip-time/opening-night relationship is the roughly 16 percent of the persons who came from some distance to most or all of the openings in 1972 (see Table 7.4). For this small group, distance appears to have had little effect. The person who much enjoys the opening night exhibitions will come from a considerable distance to enjoy them. Again, one must recall the differentiation in taste among the various art publics, as evidenced by the cost this 16 percent will incur to come. Fifteen of the 20 persons who made this longer trip (25 minutes or more) were members.

A further characteristic of this small group of regular attenders was the fact that, like the larger group, they came largely in groups of two. In spite of the length of the trip, no attempt was made to reduce the cost of the trip by adding more persons to the car.

But, for the larger group of persons attending the opening-night preview, the more time taken for the trip, the greater the number of persons who come together. Comparing trips of more than 20 minutes to trips of less than 20 minutes, roughly 28 percent of those making the shorter trip came in groups of four or more, while for those taking the longer trip, 43 percent of them came in groups of four or more. Similarly, people who came in larger groups tended to stay longer at the museum than did couples. Again, it is unclear as to whether we can attribute this difference to cost saving or to socializing. Likely, in the less lengthy trip, we might posit that the reason is more likely to be social than cost saving, and in the longer trip cost saving may be more significant.

Participants in the openings were asked how they had heard about the opening. Sixty-five percent of the total had heard through direct mail from the Art Institute, while only 3 percent had read about the opening in the local newspaper. Thirty-two percent had heard about the opening from friends or acquaintances. Among members, the vast majority had received the mail announcement, and among nonmembers, word of mouth (obviously from members) was the principal way of communicating the opening

TABLE 7.4

Responses on Numbers of Openings Attended in 1972, against the Number of Minutes for the Trip to the Art Institute (number and percent of respondents)

Number of Openings Attended in 1972	Minutes in Trip							Total Respondents
	0-4	5-9	10-14	15-19	20-24	25-29	30 or more	
0-3	2 (1.5)	5 (3.6)	24 (17.7)	30 (22.1)	18 (13.3)	10 (7.3)	1 (0.7)	90 (66.7)
4-6	1 (0.7)	1 (0.7)	10 (7.3)	5 (3.6)	2 (1.5)	4 (2.9)	0 (0.0)	23 (17.0)
7-10	0 (0.0)	3 (2.2)	8 (5.9)	3 (2.2)	3 (2.2)	4 (2.9)	1 (0.7)	22 (16.3)
Column total	3 (2.2)	9 (6.5)	42 (30.9)	38 (27.9)	23 (17.0)	18 (13.1)	2 (1.5)	135 (100.0)

Note: Chi-square = 174.5; significance = 0.11.
Source: Compiled from sample data.

of the quilt exhibit. Newspaper announcements were limited to a gazette notice; thus no judgment can be made with regard to the efficacy of advertising.

Competing Alternatives For Use of Time

Visitors were asked: "What would you be doing tonight if you had not come to the opening?" The answers were diverse, but a number of basic patterns were apparent. The alternative activities were classified under seven headings and by membership status for purposes of analysis. The fact that winter is not conducive to active adult leisure pursuits is evidenced by the small number of persons who might otherwise have been engaged in active physical recreation. None of the respondents in fact could be said to be engaged in rigorous outdoor sports, at least not in the evening (see Table 7.5).

Of those attending the quilt-exhibit opening, respondents indicated that they would have pursued a variety of activities that were essentially passive and personal as opposed to being either active or social. Only about 25 percent of the total number indicated that they would be pursuing an activity that was essentially social in nature, either at home or outside the home. Twenty-nine said that they would have gone out for the evening, while six indicated they would either entertain others at home or visit friends. The impression one gains from such data is that either the respondents are not so inclined to socialize (even given the fact that they made the effort to actually come out for the opening), or that only a modest amount of socializing is required or pursued.

As to particular choices, about 24 percent indicated that they would have stayed at home, engaging in a variety of pleasures including sex. Since it was a weekend night, 21 percent indicated they would have gone out to another entertainment. Nearly 18 percent specifically mentioned that they would have watched television, or listened to radio or stereo, in that order. Eleven percent would have read for pleasure or worked with hobbies, and small numbers would have "studied," or entertained others in their homes. There were no really significant differences among members as opposed to nonmembers. It is clear that those in attendance thought largely in terms of other amusements either at home or away as competing alternatives for the use of their leisure time, as opposed to other art-related activities. This is not to say that most persons would prefer the art event they attended over all other possible choices, or that other art events do not figure in their thinking. But those who came made the choice to do so for whatever the reasons may be, and if they were choosing between art events, they may have thought in terms of other art events occurring not just on that particular night, but within a time frame of several days. Therefore, the comparable choice may only be between doing something in the planned sense, whether it would have been this art event or another event, going out, entertaining, as

TABLE 7.5

Responses of Members and Nonmembers on the Type of Activity That Would Have Been Pursued If Respondent Had Not Attended the Opening
(number and percent of respondents)

Membership Status	TV Radio, Stereo	Reading or Working with hobbies	Working or Studying	Going Out	Entertaining	Just Staying Home	No Response	Total Respondents
			Activity Categories					
Member	18	11	4	18	4	23	14	92
	(13.2)	(8.1)	(2.9)	(13.3)	(3.0)	(17.0)	(10.4)	(68.1)
Nonmember	6	4	2	11	2	9	9	43
	(4.4)	(2.9)	(1.4)	(1.5)	(6.6)	(6.7)	(6.7)	(31.9)
Column total	24	15	6	29	6	32	23	135
	(17.6)	(11.0)	(4.3)	(21.4)	(4.5)	(23.6)	(17.1)	(100.0)

Note: Chi-square = 17.5; significance = 0.42.
Source: Compiled from sample data.

opposed to unplanned activities around the house. And even if we limit the comparison to planned activities, then the competition may be between several activities occurring on that evening and activities on subsequent evenings. Thus choosing art this time may be within a matrix of choice where going to a movie yesterday and entertaining tomorrow may both have been consciously selected from among alternative choices. Thus one night's choice is likely one of several related choices, not a single daily choice made in competition with only those activities available that one evening.

OTHER USE AND ATTENDANCE PATTERNS
AT THE AKRON ART INSTITUTE

Survey results concerning other patterns of use of the museum were gained through a brief headcount and survey conducted for a three-week period in the spring of 1972. The results of the survey indicated a number of interesting patterns of use of the institute by both large and small groups.

People who came alone or in small groups to the institute traveled an average distance of 10.69 miles (one way). Among 60 respondents, the largest number, 48, or 80 percent, came from 11 miles or less. Ten percent came from 11 to 20 miles, one way, and the other 10 percent came from 20 or more. These results suggest that some who visit the institute do not reside in Akron's own Summit County. But, as in the case of classes, the Art Institute appears to present exhibitions for a constituency that goes only slightly beyond Akron.

Other patterns of use included the fact that, unlike the opening, nonmembers predominate; 55 of the 60 respondents (90 percent) were not members of the Art Institute. Visitors were equally divided among males and females. The age distribution of visitors suggests the diversity of user populations, with a high proportion of visitors being young people under 20 (25 percent), nearly 24 percent being between ages 20 and 25, about 16 percent between the ages of 26 and 30, about 33 percent between ages 31 and 50, and the rest above 50 years of age. Such an age distribution suggests that the visitors to the museum represent an age distribution similar to, but somewhat younger than, the national age distribution. Similar to Akron's experience, the findings of the American Association of Museums, in a national sample of museums, indicated that the young represent the vast majority of visitors. Fully 54 percent of museum visitors were 23 years old or less.

Sixty percent of the respondents indicated that they came to the Akron Art Institute by car, while 10 percent walked, and the remaining 30 percent came by bus and by cab.

Most of the 60 respondents came either by themselves (23 of the 60) or with one other person (25 of 60). A few of the visitors came in groups of three, and the remaining came in groups of four or five.

As to the reasons people came downtown, over one-third came specifi-

cally to visit the Akron Institute. Fifteen percent came as a result of an assignment connected with a class at Akron University. The other visitors who came did not do so specifically to visit the institute, but for shopping, work, or business. It is clear that about half of the visits come from those visitors specifically interested in visiting the institute, or who come becuase of an assignment from a university class.

In total, there were nine large groups that toured the museum during the survey period, numbering nearly 400 persons. The number of large-group visits obviously accounts for a large proportion of visits to the institute. Among these groups were representatives of the Ohio Music Teachers Association, five elementary school groups, and three classes from the University of Akron's Art Department, leaving little doubt that the educational aspects of exhibitions are primary for the majority of viewers who come to the Art Institute.

SUMMARY

In 1971-72, The Akron Art Institute offered seven major exhibitions in a multiple-show format, with lesser exhibitions at the same time. Exhibitions usually ran for some five weeks, with attendance ranging from about 1,300 visitors to 4,300 visitors. The major exhibitions could all be classed as featuring contemporary art, with a total of some 22,000 viewers coming to the museum to view its offerings.

In examining the ways and means of presenting exhibits, several dimensions were suggested that would lead to an evaluation of presentation. An exhibit's organization (systematic or ecological), its interpretive aspect (from interpretive to overinterpretive), and its intent (aesthetic, conceptual, factual) were three major dimensions.

The problem of capturing attention also focused on concerns with external pressures or rewards, the level of complexity in the presentation, visibility of the art, lighting, and background elements, all leading to the point that the time visitors spent on an exhibition, and the number of visitors who come, are approximate measures of the success of an exhibition.

In turning to a particular opening, we found that most of the viewers did not regularly attend openings at the museum. Visitors come as couples, and a distinct distance/attendance-decline function is obvious, that is, the greater the distance from a particular area to the museum, the fewer will be the visitors from that area. Both from looking at the opening and from a survey of other visitors to the museum, it is obvious that the museum serves the Akron area, not a large regional audience. The competition for visitors' time was seen as a complex phenomenon in which a wide variety of activities could be said to compete.

Given the very short period of time that most visitors spend at an

exhibit, it was suggested that a ratio of four to one, of viewing time versus travel time, was an appropriate goal to seek. The failure to even come close to this suggests that the museum is too small, in terms of gallery space, for a central location. Decentralization of service is a means of improving service, as is expansion of gallery space.

NOTES

1. Alma S. Wittlin, *Museums: In Search of a Usable Future* (Cambridge and London: MIT Press, 1970), p. 105.

2. G. Ellis Burcaw, *Introduction to Museum Work* (Nashville: American Association for State and Local History, 1976), p. 117.

3. Wittlin, op. cit., p. 108.

4. Warren Jefferson, *Exhibit Methods* (New York: Sterling Publishing Co., 1972), p. 18.

5. Kenneth Hudson, *A Social History of Museums: What the Visitors Thought* (Atlantic Highlands, N. J.: Humanities Press, 1975), p. 38.

6. James Gardner and Caroline Heller, *Exhibition and Display* (New York: F.W. Dodge Corp., 1960), p. 153.

7. Ibid., p. 153.

8. Burcaw, op. cit., p. 121.

9. Henry Moe, "The Role and Obligation of Museums as a Scholarly Resource," in *Museums and Education,* ed. Eric Larrabee (Washington, D.C.: Smithsonian Institution Press, 1968).

Chapter Eight

ECONOMIC ANALYSIS OF EXHIBITIONS

Given the materials of the previous chapter, it should be very apparent that there are as many unanswered questions as there are answered ones in analyzing the exhibitions of the Akron museum. The complex of qualities that an exhibition includes can only be partially captured in an economic analysis of exhibition efficiency. It is usually possible to call efficient an exhibition which generates greater attendance than one which generates less, assuming comparable costs, and only if we assume that the expenditures which visitors to the museum make (in terms of travel, etc.) reflect in part the esteem in which they hold that particular visit to the museum. Also, it is not being argued that the art of one exhibit is better than that of another; nor are we saying that a person's satisfaction derived from the exhibit is greater because that person paid more to get to that exhibit.

If museum people can detail in economic terms such things as the quality of the display arrangement, how well the art is presented, economics can add insights into the successful operation of the museum in the important function of exhibitions. After all, economics is of considerable use in detailing the process of maximizing the satisfaction of the visitors to the museum, even if it is of little use in addressing the issue of artistic merit of the particular art exhibited.

The specific reasons for developing a cost-benefit model applicable to exhibitions are to assist the museum in efficient allocation of its resources, to aid in its planning, and even to offer some useful data for understanding and promoting itself. A gross-expenditures model such as has been developed throughout this book is, in economic terms, simplistic in comparison to the more sophisticated elements of models such as the Clawson-Knetsch model used in outdoor recreation. But the more sophisticated models applied to outdoor recreation are used by such bodies as the U.S. Army Corps of Engineers, who can spend considerable funds developing a sophisticated

model that will then be applied to dozens of lakes. The small museum, interacting much less formally with other museums, finds no government department at the federal level creating a general-use model. No, a given museum is forced to do its work itself, and because of this, a logically correct model, albeit unsophisticated, is better for evaluation purposes; it represents something which any museum staff can understand and undertake. This is its strength as well as its obvious weakness.

As in the case of museum classes, the principal or primary benefit measure is a developed shadow price for attendance at exhibitions, in the absence of a real price, that is, a fee to be admitted. We are not measuring consumer surpluses; rather, we are interested in the travel prices that people actually pay, a measure which is comparable to the price paid in the private sector under traditional demand analysis.

Another kind of benefit measured in the willingness to pay is represented by the allocation of members' fees. In this case, we allocate according to the responses of members as to the thing they like best about the Akron Art Institute, when that aspect most liked is exhibitions.

Another willingess-to-pay measure lies in an allocation of grants and donations made to the Art Institute. A problem arises with counting grants and donations given during the fiscal year as having been attributable to that year's exhibitions. Obviously, the time frame for giving by particular donors may have nothing to do with the timing of particular exhibitions. There seems, on the other hand, no acceptable way to allocate grants and donations except to the year in which they are given; the next year or the year before would make even less sense. Obviously, if a piece of art is donated to the museum, the use to which it will be put is exhibition; that could certainly be the intent of the donor as well as the museum, unless the art is a particularly inferior or unwanted piece. But, the value of that art is attributable to museum development, not exhibition.

Yet another form of benefit would be the sales revenues received in the sale of any of the art in an exhibition, at the time of the exhibition or immediately thereafter. If the museum generates revenue by selling items from the exhibit, then that net sale price (price less cost) is a measure of benefit. If the art sold as a result of the exhibit belongs to, say, an artist or someone else, then the net benefit still exists, but the museum does not gain the benefit; someone else does. But it is still a benefit generated by the exhibition.

If sales of books, prints, slides, and so on, recorded by a museum's shop, were considerable, then these profits would largely be attributable to exhibition and, to a lesser degree, to educational elements of the museum. In Akron's case, the shop did not figure greatly in the analysis because it had only recently opened and was not generating very large revenues.

Another form of benefit, similar to the preceding one, is the appreciation in value of the art exhibited. There is little doubt that much art

appreciates in market value as a result of having been exhibited, even though it may not be immediately sold. If the art is subsequently sold, then some of the appreciated value is attributable to the exhibition. Unfortunately, tracing these latter values is not always possible, nor is it the case that, in the exhibitions studied, any of the art was, in fact, sold.

Interestingly enough, the question of sales of art from an exhibition suggests the sale-lease questions of economics. A sale is after all a sale, but a visit to the museum becomes a sort of lease of the art to the viewer, but in a collective sense. Although a consumer can be excluded from viewing the art if he or she does not pay the admission price, what is the price? The basic price is the travel cost, the same price that people pay to go to most city parks. Therefore, it is easy to argue the public nature of art exhibitions where no direct fee is paid for admission. Even if a fee is paid, art is still viewed collectively and publicly because externalities do occur in viewing art (the loud child in the museum), and because collective consumption of the art is usual rather than exceptional.

BENEFITS AND COSTS OF EXHIBITIONS

Allocations of economic as opposed to purely accounting costs were made that were thought to reflect the value of the resources used in producing exhibitions. Table 8.1 reveals the costs allocated to exhibitions, and indicates a total exhibition cost for the 1971–72 fiscal year of $107,924.42. Again, as in the case of education, certain salary items and other expenses are thought to be appropriately allocated to exhibition. Throughout this study we operated on the assumption that the exhibition and educational functions were of prime importance, and have allocated approximately two-thirds of total economic costs to these functions. The remaining one-third we allocate to development and general administration.

In Table 8.2 we combine the costs from Table 8.1 with computed benefits as shown. The benefits for the fiscal year 1971–72 amount to a total of $110,502, and are the sum of allocations made by methods already explained. The cost per user visit for exhibitions amounts to $5.02, while the benefit per user visit amounts to $5.13. The benefits-to-costs ratio was calculated to be 1.023, less than the 1.172 computed for education programs. Benefits for exhibitions represent a modest excess over costs, but the prices paid to view exhibitions were more than the costs of providing them. Exhibits at the museum are therefore judged to be marginally efficient as economic activities of the museum. The appendix at the end of this chapter details the manner of assessing the transportation benefit for each exhibition.

A possible undervaluation of exhibition benefits may arise from the fact that many persons enjoy the benefits of exhibitions at prices much less than they would be willing to pay. This value, which we refer to as the consumer

TABLE 8.1

Total Exhibition Costs, July 1971-June 1972

Cost Item	Amount	Percent of Total Amount
Salary assessments		
Curator (75% of $12,000)	$ 9,000.00	8.1
Director of institute (33% of $23,000)	7,590.00	6.8
Director of development (20% of $17,000)	3,400.00	3.1
Registrar/security officer (70% of $7,400)	5,180.00	4.6
Business manager (33% of $9,200)	3,036.00	2.7
Gallery technician (75% of $6,000)	4,500.00	4.0
Bookkeeper (25% of $5,400)	1,350.00	1.2
Maintenance (33% of $5,700)	1,881.00	1.7
Membership secretary (10% of $5,500)	550.00	.5
Executive secretary (10% of $5,500)	550.00	.5
Volunteer coordinator (33% of $3,600)	1,188.00	1.1
Librarian (5% of $5,000)	250.00	.2
Total salary assessments	38,475.00	34.5
Cost of exhibitions	33,805.34	30.3
Publications (catalogs, etc.)	8,623.33	7.7
Overhead, business costs (33% of $38,475.00)	12,696.75	11.4
Assessed value of gallery space—		
7,161 sq. ft. @ $2.00 per sq. ft.	14,322.00	16.0
Total exhibition costs	107,924.42	99.9

Source: Compiled from Akron Art Institute records, and estimates of value.

TABLE 8.2

Estimated Costs and Benefits of Exhibition Programs

Item	Amount
Total estimated costs	$107,924.42
Estimated benefits[a]	
Travel expenditures[b]	38,800.17
Membership-fee allocations[c]	28,216.86
Exhibition sales	N.A.[d]
Endowment income (33% of total: $24,474)	8,076.42
Special fund raising (23% of $44,100)	10,143.00
Miscellaneous income: sale of	
catalogs, net shop sales, etc.	6,538.99
Donations and grants: $14,464 special	
grant + 23% of 18,536[c]	18,727.28
Total	110,502.72
Benefit-to-cost ratio	1.023
Benefit per user visit	$5.13
Cost per user visit	$5.02

Note: Data include all exhibition-collection activities.

[a]All evidences of willingness to pay.

[b]Price paid for travel to Akron Art Institute—round trip.

[c]Based on allocation of fees of members, according to what they liked best about the institute (23% of total members' fees).

[d]Not available, nor are artists' costs included in estimates.

Source: Compiled from Akron Art Institute records.

surplus, was not measured in this study. Such estimates of the value of the surplus would suggest a higher benefit-to-cost ratio than we have been able to compute. In addition, note that the benefits were calculated only for those whose primary aim was to view an exhibit. Those who came to classes at the museum but also viewed exhibits were not counted, even though part of their benefit was undoubtedly due to exhibitions.

Another point needs to be made. Some may think that in fact we are dealing with "funny money" when we estimate benefits based on willingness to pay. Such is really not the case, because in order to have the visit, the consumer must pay these costs (such as transportation). The fact that such values accrue to the individual consumer or are paid to others, rather than to the producer (in this case the Art Institute) does not mean they are a fiction. They in fact exist. In the production of normal goods, the private profit taker is only interested in his own profit, not the value that his product represents to others. In this case, the public producer of goods, the Art Institute, should be interested in financing itself, but it should be interested in the value which the community places upon its outputs. Thus, the value of its service is a better statement of the esteem in which the institute is held than is the amount of dollars it has in its budget. While the Art Institute

cannot live on esteem, it should recognize that it is creating values, and these values are not always reflective of income the museum gains.

Turning to the question of the extent to which the museum appropriates the benefits, museum costs totaled $107,924, and the museum captured about $72,000 to cover its costs.

From the above analysis it is obvious that just as in the case of the museum's educational programs, benefits exceed costs in the exhibition programs of the museum, but the museum fails to some extent in attracting a sufficient number of visitors to its galleries.

EXTERNALITIES OF ART

In the literatures of the sociology of art, educational theory, and psychology, it is easy to gain some sense of possible external economies— externalities which have economic value even if methods to measure their economic value have not been developed. Were these externalities measurable, then there is little doubt that their positive benefits would offset diseconomic effects, and that benefits in general might far exceed costs. Externalities of art are those economic values (either positive or negative) beyond the immediate enjoyable consumption of art that may accrue to others—that is, social benefits. Such benefits could be attributable to either education or exhibition programs.

Art and Play

One positive source of the external value of art derives from the fact that art and play are similar, and that some of the positive attributes of play can also be attributed to art.

Art and play are similar, according to Herbert Spencer, in that neither one is essentially necessary for bodily survival.[1] Rather, they are valued for their own sake as pleasurable, with no direct or necessary connection to the surivival of the organism. In essence that may be gratuitous. The psychological and social functions of art may for some be essentially keyed to recreation, a mechanism of restoration necessary for counteracting the demanding effects of work.[2]

When the work-leisure dichotomy is suggested, it leads inexorably to the idea that art and play become compensations for the tensions and demands of the roles performed in the work world. Thus, art and play become means for compensating for the alienation and the impersonality of the everyday work world. As such, art and play may drain off tensions and provide an essential curative service within society. Insofar as the reduced tension of an individual positively affects others, art has social value beyond the value to the individual. Museums help create this social value.

Art and Productivity

While an important idea in the possibilities for reducing social costs, the idea of release of tension is only one possible social value of art. For example how would one consider the value of works of art placed in corporate headquarters and offices of workers? The pleasure derived from some works of art might actually be thought to expand the productivity of the worker or the administrator; or negatively, the work of art may be distracting and thereby reduce productivity. Music used in offices probably enhances the productivity of some workers, but for people who genuinely like a variety of music, canned music, with its terrible monotony of sickening strings, may result in significant pain and distraction. As we are all well aware, such music may savage the soothed beast.

Art as a Reducer of Antisocial Attitudes and Behaviors

The tension-releasing idea suggests the possibility of time use in social as opposed to antisocial ways; that is, merely using the time of a potential juvenile delinquent in the pursuit of art, as opposed to the possible pursuit of antisocial street habits.

In addition to reallocations of how time is spent, there appear to be carryovers of art to actual behavior perceptions and actions. T.W. Adorno's theory of modern-art appreciation states that those who freely accept modern art tend to be nondogmatic and nonauthoritarian, while those who reject it are usually dogmatic, conventional, prejudiced, and authoritarian. Supporting Adorno's theory of modern-art appreciation, Christian Rittel-meyer suggests:

1. The more modern the work of art, the greater is its rejection.
2. The more a work of art is rejected, the more the artist is rejected.
3. Highly dogmatic and intolerant persons have a poorer opinion of modern art than less dogmatic or intolerant persons.
4. Dogmatic or intolerant persons are inclined to have a lower opinion of the artists who create modern works than persons who are not so dogmatic or intolerant.[3]

Museum exhibitions may serve to reduce antisocial attitudes and prejudices, and this has value even if it touches only a few peopl.e But while art may reduce antisocial attitudes, it does not necessarily reduce antisocial behavior. One study conducted among two groups—juvenile delinquents showing artistic talents and criminals indulging in artistic creativity, compared to two control groups of nonartistic normal counterparts—revealed that the experimental groups were characterized by nonconformity and showed significantly higher tolerance and acceptance of ambiguity in their perception than normal.[4]

In yet another study, the use of the adjective check list to investigate the

self-image of 800 highly creative high school students revealed that the adolescents had a strong self-concept regardless of sex, which could be summarized by the following characteristics: complexity, reconciliation of opposites, impulsiveness, a craving for novelty, autonomy, and self-assertion.[5]

In sum, art can be a powerful force in human behavior. As such, the force may be problem solving for the individual, and if so, it may have value in alleviating problems for society. In fairness, however, there is some doubt that art museums may have an impact on more than a small minority of persons.

Aside from its implications for individual behavior, and the impacts that behaviors may have on others, there is not much question that art shown in museums can be somewhat socially significant in other ways. Although perhaps more effective in arenas other than museums, art may create awareness of social issues. Art may create a sense of group solidarity or unity. Its popular forms may become part of the economic system and become significant artifacts in our daily life.[6]

Art as Social Change and Social Stability

Some social purposes can be viewed as essentially qualitative. Artistic beliefs may be, in this sense very similar to religious beliefs; both represent a kind of set of absolute values with the society.[7] As such, these values reflect the importance of the qualitative nature of experience, as compared to the mechanical, quantitative character of both technology and science.[8] Similarly, a sense of wholeness of being, as opposed to the fragmentation in the specialization of human roles, bespeaks another qualitative dimension.[9] The idea of wholeness and the idea of a sense of community can be enhanced in art and reflect the kind of counterpoint to the impersonality of bureaucratic processes, contract relationships, and some dominant values of middle-class society.[10] In an extreme way, art may represent a subculture of a very specific kind for some who oppose the general culture of the larger society; thus, art can become a subculture or, in this sense, a counterculture.[11] Such qualitative possibilities for art are easy to see in the extensive use of music and the graphic arts in all kinds of social movements.

In this sense, art cannot be conceived as essentially negative. Its positive aspects, whether they be in a counterculture, in the larger society, or both, suggest and lead to change within the society. Stabilizing, on the other hand, refers to a sense of balancing emotional against instrumental needs (by releasing tensions), but also makes possible congenial occupations and interests for what some might call deviant personalities. Perhaps the terms nonconformists or nonconforming represent a better choice of words than the term deviant.

If art becomes an independent and important value system, much in the way that religion exhibits independent values, it can become the basis for

social change, not simply a way of supporting and giving expression to a nonconforming social movement.[12] In this sense, one may not need to be in ready and constant contact with art to be influenced by its values. Social change as related to art may arise out of the fact, as Jacques Barzun suggests, that much of what is written, formed, or viewed in our society is contructed or created by artists, and an educated person within the society has little choice but to fall under the influence of aesthetic creeds and emotions.[13] When one considers such a statement, it is hard to imagine a world without the arts; on the other hand, it is easy to see how the arts rise and fall due to the extent to which avenues, opportunities, and mechanisms for expression are provided for people with particular aesthetic positions in the society.

Art as Mental Therapy

Art has long been used as a device to enhance the skills and abilities of persons with mental problems. For example, among mentally retarded children, attitudes toward peers, interaction with the school and teacher, and enhanced development of self-identity result from creating aesthetic experiences.[14] Of course, none of these extraaesthetic uses of art takes place in a formal way in museums.

One study exploring the opportunities in art for assessing and developing the abilities of deaf children resulted in findings that are somewhat inconclusive, but such studies tend to support the belief that art can have special values in educating children handicapped by deafness, in the enhancement of attitudes, interests, knowledge, abilities, and awareness of needs.[15]

In a study of minimally brain-injured children, John Carter and Phyllis Miller found that creative art activities were one way of enhancing visual-perception abilities.[16] Studies like the Charter-Miller study reflect the success of well-applied therapeutic methods using art as the mechanism.

Describing a weekly art class for psychiatric day-care and hospital patients in a city hospital, Vernon Patch and Carolyn Refsnes discovered that the benefits of art therapy can include the provision of an organized group activity; help for patients with problems of self-control, through a structured class situation; and the opportunity to identify patients who would benefit from individual art therapy.[17] Whether art therapy succeeds depends upon the practitioner. The quality of art therapy depends very heavily upon the quality of aesthetic knowledge that the therapist brings to the endeavor. The art therapist's success in bringing a picture's meaning into focus for the patient depends on his or her long familiarity with the connotations of formal pictorial qualities and the complex interplay of manifest content, latent content, and artistic style.[18]

Considerable literature supports the value of art in these applications, when properly conceived. Art therapy without the therapist's having had a solid education in aesthetics may not be as useful, however.

Aesthetics in Education

Aesthetics in education has been alluded to previously. It has generated a complex and broad literature, and one that we will discuss only briefly. Aesthetics in educational institutions is a complex of many problems of content and methods. Traditionally:

> The assumption is that aesthetic experiences, aesthetic judgment, and aesthetic modes of perception in general, are to be predominantly related to the area of the so-called fine arts. Thus, the way to meaningful aesthetic understanding is to the study of architecture, sculpture, painting, drawing, music, theatre, and the dance. Aesthetics in education, therefore, is seen as work in or about these various forms of art.[19]

Different schools have different purposes and, therefore, different methods of perceiving art education. Emphasis may be on art appreciation, technical competence, the history of art, or simple performance.[20] Applied aesthetics, that is, the use of art-appreciation courses, is justified on the assumption that aesthetic experiences are pervasive experiences affecting the whole personality, and that aesthetic experiences are transferable to other areas of human functioning, especially the cognitive area.[21] When many of society's members suffer from frustration, uncertainty, alienation, estrangement, depersonalization, automation, despair, helplessness, and other problems, art education can be socially useful. Much of this kind of education can and does take place in museums and has, when well executed, considerable social value.

Art as Social Control

While art has many positive social values, it also has some potentially negative uses. Art's strong emotional appeal can be used to control populations. Values can be propagandized, whether one considers them positive or negative. The control aspect of art is one negative externality that needs to be carefully researched and analyzed. In mild ways, strong biases in art itself, or strong biases in other areas, can prostitute art by using the aesthetic appeals of art for unacceptable extraaesthetic purposes.

Art as Elitism

Another possible negative external effect in the consumption of art is the possibility of creating an elitism in which intolerance toward others is

increased. This arises not directly from the art, but from the social relations of the art world. Perfection as a steady diet in art may for some generate an unwillingness to accept imperfection in other aspects of life.

Unfortunately, the potential positive and negative externalities discussed previously do not lend themselves to economic measurement. It may well be, however, that the estimated economic benefits of exhibition are arguably greater than those that our partial analysis has expressly measured.

To bring the benefits more in excess of costs demands more use of the programs and facilities of the Akron Art Institute. Take one significant problem, for example, the problem of downtime between exhibitions.

Exhibition Downtime

In assessing the use of the Akron Art Institute, consideration must be given to the amount of time during which there are no exhibitions being displayed in any of the galleries. Since an important source of exhibitions shown by the institute is provided by traveling commercial shows, the museum's exhibition schedules are more or less determined in advance by rental fees (what the museum can afford), by how long the renting agency or lending museum will allow its exhibit to be shown at the institute, by seasonal factors, and gallery size.

Most exhibitions are displayed for a five-week period, followed by a period of approximately two weeks with no exhibitions. As an example of exhibition downtime, an exhibition at the Art Institute ended on May 8, and the staff began the process of disassembling the exhibit. The exhibition galleries were closed and did not open again until May 19, for a members' preview, and then opened on May 20 to the general public. This represents 12 days of downtime for the exhibition galleries.

As indicated in the previous chapter, during the fiscal year the Art Institute had seven multiple exhibitions, each being displayed for slightly over five weeks and followed by a two-week period of downtime or gallery inactivity. This means that for 14 weeks in the fiscal year, the institute had no exhibition on display to attract visitors. To restate, for approximately 98 days, or 27 percent of the year, the institute did not have anything on display in its galleries. (See Figure 8.1)

In examining attendance data, it is readily apparent that the closing of the galleries has a demonstrably depressing effect on visitors' use of the Art Institute. When the galleries are open, there is a mean daily attendance of about 125 persons; when there is no exhibition on display, the mean daily attendance is 42 persons (people going to classes, lectures, etc.).

These calculations show that exhibitions attract 83 additional persons per day to the Art Institute. If we take the 83 persons per day and impute a benefit to them, by multiplying the 98 days of downtime by the 83 persons per day who do not come, then we gain, just on transportation benefits, an

FIGURE 8.1

Mean Daily Attendance During Exhibition Periods and Periods Between Exhibitions, July 1971–July 1972

Mean Daily Attendance

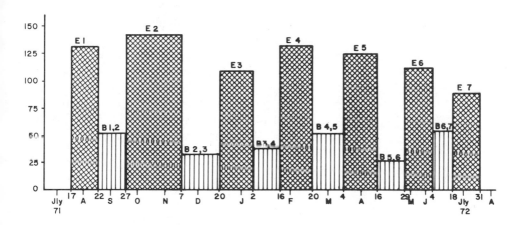

Exhibitions

Period between exhibitions

Source: Monthly attendance records and exhibition calendars of the Akron Art Institute.

additional 8,134 visits, for a benefit increase of $14,690.00. This loss of benefit due to downtime would be enough to raise the benefits substantially.

Downtime is therefore to be avoided, but if it cannot be, exhibitions which would require the use of all four galleries should be avoided because the museum is essentially closed during these downtime periods. In short, benefits of exhibition can be greatly increased by an avoidance of downtime, which decreases the number of visitors to the Art Institute.

Unassigned Costs: The Permanent Collection

Because of the unrealistic results that would cloud the costs and benefits of other exhibition activities, the permanent collection is a nagging major source of significant loss, to be largely left out of the exhibition analysis except when it is displayed. Most of the collection is not displayed, and the idea of a highly valued permanent art collection in disuse is enough to throw

a cost-minded economist or a profit-oriented businessman into amazement. If valued at between $800,000 and one million dollars, the loss of unused art to a public institution like the Art Institute is large. The collection has value in terms of sales, rental fees, exhibitions to increase attendance; it has value in local public relations and in the development of local support for the institute. In short, its value is high. Even if it were liquidated, and the amount gained was only $800,000, at a yield of 7 percent it would produce annual revenue of $56,000, enough to pay some staff salaries or enough to cover some exhibition costs.

We do not suggest selling, or any particular policy, save exhibition of the permanent collection; we do recommend using it. For example, if high-quality space could be found at a shopping mall in which the art was well protected, and provisions were made for its insurance, then a gallery, say, in a large department store, could exhibit part of the permanent collection, and, over a 30-day period, probably triple the average visitation rate for an institute exhibit downtown and thereby easily account for 12,000 additional visitors to the institute (by proxy). Assuming the guess of 12,000 additional viewers, even on transport benefit alone, the additional benefit would be at least $12,000, even assuming we split the benefit measure between shopping visits and art visits.

The above figures are mere estimates, but the fact is clear: The collection should be on view and used, and decentralized exhibition should represent a significant possibility. Perhaps more importantly, the loss which occurs by having the permanent collection largely unused is very heavy, although we recognize that the Art Institute's gallery space is limited.

BARRIERS TO EXPANSION OF ACTIVITIES

In economics it is common to refer to barriers to growth. In this case the argument would not hinge really on long-term growth, but rather, on increasing present visits to make the operation more beneficial. Barriers to growth in the case of the Akron Art Institute have two broad dimensions, the consumption side and the production side. On the production side we are concerned with barriers to expansion. On the consumption side we are fundamentally interested in barriers which arise as impediments to use of the Akron Art Institute by the various local art publics. The majority of barriers discussed have implications for both the production side and the consumption side of the museum's market.

Location

Although location has been mentioned earlier, it also affects exhibition attendance. As previously noted, in the production of normal goods it is usually thought wise for the producer to locate either near the market for his

goods or near specific production-materials sources. From the standpoint of exhibition, the obvious locational advantage is to be near the marketplace, that is, near the citizens in the community who consume the services provided by the Akron Art Institute. The present location of the Art Institute may not be viewed as optimal. From the consumption side, there are a number of limitations: distance from consumers, parking facilities relative to other recreational activities, and gallery space itself. Parking is not readily available to the regular users of the Akron Art Institute, and for the casual user there is considerable uncertainty as to where he may park to make use of the Akron Art Institute's facilities.

Clustering of cultural facilities is used in many communities to expand the usefulness of all cultural services. With regard to location relative to other recreational activities, the concern is with the kinds of informal use of the Art Institute that would be available to downtown shoppers, people going to other facilities within the community, either historical or recreational. Proximity to the library does not appear to be sufficiently important to maintain a steady casual use of the Art Institute by people who would be in the downtown area. Just as retail sales have declined in the downtown area, we may anticipate that there will be declines in the use of the Akron Art Institute since it is not readily accessible to shoppers. The connection between shopping and use of the institute lies in the fact that probably the most significant recreational activity pursued by people in the city of Akron is the casual shopping trip, the window shopping and the strolling through the regional shopping centers or malls of the city. With this kind of activity being a prominent use of leisure time, it is logical to assume that leisure time will, for the majority of Akronites, not be used in the downtown area. Location, as was indicated in an earlier chapter, is a function of the audience the museum seeks to serve. A central location is probably better if one wishes ultimately to attract citizens from all around the community.

Scale of Facility

Another barrier to the consumer is the limited size and scope of the Akron Art Institute and of its activities. The institute is not sufficiently large to be able to provide a regular and varied stream of exhibitions where one may see extensive multiple exhibitions on a given visit. As a result, fare at the Art Institute must be viewed as distinctly limited. Gallery space in the building is not sufficient to encourage large numbers of people to overcome the other barriers and regularly visit the institute. In addition, the building's interior is, in some gallery areas, cramped and unattractive.

Exhibitions: Selection and Number

There appears to be a wide diversity in the groups attending various exhibitions that the Art Institute provides. The Art Institute provides only a

limited number of exhibitions and is seldom capable of providing more than one major exhibition at a time. Certain types of exhibitions appear to be more appealing to the local art publics than do others. For a museum serving a diverse group of art publics, one may not logically suggest that only those exhibitions which draw large numbers of people are necessarily the only choice. Likewise, one may not claim that the exhibitions which do not attract very many people are, in a qualitative sense, unsuccessful exhibitions. From an economic standpoint, use is a proxy for value, but this proxy does not completely address the question of high-quality use on the part of certain art publics as opposed to the kind of casual use that other art publics may find in the exhibitions. It is unfortunate, however, that exhibitions may tend to appeal to only specific art publics, but we must recognize that people who view certain exhibitions with pleasure may not attend other exhibitions at the institute. Consequently, to achieve efficiency, the museum must be larger in scale to capture larger audiences.

Costs to Users

To some extent, the cost of various types of art activities may be a deterring factor in the use of facilities and services provided at the Art Institute. However, given the nominal fees that are required for some activities (movies, concerts), direct price barriers to use do not seem to be extreme. No price is charged for admission to exhibitions. The price of admission may deter persons in the community from attending certain Art Institute functions, but it is not as significant a deterrent as other barriers. Taking the other view for a moment, a fee charged for a particular activity at the institute may of necessity eliminate the participation of low-to lower middle-income families in the community. However, it is probably not the price barrier, but rather, the atmosphere, the offerings of the Art Institute, and the preferences of nonusers that keep people away.

Class Orientation of the Art Institute

One of the most distressing aspects of art museums in most cities in the United States is that they are fundamentally upper middle-class oriented. One sees this in the membership as well as in the attendance of nonmembers. With an upper middle-class orientation, the art museum does not widely serve the larger population in the city, the only notable exception being in tours of exhibitions provided for public school groups. The class orientation presents a peculiar kind of dilemma for those who wish to see the Art Institute develop. The question becomes: Can we serve all of the population in some way, or do we merely, because of scarce resources, continue to serve the upper middle-class population of the city? With the resources available to the Art Institute at this point in time, supporters of the institute cannot fully expect the staff to be able to enlarge its efforts in an effective outreach

program. Presently, the Akron Art Institute has little fundamental opportunity to be a large-scale urban institution, given its current physical, budgetary, and programmatic components.

Art as a Secondary Social Institution

Relatedly, another barrier to use lies in the fact that art museums do not, in any community, represent a major use of citizens' time. While cultural institutions in any community continue to exist fundamentally as secondary institutions, that is, secondary to commercial, industrial, legal, and educational institutions, there is very little likelihood that any cultural institution, either in music, art, or otherwise, may fulfill a prominent urban role for the majority of citizens in the community. For example, the Art Institute's budget is not significantly greater than the average operating and salary budgets of a middle-sized department on a university campus. Its budgetary expenditures place it, in a business sense, in the position of being a very small business. We do not expect a neighborhood grocery store to have significant impact on the majority of citizens in an urban area. It may well be that our expectations for the Art Institute as an urban institution are much too exaggerated for any small art museum to be able to accomplish.

Competing Alternatives

Obviously, one of the most significant aspects of the limited use of the Art Institute lies in the competing alternatives for the use of leisure time that other facilities and activities within the community provide. As a park system develops, as commercial recreation activities increase, as malls and shopping centers present recreational programs, shows, and exhibits, and as other institutions within the community expand to compete for the use of leisure time of residents, the Art Institute may not be in a sufficiently viable competitive position to be able to do anything other than decline. At a time when leisure is increasing and affluence provides additional income for people to spend, it is a sad thing to recognize that orchestras around the United States, art museums in various cities, and other cultural institutions are not all prospering. This does not mean that all cultural institutions in the community are dying; it simply refers to the fact that cultural activities may not expect to continue to anticipate the kind of rapid growth that, for example, is evident in sales of recreational equipment and in commercial leisure pursuits.

In one sense the Art Institute faces the same kind of problem that any public or quasi-public institution faces in today's use of leisure. When a school system runs into budget difficulties, the first things it may cut are the cultural activities, such as art classes, music classes. Likewise, education programs in outdoor recreation are not effectively executed in relation to the importance that leisure has for Americans today. Neither recreational nor

cultural activities in the schools are given the kind of importance required to enable Americans, presently or in the future, to profitably deal with leisure. The reason is quite simple: in a society that is still much involved in the carryovers of a work ethic, leisure pursuits are considered to be less valuable than work-related activities.

As a result of the foregoing points, it is easy to understand why cultural activities within a community suffer in the competition for citizens' use of leisure. The extent to which a single institution such as the Art Institute may challenge this competitiveness, or this lack of competitive position, is probably limited. What may well be required is a consortium, an internal organization of all of the cultural activities within the community to form a strong, effective primary cultural institution. We all recognize the pervasiveness of art and other cultural activities within a community. They permeate, on an informal basis, virtually every activity that we pursue. Unfortunately, while they permeate most of our activities, they are of a secondary nature in relation to the activity involved. Therefore, one must perceive cultural activities within a city like Akron as fragmented into somewhat ineffectual splinter groups representing different art forms.

A Limited Collection

Another serious problem is the Art Institute's limited collection, which places it in a vulnerable position with regard to developing high-quality exhibitions. While this may not be a permanent or regular difficulty, there is not much question that in the common borrowing of works of art from other museums for local exhibition, Akron has no collection of importance to enable it to function well in museum networks. Another point to be raised with regard to collections as a barrier to use is that a limited collection will probably generate only a limited public interest.

But, one may also question whether all museums need to have a permanent collection, or whether a permanent collection is undesirable. One may also question, assuming that a permanent collection is desirable, whether a high-quality collection is possible. A related question, assuming that a collection is desired, is, In what sense should the collection be specialized and, if so, in what directions? Given art markets today, there is not much question that the budgetary allocations for acquisitions at the Akron Art Institute leave it with only limited possibilities for increasing its permanent collection. If it can gain additional funds for acquisition, there is no doubt that high-quality contemporary art probably represents an efficient use of its accessions budget. It is better, from the standpoint of the community, to have a first-rate contemporary work than a second-rate work from an earlier period or a second-rate modern work. With prices rising rapidly in art markets in the United States and around the world, acquisitions of high-quality contemporary art represent significant investments that the Art Institute might make to ensure its financial stability in the future.

Recognize the fact that art is not collected primarily for investment purposes. Yet, it is certainly true that careful investments in contemporary art can provide an important opportunity for a sound financial base in the future. Many museums specialize in order to create a market for certain kinds of art. By specializing in buying in particular areas, an art museum may put itself in a position of seeing rapid appreciation of the value of its collection. The ability to buy and sell provides the art museum with an opportunity that should not be overlooked, risky though it may be.

On the other hand, with the large canvases of contemporary art, can a museum with limited space do credit to a major contemporary collection? No doubt, if the museum intends to continue to collect, its storage and gallery space is inadequate. Perhaps this problem leads one to suggest that space is a sufficient barrier to contemporary art as the primary thrust of collections. Specialization seems important, so that the museum may have a full collection in a particular area, but contemporary art may not be the best choice for that specialization, or if contemporary art is still the preferred choice, limits within that broad area will still have to be set.

SUMMARY

In this chapter the economic benefits and costs of exhibitions were analyzed in a partial way by use of a simple willingness-to-pay model. Benefits were seen to exceed costs, although the margins were not great. Possible costs and benefits not measured include such positive elements as the release of tension noted in the discussion of art and play, the relationship of art to productivity, the use of art in curbing antisocial behaviors, the use of art as a means of social change and social stability, art as therapy, art as education, and its impacts; and the negative elements, art as social control and art as elitism. These extraaesthetic elements of the analysis may not be significant for this museum, but future research should attempt to develop methodologies to examine each of these and others.

One major loss of benefit was seen to be the fact that the museum has a long downtime between exhibits, thus cutting itself off from additional attendance and perhaps discouraging those who attempt to attend, find nothing available, and are discouraged from returning. The failure to make effective use of the permanent collection was also seen to be a limiting factor on the level of benefits.

In addition, barriers to expansion were discussed, with principal barriers including the museum's location, the scale of its operations within its building, the limited number of exhibitions, the social-class orientation of the museum, the fact that art is a secondary social institution rather than a primary one, the limited size of the collection, and the fact that, increasingly, consumers have other uses for their leisure time.

As a final note, this chapter did not analyze individual exhibitions,

although an approximate analysis would have been possible. One could take the transport-benefit models in the appendix, and compare the transport benefit of each exhibit against the cost of putting together the exhibit (rentals, time costs of labor, and so on). One limitation in doing this is that the exhibitions cannot be easily separated—that is, the major and minor exhibits presented at the same time could not be separated; thus one is covering all exhibitions within a time period. Were the analysis undertaken, however, some comparative data could be given for major exhibition periods.

APPENDIX

Methodology for Analyzing Exhibition Benefits

Benefits-Analysis Method, Exhibition 1

Exhibition: Constructivist Tendencies
Length of exhibition: 37 days, from July 17 to August 22, 1971

Mean daily attendance during the exhibition[a]	132.4	(\overline{X}_1)
Mean daily attendance during preceding downtime[b]	50.8	(\overline{X}_2)
Mean daily attendance during succeeding downtime[c]	42.8	(\overline{X}_3)
Mean daily attendance during both downtimes[d]	46.8	(\overline{X}_4)
Mean difference, exhibition and downtime[e]	85.6	(\overline{X}_5)
Computed attendance for the exhibition[f]	3,167.2	(Y)
Computed benefits for the exhibition[g]	$5,713.43	

For each exhibition the means were calculated as follows:

[a]\overline{X}_1 computed by dividing total exhibition attendance by the number of days the exhibition was shown.

[b]\overline{X}_2 refers to the period prior to this exhibition, in which there were no exhibitions shown; total daily attendance for the period was divided by the number of days of the period.

[c]\overline{X}_3 refers to the period immediately following the exhibition, when there were no exhibitions shown; computations are the same as for \overline{X}_2.

[d]\overline{X}_4 computed as follows: $\dfrac{\overline{X}_2 + \overline{X}_3}{2} = \overline{X}_4$

[e]\overline{X}_5 shows the loss of attendance during the downtime period: $\overline{X}_5 = \overline{X}_1 - \overline{X}_4$.

[f]The computed attendance for the exhibit is \overline{X}_5 times the number of days the exhibition was shown.

[g]The computed benefits for the exhibition are computed as follows: Y times 21.38 (average length of a round trip to and from the A.A.I. to see an exhibition—based on survey data) times .135¢ (a cost per-mile factor) divided by 1.6 average persons per car (factor based on other research findings).

Benefits-Analysis Method, Exhibition 2

Exhibition: Celebrate Ohio, Gary Bower
Length of exhibition: 43 days, from September 27 to November 7, 1971

Mean daily attendance during the exhibition[a] 141.8 (\overline{X}_1)
Mean daily attendance during preceding downtime[b] 50.8 (\overline{X}_2)
Mean daily attendance during succeeding downtime[c] 33.4 (\overline{X}_3)
Mean daily attendance during both downtimes[d] 42.1 (\overline{X}_4)
Mean difference, exhibition and downtime[e] 99.7 (\overline{X}_5)
Computed attendance for the exhibition[f] 4,287 (Y)
Computed benefits for the exhibition[g] $7,733.48

Benefits-Analysis Method, Exhibition 3

Exhibition: Twentieth Century Sculpture, O'Neil Collection, M.A. Scherr
Length of exhibition: 42 days, from November 20, 1971 to January 2, 1972
Mean daily attendance during the exhibition[a] 109.1 (\overline{X}_1)
Mean daily attendance during preceding downtime[b] 33.4 (\overline{X}_2)
Mean daily attendance during succeeding downtime[c] 36.4 (\overline{X}_3)
Mean daily attendance during both downtimes[d] 36.7 (\overline{X}_4)
Mean difference, exhibition and downtime[e] 72.4 (\overline{X}_5)
Computed attendance for the exhibition[f] 3,040 (Y)
Computed benefits for the exhibition[g] $5,483.97

Benefits-Analysis Method, Exhibition 4

Exhibition: Four Artists
Length of exhibition: 37 days, from January 16 to February 20, 1972
Mean daily attendance during the exhibition[a] 131.4 (\overline{X}_1)
Mean daily attendance during preceding downtime[b] 36.8 (\overline{X}_2)
Mean daily attendance during succeeding downtime[c] 50.8 (\overline{X}_3)
Mean daily attendance during both downtimes[d] 43.8 (\overline{X}_4)
Mean difference, exhibition and downtime[e] 87.6 (\overline{X}_5)
Computed attendance for the exhibition[f] 3,241.2 (Y)
Computed benefits for the exhibition[g] $5,846.92

Benefits-Analysis Method, Exhibition 5

Exhibition: Warhol Graphics, Alan Sonfist, Haitian Serigraphs
Length of exhibition: 44 days, from March 4 to April 16, 1972
Mean daily attendance during the exhibition[a] 124.4 (\overline{X}_1)
Mean daily attendance during preceding downtime[b] 50.8 (\overline{X}_2)
Mean daily attendance during succeeding downtime[c] 23.9 (\overline{X}_3)
Mean daily attendance during both downtimes[d] 38.8 (\overline{X}_4)
Mean difference, exhibition and downtime[e] 85.6 (\overline{X}_5)
Computed attendance for the exhibition[f] 3,764.2 (Y)
Computed benefits for the exhibition[g] $6,790.38

Benefits-Analysis Method, Exhibition 6

Exhibition: FTD Collection, Print Invitational
Length of exhibition: 37 days, from April 29 to June 4, 1972

Mean daily attendance during the exhibition[a]	112.1	(\overline{X}_1)
Mean daily attendance during preceding downtime[b]	26.9	(\overline{X}_2)
Mean daily attendance during succeeding downtime[c]	53.7	(\overline{X}_3)
Mean daily attendance during both downtimes[d]	40.3	(\overline{X}_4)
Mean difference, exhibition and downtime[e]	71.8	(\overline{X}_5)
Computed attendance for the exhibition[f]	2,656.6	(Y)
Computed benefits for the exhibition[g]	$4,792.34	

Benefits-Analysis Method, Exhibition 7

Exhibition: Drawing Invitational, Richardson Sculpture, Ceramics
Length of exhibition: 49 days, from June 18 to July 31, 1972

Mean daily attendance during the exhibition[a]	82.4	(\overline{X}_1)
Mean daily attendance during preceding downtime[b]	53.7	(\overline{X}_2)
Mean daily attendance during succeeding downtime[c]	55.8	(\overline{X}_3)
Mean daily attendance during both downtimes[d]	54.8	(\overline{X}_4)
Mean difference, exhibition and downtime[e]	27.6	(\overline{X}_5)
Computed attendance for the exhibition[f]	1,352.4	(Y)
Computed benefits for the exhibition[g]	$2,439.65	

NOTES

1. Milton C. Albrecht, "Art as an Institution," *American Sociological Review* 33 (1968): 388.

2. Ibid., p. 389.

3. Christian Rittelmeyer, "Dogmatism and Tolerance and the Judgment of Modern Works of Art," *Koelner Zeitschrift fuer Soziologie und Sozialpsychologie* 21, no. 1 (1969): 93–105.

4. Amal K. Maitra, Kamal Mukerji, and Manas Rayschaudhuri, "Artistic Creativity Among the Delinquents and the Criminals: Associated Perceptual Style," *Bulletin of the Council of Social and Psychological Research*, no. 9 (July 1967): 7–10.

5. Charles E. Schaeffer, "The Self-Concept of Creative Adolescence," Journal of Psychology 72, no. 2 (1969): 238.

6. Albrecht, op. cit., p. 390.

7. Ibid.

8. Ibid.

9. Ibid.

10. Ibid.

11. Ibid.

12. Ibid., p. 391.

13. Ibid.

14. Richard Incerto, James Morrison, David Weissman, and Gertrude Cormier, "Aesthetics and Special Programs," *Journal of Education* 152, no. 2 (December 1969): pp. 66–69.

15. Rawley A. Silver, "Art and the Deaf," *American Journal of Art Therapy* 9, no. 2 (January 1970): 63–77.

16. John L. Carter and Phyllis K. Miller, "Creative Art for Minimally Brain-Injured Children," *Academic Therapy* 6, no. 3 (Spring 1971): 245–52.

17. Vernon D. Patch and Carolyn C. Refsnes, "An Art Class in a Psychiatric Ward," *Bulletin of Art Therapy* 8, no. 1 (October 1968): 13–24.

18. Rita M. Simon, "Significance of Pictorial Styles in Art Therapy," *The American Journal of Art Therapy*, 9, no. 4 (July 1970): 159–76.

19. Adolph Manonil, "Aesthetics in Education," *Journal of Education* 152, no. 2 (1969): 4.

20. Ibid.

21. Ibid.

Chapter Nine

Museum Development

The issue of long-run museum development centers on ensuring the continuation of arts programming at the museum. Obviously, the goals and objectives of a museum cannot be fulfilled if the museum ceases to exist; thus survival of the organism is central to museum policy. Survival, then, is basic to museum development and more central than growth. First a museum survives, and then perhaps it grows.

From a quantitative standpoint, long-run development refers to continuation, and then to whether or not that continuation reveals growth in such input elements as budget, expenditures, staff, size, quality and scope of the permanent collection, organizational structure, size and shape of the museum building or buildings; along with the output elements of attendance and revenues.

Further, long-run development of the museum's collection and facility is properly aimed at improved production and attendance at art exhibitions and educational activities. For after all, the central purpose of surviving is to bring art to the community, whether it be done so aggressively or passively. Fundamentally, then, survival to attempt these outputs depends primarily on the long-run development of the permanent collection and a museum's physical facilities.

This chapter develops a cost-benefit analysis of development activities for a short-run period, the fiscal year 1971–72, rounding out the fiscal-year analysis of previous chapters. The central question in this case is the extent to which the museum had a good year in development or did not. The purpose of this chapter is also to analyze long-run museum development by generally assessing the permanent collection, budget size over time, staff developments, administrative organization, and the museum's planning for facility alteration and change.

Recognize the fact that long-run variables such as the collection and

staffing also have short-run aspects and are essentially fixed in a short-run period (a fiscal year). One does not quickly alter the collection as a short-run decision, but art can be bought and sold. Museum buildings are not usually changed in the short run, but some modification is done. Nor is administrative organization easily changed from year to year. In spite of the fixed nature of the elements, some short-run changes and alterations can be made in some of these variables, and in the staff perhaps more so than in the others. But one may raise the question of why staffing is more nearly a short-run element than the collection, the building, and organization. Collections cannot be significantly altered in the short run to affect present programs. Art may be added or subtracted, but changes in the collection will not usually alter current programming in a given year. Similarly, buildings are fixed in the short run. We cannot simply put up a new facility. Likewise, formal organization is not a flexible aspect of museum operations. One does not reorganize administrative structure in a museum overnight. It usually takes years to do so, and changes are slow to come.

Staff changes, however, appear frequent and are easily made. Staff changes occur sometimes with personnel flying in and out of a museum like bees going in and out of a hive. Lack of collective bargaining, and historic tyrannies in museum management, along with low pay, are probably the keys to staff turnover where it occurs. Short-run variability in staffing is tied also to the need for temporary and part-time teachers, docents, and general volunteers. Maximum flexibility in the museum (to the extent it exists at all) comes in these latter cases.

In sum, while most development elements are variable in the long run and fixed in the short run, it does not mean that some changes cannot be made in the short run; flexibility occurs to some extent in inputs.

SHORT-RUN COST ANALYSIS OF MUSEUM DEVELOPMENT, 1971-72

Fiscal-year costs for development of the Akron museum and its collection totaled about $58,000 (see Table 9.1). Operational expenditures ascribed to development totaled almost $37,000. Among the items within operating costs, the museum director's salary, allocated, on a one-third basis, to development, was nearly $7,600. This allocated figure is probably conservative, but varies logically with how museum directors actually spend their time. Some directors are almost exclusively involved in development activities, that is, promotion, raising of funds for the general development of the museum, and curatorial functions in regard to its collection. Others may devote considerable time to exhibition development. But since there is some leeway, an allocation of one-third to each of the major functional areas of the museum (education, exhibition, and development) seems the better way to proceed, bearing in mind that year by year, there will be subtle shifts in

TABLE 9.1

Development Costs (Including Collection), July 1971-June 1972

Cost Item	Amount	Percent of Total Amount
Salary Assessments		
Director of institute (33% of $23,000)	$ 7,595.00	13.1
Curator (25% of $12,000)	3,000.00	5.2
Director of development (47% of $17,000)	7,990.00	13.8
Registrar/security officer (20% of $7,400)	1,480.00	2.6
Business manager (33% of $9,200)	3,036.00	5.3
Gallery technician (25% of $6,000)	1,500.00	2.6
Bookkeeper (50% of $5,400)	2,700.00	4.7
Maintenance (33% of $5,700)	1,881.00	3.3
Executive secretary (55% of $5,500)	3,025.00	5.2
Librarian (95% of $5,000)	4,750.00	8.2
Operations' expenditures: overhead	36,957.00	
Business costs (33% of 38,475.00)	12,696.75	21.9
Assessed value of storage space, offices, library—8,159 square feet, $1 per square foot.	8,159.00	14.1
Total development costs	57,812.75	100%

Source: Compiled from Akron Art Institute records.

the way the director functions. An allocation of 47 percent of the salary of the director of development might seem low, but based on time allocations, only about 47 percent of his work time appeared to be in the general area of development. Obviously, development activities are also found in education and exhibition functions as well. Allocating most of the librarian's salary to development in this case reasonably reflected the time spent in curatorial research and general developmental activities, rather than in the education function.

Costs of promotion, supplies, allocated utilities, plus spatial-rent allocations, added another $20,855 to developmental costs, bringing the total for the fiscal year to $57,812.75.

BENEFITS ESTIMATES FOR DEVELOPMENT ACTIVITIES

Benefits estimates for development activities were quite high relative to costs, benefits totaled $128,533 for the museum, all of it captured in the museum budget (see Table 9.2). Membership fees accounted for some $80,000 and the Day at the Races fund-raising project brought in $28,665. Membership fees attributed to development represented an allocation (65%) of total membership fees representing in turn the basic support of people who may not have strong interest in exhibition and education programs, but who generally support the arts for their own reasons. Of course, the idea of

Table 9.2

Estimated Costs and Benefits of AAI General Development and Collection Activities, 1971-72

Cost/Benefit Item	Amount
Estimated costs	$ 57,812.75
Estimated benefits	
Membership-fee allocation[a]	79,743.87
Endowment income[b]	8,076.42
(33% of $24,474)	
Special fund raising[c]	28,665
Grants and donations[d]	12,048.40
Total	128,533.69

[a] An allocation based on membership services, and members' reason for joining: a "general interest in the arts and the museum" (65 percent of total responses).

[b] Allocation of one-third to each function: exhibition, education, and general development.

[c] General fund raising—Day at the Races; tickets on a new-car lottery; plus entry fee to special horseracing event.

[d] Donations and grants made for general development of museum and its collection.

Note: Benefit-to-cost ratio is 2.22.

Source: Compiled from Akron Art Institute records.

the long-run development of the museum is based on having a permanent collection, and development funds are used to support the collection and to subsidize programmatic aspects of education and exhibition.

Endowment income of some $8,076 is allocated by taking one-third of total endowment income, because over time there are various endowments, and the reasons for their being established, specifically for education, exhibition, or development, are largely buried in the past.

In sum, because of the kind of extrinsic or instrumental reasons that people have for giving to the arts, and becuase of a lack of knowledge of the arts among many donors and members, general development benefits far exceed the costs of gaining them. Benefits exceed costs by over 2.22 to 1, and happily for the museum, the benefits in this instance can be appropriated by the museum for budgetary use.

In previous chapters, analysis has revealed that in the aggregate, education and exhibition programming have been relatively efficient even though no claim of optimality is possible. Because of some citizens' considerable willingness to support the arts, the museum's developmental activities have generated sufficient revenues to maintain these activities. As Table 8.2 indicates, development activities also generated benefits far in excess of expenditures.

It is interesting that in the benefit results of museum development, the museum itself captures funds in excess of costs. The benefits of education and exhibition are gained not so much by the museum as by visitors and participants. Were we to consider only benefits in education and in exhibition that are appropriated by the museum, then total benefits would fail to exceed total costs. The benefit-accounting differences reflect a subsidy by the museum paid to visitors to its galleries and to participants in its education programs. This subsidy is in part paid for by developmental activities, and in part by grants and donations directed toward education and exhibition programs. Obviously, the benefit-cost analysis described is only for one year and merely illustrates the idea and method. Regular annual analysis is required to make cost-benefit a useful planning tool for museum administrators.

Perhaps the interesting point to reiterate is that most supporters of the art museum do so out of a general concern for the arts rather than any interest in exhibitions or educational programming. Carried a bit further, one could suggest that such supporters might continue to provide support even though the services of the museum deteriorated simply because most of these supporters are buying the satisfaction of supporting a museum; they are not buying direct satisfaction from its services. If this is so, then such satisfactions (and indeed the value of the option of a visit when one wishes) may continue as long as something called an Akron Art Institute continues to exist with a building and a storehouse of art. Services to the community may in theory be more important to these supporters than the museum's.

Finally, such support may be seen to devolve from the old civic temple idea of art, and argues the strong role that such a perception holds today. Certainly from a cash standpoint it may be the dominant view.

One further notion needs to be suggested. If the benefits of development that are actually appropriated by the museum are so much higher than benefits that the museum itself gains from exhibition and education activities, then it is easy to speculate that museum directors will have incentive to gain such general funds in preference to funds that are earmarked for education or exhibition. Further, a museum director may begin to think of using education and exhibition merely as means to maintain the museum ("Look at the services we perform for the city"), rather than regarding them as valuable for their own sake.

As noted, however, in the short run, the development activities bore greater fruit than other activities of the museum and could be deemed efficient in an economic sense.

But, beware of cross-sectional analysis, because even though profitable in the short run, the museum is, as we will see, in a long-run downward spiral in terms of its attractiveness to citizens. Even though it may keep its budgets up, the decline of the community's interest may eventually affect those nonvisitors, the general supporters of the arts, and budgets may decline absolutely.

BUDGET, MEMBERSHIP, AND VISITATION OVER TIME: 1970-77

In looking at memberships, budgets, and visits for the Akron museum, growth is not a major factor. Recapitulating budgets on an annual basis and inserting more recent years, we found that Akron's income does not indicate a growing organization; rather it presents a stabilized pattern (see Table 9.3). For example, income in the fiscal year ending 1970 was $186,638. By 1977 this income had risen to about $307,000. It may appear to be a significant rise, but if we compound an inflation rate of 8 percent, the total budget required in 1977, using a 1970 base, would be $318,000. While inflation varies from year to year and alternate bases may be used, the point is that just to keep up, the museum needed that increase from 1970 to 1977. Thus, development for the Akron Art Institute means continuation, not growth. This does not mean that it could not grow, but simply that for whatever the reasons may be, it has not. Actually, raising its money income to keep up with its real expenses is no mean accomplishment.

On the other hand, the museum's memberships have fallen consistently over time, with a drop by 1977 to only 962 (see Table 9.3) members. This radical fall in memberships is primarily the result of lack of organized membership drives and a lack of administrative effort.

TABLE 9.3

Total Museum Income, by Fiscal Year, 1970-77

Year Ending	Revenue Amount	Attendance	Membership
1970	$186,638	49,945	1,843
1971	221,382	42,056	1,822
1972	248,628	37,736	1,308
1973	269,257	41,443	1,309
1974	216,455	34,412	1,093
1975	251,130	35,447	1,194
1976	311,876	31,857	1,143
1977	307,233	32,747	962

Note: Attendance figures include all persons coming to the institute, regardless of purpose. They do not include persons visiting the Artmobile, operating since 1975, or participating in outreach programs.

Source: Akron Art Institute records.

Budgets are maintained but membership support is not. The new director (1978), John Copelans, has compared the Akron museum with other museums in the Midwest. The comparison is devastating. Akron's membership drops and others stabilize or gain (see Table 9.4). Copelans has arrived to captain what appears to be a sinking ship. Positive gains in 1971–72 have undoubtedly moved to losses over recent years, and a continuation of downward trends could lead to disaster.

With membership declining, attendance in recent years has declined from the 40,000s to the low 30,000s. The drop coincides, as do the membership figures, with the museum's commitment to twentieth century art. Copelans compared the Akron museum's attendance with other museums in the region (see Table 9.5) and found either little attendance growth, as at Canton, or considerable growth, as at Oberlin. No museum suffers the decline in visitation that Akron has. The picture is not good for the long run. What are some of the major elements that play a role in this decline?

THE ROLE OF THE PERMANENT COLLECTION
AND THE MUSEUM BUILDING

The permanent collection of the museum means more to the long-run development of the museum than it does to short-run aspects of programs of exhibition and education. Certainly in the short run, small pieces from the permanent collection are used in the museum's classes and are exhibited in its galleries, and in this sense the collection represents useful capital goods, that is, tools to produce exhibition and education programs. In the long run,

TABLE 9.4

Five-Year Membership Comparison: Akron Art Institute and Other Museums

Museum	1973	1974	1975	1976	1977
Akron Art Institute	1,309	1,093	1,194	1,143	962
Allen Memorial Art Museum (Oberlin)*	619	477	613	465	513
Canton Art Institute	N.A.	1,403	1,290	1,315	1,241
Dayton Art Institute	1,529	1,501	1,652	1,726	1,925
Des Moines Art Center	N.A.	N.A.	N.A.	N.A.	3,000
Stan Hywet Hall	N.A.	2,181	2,400	2,726	2,900

*Museum closed from May 1, 1975 to January 1, 1977, for renovation.

Note: N.A. indicates statistics not available.

Source: John Copelans, "Akron Art Institute Feasibility Study" (Akron: Akron Art Institute, 1978).

TABLE 9.5

Five-Year Attendance Comparison: Akron Art Institute and Other Museums

Museum	1973	1974	1975	1976	1977
Akron Art Institute	41,443	34,412	35,447	31,857	32,747
Allen Memorial Art Museum (Oberlin)[a]	17,556	17,880	13,979	–	27,069
Canton Art Institute	N.A.	N.A.	29,100	28,200	30,000
Dayton Art Institute[b]	129,431	149,446	113,135	–	138,891
Des Moines Art Center	N.A.	N.A.	N.A.	N.A.	100,000
Stan Hywet Hall[c]	N.A.	120,367	129,535	125,844	129,804

[a]Museum closed from May 1, 1975 to January 1, 1977, for renovation.
[b]The art school in the museum closed permanently in 1976.
[c]A preserved Tudor mansion in Akron, open to the public.
Note: N.A. indicates statistics not available.
Source: John Copelans, "Akron Art Institute Feasibility Study" (Akron: Akron Art Institute, 1978).

however, the idea of having some kind of permanent collection in the museum ensures the organization's continued long-run existence more effectively than any other single element of the museum's component parts or programs. If a permanent collection ensures the survival of an art museum, a permanent address does also; the collection and building are both of developmental importance.

Each aids in the survival of the other, and together they aid in the survival of the museum operation. Museums without collections that are operating out of museum buildings can more easily cease to exist if the museum does not own a permanent collection. Certainly, large museum edifices help secure the future, but permanent collection, as a storehouse of value, that is, an art treasure, provides the strongest aid to permanence, and is probably more important than even the most ambitious building. The public may be willing to permit a building, in which a staff conducts programs, to cease to exist, but seldom is this same public willing to have objects of art, prime pieces of property evicted and left crying on the city sidewalk. These points do not seem idle. There is great psychological strength in the public's knowledge that a building with a collection exists as a valued public property. That is undoubtedly why museums have gone into new-building development with no new operating money, and succeeded. That is why the museum's acquisition of a known work of art may increase revenues of the museum. New additions to collections and new buildings generally breed development and can create growth situations. A quality collection helps, but even a poor collection may help.

In sum, it can be argued that what is of most importance in ensuring the museum in the future is having some kind of permanent collection, which can be so called, and making additions to it. Important also is the existence of a museum building. Some may argue that the building is more important than the collection, but recognize the fact that collections precede buildings and are the initial and continuing reason for most museum buildings.

Donor Incentives

It should surprise no one that development funds provided to museums may be larger than funds available to museums for programs. Often, as indicated earlier, it appears that donors grant and members join even though their reasons appear vague; they are really development reasons—that is, people say they have "a general interest in the arts," wish "to support local cultural institutions," or to "make the city a more attractive, or sophisticated or exciting environment in which to live." Thus, one hears less frequently that a donor has given, or a member has joined, because of some program aspect.

But if contributors are not vague about their reasons for giving, why do they donate to museums which they may not actively participate in or regularly visit? Church members at least attend church with some regularity,

but Akron's museum donors and members, in general, do not frequent museums with any great regularity. Apparently, contributors have a number of incentives to which they respond. First, they give because to them the museum provides stability in a rapidly changing urban landscape; a museum provides permanence. Second, they may give because the museum is a source of local pride; we identify with our cities, and our people are made better off if our city is well thought of as a cultural center. Third, contributors, individual or corporate, give in some cases to aid their tax positions, that is, to avoid taxes. Fourth, they contribute to seek immortality, listings of their names in the good book of civic works. Fifth, they gain immortality, but they also gain social status in the present life. Sixth, some of them are deeply interested in art. Finally, people who contribute to museums may do so because such donations represent an option value, the value of having the option to visit, even if they do not visit. In general, one would have to say that people give to museums because of both aesthetic and extraaesthetic reasons. And, everyone likes to give to a winner. Thus, it is that the collection and the building have more to do with image than do programs offered by the museum.

THE PERMANENT COLLECTION OF THE AKRON ART INSTITUTE

By December 1977 the permanent collection of the Akron museum contained over 2,000 items that have been acquired, whether through donation to, or purchase by, the museum. Ambiguities occur in attempting to classify each item in this diverse collection of art. Since many of the catalog descriptions don't have a date for the origin of the work, some careful estimating had to be done to classify the works by centuries. Even carefully estimated numbers and monetary values of pieces can only give a rough idea of the scope and depth of the museum's collection.

According to John Copelans, each object in the collection should have entered as a result of a deliberately exercised judgment based on predetermined criteria:

"1. It was a major impetus to shift in thought or style that affected subsequent artists.
2. It alternatively made a major contribution in the development and sophistication of a style.
3. It is archetypal of a particular individual's artistic endeavor.
4. Whenever an artist has worked in a monumental scale, it is one of such works.
5. Insofar as possible, it is in good physical condition and has not been heavily restored."[1]

Copelans continued:

> In fact, hardly any of the accessioned objects in the Institute's collection meet such a judgment. In other words, if even the most significant objects were to be offered from the Institute's collection, either to one of the major general museums in this country or Europe or, where appropriate, to one of those museums specializing in important modern art (i.e., The Museum of Modrn Art, New York) it is more than likely that none would be acceptable (even as gifts) for accessioning to their permanent collection.[2]

He added: "The majority of the permanent collection has been obtained as gifts with no clear purpose in mind. In general, the more signifiant of the individual objects have been acquired as a consequence of purchase. This is not to say that all purchases have been significant, but there have been past directors who applied discrimination and scholarship within their limited budgets and consequently purchased a number of relatively superior objects."[3]

According to directoi Copclans:

> "The collection is extremely diverse and lacks both concentration and focus, primarily as the result of:
>
> 1. The lack of a well defined and articulated program.
> 2. The acceptance of any gift offcred, whether aesthetically important or not, in order not to offend the donor.
> 3. The dumping of unsalcable works on the Akron Art Institute as gifts for purposes of tax-deduction by dealers.
> 4. The lack of knowledge of some of the directors or, on the other hand, the use of available funds to acquire several minor works rather than a few of significance.
> 5. The changing role of the Institute from a teaching school that required a study collection to that of a more general collecting and exhibiting museum and finally to a museum of contemporary art.
>
> In summary, the Akron Art Institute owns a vast number of art objects that would be appropriate to either a personal study or university teaching collection.[4]

For our purposes, the collection has been classified into nine categories corresponding to each art medium. The greatest number of works are graphics (840), with the second largest group being paintings (384), as shown in Table 9.6. The remaining categories are sculpture (230 works), objects (301), ceramics (224), textiles (89), drawings (50), books arts (16), and photographs (14). The works are predominantly from the twentieth century (990 out of 2,148), followed by nineteenth century works.

TABLE 9.6

Total Permanent Collection: Dates of Origin

Category	20th Century	19th Century	18th Century	17th Century	Earlier	Undetermined	Total
Paintings	254	49	19	14	4	44	384
Graphics	508	148	72	19	11	82	840
Drawings	36	9	1		1	3	50
Sculpture	81	39	18	4	60	28	230
Ceramics	25	44	10	1	112	32	224
Objects	39	57	25	8	94	78	301
Textiles	33	30	16	6		4	89
Book arts		2	3	3		8	16
Photographs	14						14
Totals	990	378	164	55	282	279	2148

Source: Records of the Akron Art Institute.

TABLE 9.7

Total Permanent Collection: Country of Origin

Category	America	Egypt	Japan	France	Britain	China	All Others	Total
Paintings	294		3	13	5	6	63	384
Graphics	422		131	90	81	3	113	840
Drawings	40			3	1		6	50
Sculpture	48	15	3	6		10	148	230
Ceramics	23	83	7	8	4	41	58	224
Objects	10	97	2	21	34	21	116	301
Textiles	2	1	2	10	2	1	71	89
Book arts		3					13	16
Photographs	14							14
Total	853	199	148	151	127	82	588	2148

Source: Records of the Akron Art Institute.

American works (853) dominate the collection (see Table 9.7). The second most numerically prominent country represented is Egypt (199). Generally small pieces, most of the Egyptian items came as a gift of items resulting from an archeological dig during the 1960s. France is third, and the fourth greatest number of works are from Japan (148), with the majority of these being graphics of the Ukiyoe school. The remainder of the collection is varied, representing at least 41 other countries.

For 1977, the estimate of the permanent collection's worth is $1,148,-190. The most expensive piece is the newly acquired, concrete "Inverted Q," by Claes Oldenburg, valued at $75,000. The next most expensive piece of sculpture is also by Oldenburg and is the synthetic-rubber "Soft Inverted Q" valued at $25,000. Next come Louise Nevelson's "Bimensions Gold" and Charles Russell's "Stagecoach," conservatively valued at $27,000 and $23,000, respectively. There are six remaining sculptures valued at over $5,000.

The medium which represents the greatest proportion of the total value of the collection is painting. There are 45 paintings valued at $15,000 or over, the most expensive of which is Jean Dubuffet's "Tete Aux Quatre Raclages," valued at $50,000. Other paintings include "Bedford Hills," by Childe Hassam ($40,000); "The Backgammon Players," by Dirk Von Baburen ($25,000); "Apotheosis of William the Silent," by Ferdinand Delacroix ($35,000); "Spring Shower," by Charles Burchfield ($25,000); and "California Redwoods," by Thomas Moran ($20,000).

Graphics, being a less expensive medium, are third in monetary value. The most expensive graphics are an etching and linocut by Picasso, valued at $6,000 and $8,000, respectively.

In keeping with museum policy, accessions since 1967 have been primarily twentieth century works. The greatest number of them have been American graphics and paintings, followed by European graphics and American sculpture. Interestingly enough, the average value of a piece of art in the permanent collection is only about $570.

Paintings

The collection of American paintings represents by far the largest category of paintings in the permanent collection, comprising over three-fourths (294 works) of the 384 paintings in the museum's collection (see Table 9.8). No other country is well represented among the paintings.

American Paintings

The great majority (224) of the American paintings are from the twentieth century, with only a few (26) from the nineteenth century and none from the eighteenth century. There are some paintings (44) from around the turn of the century whose dates were not listed in their catalog description,

TABLE 9.8

The Origins of Paintings in the AAI Permanent Collection

Country Classification	20th	19th	18th	17th	Earlier	Undetermined	Total
			Century				
American	224	26				44	294
Italian	1	1	6		2		10
French	7	5		1			13
British	1	2	2				5
Dutch			2	5	1		8
Flemish				5			5
Austrian		1					1
Greek					1		1
Spanish	2	1					3
Russian	1						1
Belgian	1	1					2
German	4	2					6
Lebanese	1						1
Total	242	39	10	11	4	44	350
Oriental							
Japanese	2	1					3
Chinese	3		1	2			6
Korean		2					2
Siamese		4	3				7
Tibetan	1	2	5				8
Total	6	9	9	2			26
Peruvian		1		1			2
Haitian	1						1
Guatemalan	1						1
Unknown	4						4
Total	6	1		1			8
Grand Total	254	49	19	14	4	44	384

Source: Records of the Akron Art Institute.

but even if they were all from the nineteenth century, they would not dramatically alter the dominant representation of twentieth century paintings in the collection. The acquisition of paintings has increased in the 1970s, with approximately a third of the present American collection being acquired since 1970. The new accessions are almost entirely twentieth century works.

European Paintings

European paintings are the second largest category of paintings represented in the permanent collection, comprising 53 of the 384 paintings in the

collection. Spanning five centuries, the European collection ranges from two paintings from the fifteenth century to 18 paintings from the twentieth century. Twelve countries are represented in the European collection, with the greatest number coming from France (13). The French paintings are basically from the nineteenth and twentieth centuries, with the majority from the twentieth century (seven). The next largest number of paintings (ten) come from Italy, ranging from the fifteenth to the twentieth centuries, with the majority of paintings coming from the eighteenth century (six). The third largest number of paintings come from the Netherlands, spanning the sixteenth to the eighteenth centuries, with the majority of paintings coming from the seventeenth century (five). Next come the Flemish, British, and German paintings, ranging from the seventeenth century (Flemish) to the twentieth century (German). All of the remaining paintings are from the nineteenth and twentieth centuries except for one painting from sixteenth century Greece.

Oriental Painting. Oriental paintings comprise the third largest category of paintings in the permanent collection, with 26 paintings. Most of the paintings are from the eighteenth and nineteenth centuries and were acquired in the 1970s (17) and 1960s (8). The paintings come from five countries, ranging from eight paintings from Tibet to two paintings from Korea.

Primitive Painting. The final category of paintings are the primitives, numbering eight. There are two paintings from Peru, from the seventeenth and nineteenth centuries, and two twentieth century paintings (from Haiti and Guatemala). In addition, there are four twentieth century paintings of unknown origin.

Graphics

In the collection of graphics at AAI, American graphics represent over half (422) of the total number of works (840) as shown in Table 9.9. Almost all of the American graphics are from the twentieth century (391). The majority of graphics are from the twentieth century (508), although this predominance diminishes when one looks just at the European graphics, in which the number of works is more evenly split between the nineteenth century (76) and twentieth century (100). As with the paintings, there are a number of works (82) whose dates were not in their catalog description and were therefore not placed in one century. The majority of these, however, were done either in the nineteenth or twentieth centuries.

French graphics rank the highest in number among the European graphics, with 90 works ranging from the eighteenth to the twentieth centuries, and the greatest number of works being produced in the nine-

TABLE 9.9

The Origins of Graphics in the Permanent Collection

Country Classification	20th	19th	18th	17th	Earlier	Undetermined	Total
American	391	4				27	422
British	23	18	7	4		29	81
French	22	42	12			14	90
German	5	1			4	4	14
Italian	2		8	2	2	1	15
Russian	9						9
Spanish	5	4					9
Swedish	7	9					16
Dutch	1	2		8	5		14
Polish	15						15
Hungarian	4						4
Other*	11			2	1	2	16
Total	495	80	27	16	10	77	705
Oriental							
Japanese	9	68	45	3	1	5	131
Korean	1						1
Chinese	3						3
Total	13	68	45	3	1	5	135
Grand Total	508	148	72	19	11	82	840

*The other countries are Australia, Belgium, Czechoslovakia, Switzerland, Israel, and an unknown category.

Source: Records of the Akron Art Institute.

teenth century (42). The British graphics rank second with 81 pieces ranging from the seventeenth to the twentieth centuries, with the greatest number of works (23) being produced in the twentieth century. These figures are estimates due to the number of works with unknown dates. There were 29 pieces in this unknown-date category of British graphics. The remaining graphics come from 15 countries, each of which is represented by less than 16 works apiece. Most of these pieces are from the twentieth century. Notable exceptions are Italy, the Netherlands, and Germany, for which there is sixteenth, seventeenth, and some eighteenth century representation.

Oriental Graphics. There are a fairly large number of works (131) from Japan in the graphics collection. These are primarily from the eighteenth and nineteenth centuries. They were donated to the museum during the early 1970s, and there have been only 28 additions to the collection since that time. There are only a few works from outside Japan (four from China and Korea), which were produced in the twentieth century.

Drawings

There are relatively few drawings in the collection (50), most of which are twentieth century American. Seven countries are represented in the collection of drawings. France has the second highest representation, with only three drawings (see Table 9.10).

Sculpture

There are 230 pieces in the sculpture collection, which can be roughly divided into three groups: Western, Oriental, and Primitive (see Table 9.11).

The Western group of sculpture has 91 pieces, many (42) of which are from America. Except for a few pieces of unknown date, all of the American sculpture is from the twentieth century. The majority of the remaining pieces in the Western grouping have their origins ranging from the B.C. era to the contemporary era, with the second largest group (15) coming from Egypt, from early periods.

There are seven countries represented in the Oriental sculpture grouping of 56 pieces. The dates of these pieces vary greatly and appear not to be concentrated in any particular period. With regard to place of origin, the greatest number of them come from Siam and are from the fifteenth to the nineteenth centuries. The second largest group comes from eighteenth century India.

The group of primitive sculpture encompasses five basic origins and numbers 77 pieces, most (53) of which are from New Guinea. Except for ten pieces from Mexico, all of the primitive pieces are from the nineteenth or twentieth centuries. The primitive pieces were primarily acquired during the

TABLE 9.10

The Origins of Drawings in the Permanent Collection

Country Classification	Century						Total
	20th	19th	18th	17th	Earlier	Undetermined	
American	31	9					40
French			1			2	3
German	1					1	2
Italian					1		1
Swiss	2						2
British	1						1
Iranian	1						1
Total	36	9	1		1	3	50

Source: Records of the Akron Art Institute.

TABLE 9.11

The Origins of Sculpture in the Permanent Collection

Country Classification	Century						
	20th	19th	18th	17th	Earlier	Undetermined	Total
American	36					6	42
Egyptian					15		15
German	1				1		2
Greek					1	11	12
Iranian					5		5
Italian	3						3
Persian						2	2
Turkish						1	1
French	1	2				3	6
Etruscan						1	1
British	1						1
New Guinean						1	1
Total	42	2			22	25	91
Oriental							
Cambodian					3	2	5
Chinese			1	1	8		10
Indian			15				15
Japanese		2		1			3
Siamese		2	2	3	10	1	18
Tibetan	5						5
Total	5	4	18	4	22	3	56
Primitive							
African		8					8
Costa Rican		2					2
Mexican					10		10
New Guinean		53					53
North American	4						4
Total	4	63			10		77
Grand total	81	39	18	4	60	28	230

Source: Records of the Akron Art Institute.

1960s, the Oriental during the 1950s and 1960s, and the Egyptian during the 1960s. The majority (28) of the American pieces have been acquired during the 1970s.

Ceramics

The ceramics in the permanent collection number 224 pieces and can be divided into two groups, Western and Oriental (see Table 9.12). The Western

TABLE 9.12

The Origins of Ceramics in the Permanent Collection

Country Classification	Century						
	20th	19th	18th	17th	Earlier	Undetermined	Total
American	23						23
Austrian		4					4
British		3	1				4
Costa Rican						1	1
Cypriot					3		3
Dutch				1	1		2
Egyptian					69	14	83
Etruscan					8		8
French		4	4				8
German		4				2	6
Greek					1	6	7
Guatemalan						1	1
Italian			2				2
Mexican	2				2		4
Peruvian					2		2
Roman					2		2
Total	25	15	7	1	88	24	160
Oriental							
Chinese		10			23	8	41
Japanese		7					7
Siamese		12	3		1		16
Total		29	3		24	8	64
Grand total	25	44	10	1	112	32	224

Source: Records of the Akron Art Institute.

group contains about 156 pieces, ranges from sixth century B.C. to contemporary, and comes from 16 different countries. Egypt has provided the greatest single source, with 83 pieces from the ninth to fifteenth centuries. The second largest group (23) comes from America and from the twentieth century. As with the sculpture, the dates of the ceramics run from B.C. to contemporary and are generally evenly dispersed within that range.

The Oriental group comes from three countries, with 41 of the 64 pieces coming from China; the greatest number of Chinese pieces from a single time period (10) are from the Sung dynasty. Sixteen pieces come from Siam, 12 of which are nineteenth century works. The acquisition of ceramics occurred predominantly during the 1960s. Only five pieces have been added since 1970.

Objects

The collection of objects ranges from spoons to clocks. With 301 objects (see Table 9.13) from 24 countries, the dates of these objects range from the sixteenth century B.C. to the present and appear to be fairly well dispersed within those categories. The notable exception is Egypt, with 97 objects that

TABLE 9.13

The Origins of Objects in the Permanent Collection

Country Classification	Century						
	20th	19th	18th	17th	Earlier	Undetermined	Total
American	7	3					10
Austrian	1						1
British	2	11	10	5	3	3	34
Costa Rican					5		5
Dutch				1			1
Egyptian					50	47	97
French	6	8	5			2	21
German	2	3	1	2			8
Iran					2	6	8
Italian	2		1		5		8
Mexican					2		2
New Guinean	13	1				1	15
Persian					1	3	4
Peruvian					7		7
Spanish			1				1
Syrian					1	1	2
Greek						1	1
Hungarian	1						1
Unknown	1					3	4
Total	35	26	18	8	76	67	230
Oriental							
Chinese	3	3	3		12		21
Indian		1	2			11	14
Japanese	1	1	2		3		7
Siamese		19			2		21
Tibetan		7					7
Laotian					1		1
Total	4	31	7		18	11	71
Grand total	39	57	25	8	94	78	301

Note: The category of objects includes everything, from spoons to clocks, not covered under the other categories.

Source: Records of the Akron Art Institute.

come largely from the twelfth and thirteenth centuries. The country represented by the second highest number of objects is Britain, with 34 objects ranging in dates from the sixteenth century to the present, with the majority being from the eighteenth and nineteenth centuries. Acquisitions occurred mainly in the 1960s and continue into the 1970s.

Textiles

AAI has 89 pieces in its textile collection, running from religious robes to rugs and tapestries (see Table 9.14). Of the 18 countries represented, the country with the greatest number of pieces is Guatemala, with 23, 19 of which are from the twentieth century. Most of the textile pieces (63) come from the nineteenth and twentieth centuries; there are also pieces from

TABLE 9.14

The Origins of Textiles in the Permanent Collection

Country Classification	Century						
	20th	19th	18th	17th	Earlier	Undetermined	Total
American	2						2
Afghan		1					1
Algerian	1						1
Belgian	8						8
Bolivian	1						1
British		2					2
Egyptian		1					1
Flemish			1	3			4
French		2	7	1			10
Guatemalan	19	4					23
Italian	1	1	2	2		1	7
Persian		2					2
Peruvian		5					5
Swiss		2					2
Turkish	1	10	1			1	13
Unknown						2	2
Total	33	27	14	6		4	84
Oriental							
Chinese		1					1
Indian		2					2
Japanese			2				2
Total		3	2				5
Grand total	33	30	16	6		4	89

Source: Records of the Akron Art Institute.

eighteenth century France (7), nineteenth century Turkey (10), and twentieth century Belgium. There have been no textile accessions during the 1970s.

Book Arts

There are only 16 pieces under the book-arts classification. These come from five nations, with five works each from India and Persia.

Photographs

There is one portfolio of photographs in the permanent collection. It represents twentieth century America and contains 14 photographs.

THE COLLECTION'S FOCUS AS A DEVELOPMENTAL TOOL

The collection of the Akron Art Institute, although general in scope, has for the past ten years focused largely on twentieth century art. Arguments about the validity of this developmental direction have been alluded to in the chapters on exhibition. The question here is to ascertain just how strongly this direction has been pursued, and what effects this direction has had on the museum.

Since 1971 the museum has focused its exhibitions on twentieth century art. Thus shows have been developed that make use of new accessions, and traveling shows also have focused on the twentieth century. Catalogs were developed for the exhibitions of most importance. Catalogs are important because they indicate to the art world the clear focus of the museum in twentieth century art.

Accessions over the same period reveal that the museum has purchased exclusively twentieth century works, with items from other periods represented by gifts or donations. Gifts and donations of twentieth century items have increased relative to all gifts.

Of most importance to the museum has been the acquisition of Oldenburg's "Inverted Q," a major sculpture that has been placed in the museum's small sculpture garden.

Other developmental achievements at the local level include increased loans from the permanent collection. Loans to local libraries, hospitals, government offices, schools, and universities predominate. From other than a local point of view, the museum's loans have been limited to, for example, the loan of the museum's Frederic Remington to the Gallery of Western Art in Cody, Wyoming, and a loan of various pieces to the Ohio Arts Council, in Columbus. For those interested, the image of the museum is understood locally (not necessarily accepted), but its regional impact is minimal.

From a developmental standpoint, the museum has succeeded locally in gaining an image as an aggressive twentieth century-focused museum, but

only for a few persons interested in the arts. A little recognition comes from outside the community, but this notoriety remains more the recognition of the effort than of its notable success.

What impact has the direction had on visitation? Generally the museum's visitors have declined at about the same rate that its budget has increased. As noted earlier, there have been large declines in attendance in recent years. Membership has declined precipitously, although one does not know whether this is due to the museum's direction or to management incompetence. Obviously, the museum has picked up strong budgetary support by virtue of its charted direction, but visitations of general art viewers have declined. If the direction is a completely correct one, local visitations should increase, and visitors from outside the region should increase. But visitation decreases may result as much from lack of administrative effort as from the twentieth century focus. A museum may pick a correct direction and then simply carry it through badly. In summary, to this date the museum's choices have created an image which has increased the core of dollar support but has not brought it the casual support or interest of Akron's population. Further, it has probably cost the museum some individual memberships.

We have argued throughout this chapter that the permanent collection is the psychological basis upon which the museum survives. Even the most gauche community does not throw art into the street. But, does that mean we must keep every item of art? No, nor does it offer comment on the quality or size of the collection. The listing of items in the permanent collection, while diverse, is diverse in the sense of the diversity of Aunt Martha's attic. In that attic are items of some value, a few items of considerable value, and many items that may be of little value. If we must have a permanent collection, then the size of that collection is important only in the sense that the community must believe that the collection includes some excellent works of art along with other items, valuable but less so, and have a vague impression that the collection is large. One does not need to have 3,000 pieces of art; one may have less, as few perhaps as several dozen acceptable works surrounded by 100-odd lesser pieces, at least from the standpoint of maintaining development support. The point is to have a collection of some quality, but it need not be large. Much of the Akron museum's objects could be sold and never missed.

Further, why have an educational collection? This usually means lumping all the inferior pieces together that one never shows, and such a collection points in trivial directions, has no coherence, and can be used only in the most primitive objectives of art education. Thus, much of the museum's collection could be abandoned; not without the risk of selling tomorrow's jewel, but with the certain knowledge that many of the items to be disposed of will never be more than relics from Aunt Martha's attic. Incidentally, there is no reason to assume that items useless to the Akron

museum may not be highly prized in other museums, where the odd piece may round out or add to major collections. In short, it is wise for a museum to collect, but it need not have an extensive collection; at least, however, it ought to have good pieces, whatever that may mean.

THE STAFF'S IMPACT ON DEVELOPMENT

Perhaps one of the most unfortunate aspects of long-run museum development in Akron has been the lack of continuity in the museum's staff. Directors have come and gone; curators have come and gone; the education staff frequently changes, and consistent program development may well suffer as a result. Given that museum income has risen since 1971-72, it is only possible to imagine what levels could have been achieved if the museum's new direction in twentieth century art could have been carried through by a regular staff.

As Figure 9.1 indicates, the position of director has been vacant about 12 percent of the time since 1970. Also significant, the position of assistant director of education has been vacant a high percentage of the time, 57 percent, and has, during this period, been held by four different persons. Similarly, although the position of director of education has usually been filled, it too has been held by four different persons. With these two key positions not consistently filled, it is easy to see why education programs at the museum have been less effective than they might have been.

That the Akron Art Institute is constantly undergoing change is obvious when staffing is considered. The period of greatest flux came in the early 1970s, with vacancies surrounding the departure of the director in 1972. This represents a low point in attendance as well. There is no doubt that fluctuation in the staff has an impact on what takes place in the museum, and has a depressing effect on visitation. On the other hand, one might postulate that utter consistency suggests little change in a museum's activities and could therefore also have a depressing effect on visitation. There was probably a peak in staff turnover when attendance was low, but overall, the Akron Art Institute has suffered from too much turnover.

The new director in 1974 had an impact on the staff as positions were combined, positions were dissolved, and staff size was reduced. Permanent staff size was reduced from 16 persons to the present 13, by means of combining and dissolving positions. From a budgetary standpoint, there is not much doubt that the museum was relatively overstaffed at 16 persons.

There is a kind of vicious psychology that sets in with a new director. Once selected, the person is given the title of divine savior; the board members all react enthusiastically, and a new and brave program is undertaken. Soon, however, the honeymoon involving the board, the director, and the latest great dream is over, and energies become scattered,

Figure 9.1
Akron Art Institute Staff Shifts, 1970-78
(solid line indicates position filled)

Position	1970	1971	1972	1973	1974	1975	1976	1977	1978
Director				12	8 9 2			10	5
Director of education		4	6	8	9			2	7
Curator		11			6	Position dissolved			
Assistant director of education					9	8	6 10	6 8	
Business manger						3 6		11 3	3
Membership secretary						3 6		11 3	3
Librarian		8		9					
Director of development					8	Dissolved until		9	
Registrar		2				5	4	Position included with librarian	
Bookkeeper				7		9-12	5 8	3 Position dissolved	
Volunteer coordinator				1		8		Combined with other	
Custodian						11	11	2	
Assistant custodian						11	Position dissolved		
Saturday receptionist			11				4		
Sunday receptionist and guard									1
Secretary		8 10							

Year

Note: numbers refer to month of the year.
Source: Akron Art Institute personnel records

ideas and programs fail. Why? Some of it is simply the natural result of having new ideas around, but a lot of it probably comes from the pipe dream that Akron can aspire to great heights as a major specialized museum. Directors and board members alike refuse to see that a middle-size museum is not normally a great and exciting storehouse of art. Rather, it can probably be a good (not great) institution of artistic pleasure and education for the Akron community.

In view of the above data, new museum directors should not come into a museum with instant staff-reorganization plans. This is not to promote a conservative view of change, but rather to promote an argument for some amount of gradualism in staff changes and task changes among staff persons. One problem faced by the Akron Art Institute is that positions during the period studied were not well defined. Job descriptions were either nonexistent, vague, or misleading, and precise responsibility was not well drawn. One gets the impression that the staff was just large enough to present a definite lack of communication among staff persons. In small museums, small is beautiful when it comes to staff size, and growth in employee numbers may produce diseconomies of scale rather than economies of scale.

ORGANIZATIONAL DEVELOPMENT

Organized around a Board of Trustees of 25 active members, including the president of the Arts Council, there are seven ex officio members who serve without a vote. The board has eight officers (president, first vice-president, two additional vice-presidents, treasurer, assistant treasurer, secretary, and assistant secretary) who, along with the chairpersons of the standing committees, form the Executive Committee. Standing committees in 1977 included Accessions and Collections, Finance and Personnel, Long Range Planning, Fund Raising, Membership, Nominating, New Building, and Program Development. Minutes of meetings are kept on file at the Akron Art Institute and are available to anyone interested.

While the principal task of the Board of Trustees is the formulation of policy, the board is also involved with decisions about operations. The organization of the museum is detailed in its constitution and bylaws.[5]

The director of the institute is responsible to the board for administrative supervision of all activities. He recommends appointments to the staff and is the liaison between the board and staff. In 1972, under his direction were the business manager, the director of development, the curator, the director of Education, and the custodian (see Figure 9.2).

Consultant's Recommendations

In the *Akron Art Institute Study* of 1973, Edward Hanten suggested a number of administrative changes. One of the obvious weaknesses in the

FIGURE 9.2

Administrative Organization, 1972

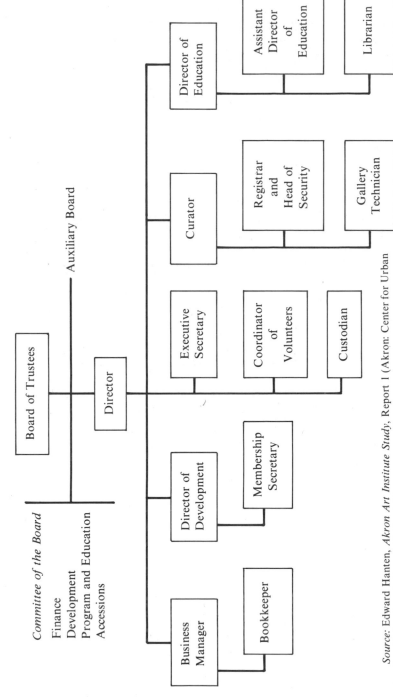

Source: Edward Hanten, *Akron Art Institute Study*, Report 1 (Akron: Center for Urban Studies, University of Akron, 1973), p. 36.

administrative structure of the Art Institute was that the Board of Trustees was not really well informed as to museum operations.[6] Hanten argued:

> Many members of the Board are quite apathetic about their involvement. This may well evolve from the fact that the Board is provided very little good information about the Art Institute. The Board operates primarily on the information provided by the Director with little or no evaluation of the quality of this information. Too often the Board acts primarily from information supplied through the revenue and expenditure statements with little concern as to program objective. What the Board needs to really make effective decisions are: first, a regular evaluation on an annual basis of the performance of particular programs offered during the previous year; second, an ongoing evaluation of what takes place in the Art Institute during the year; third, an evaluation of the performance of the staff.[7]

Hanten went on to argue that "the need for the above information can be illustrated by the fact that most Board members are unaware of the decline in attendance and membership."[8] Further: "There was no clear concept of budget or policy making procedures and little understanding of the educational activities."[9]

Hanten argued that the reason for a 1966 reduction in the number of board members was to develop a more informed board, but the reorganization did not achieve this purpose; in part due to the ineffective functioning of the board's committee structure and because some board members were willing to leave administrative considerations to others.[10] Therefore, Hanten said:

> Reducing the size of the Board and its committee structure was ill advised. It is, therefore, suggested in 1973 that the Board be increased to a total of thirty-two members, each to serve for a term of four consecutive years. After serving two consecutive terms a person must be off the Board at least two years before being eligible for another term. The problem with the present three-year term is that it is not long enough for a person to learn his responsibilities and become an effective Board member. A second reason for increasing the Board is to expand the community participation in the activities of the Institute. Persons elected to the Board should be willing to work for the Institute or at least have a major interest in the Institute's program and objectives. The Board should include various groups, even high school and college students, so that maximum inputs can be realized.[11]

Because a 32-member board could make administration difficult, Hanten recommended that a six-member Administrative Committee (including a president, two vice-presidents, a secretary, a treasurer, and an assistant treasurer) be elected by the whole board and charged with administrative responsibilities for the museum. The Administrative Committee, it was argued, should meet at least once each month, with the whole

board meeting at least twice each year.[12] Hanten suggested that the Administrative Committee appoint a group of task-oriented committees that would report to it, and that each committee provide a staff report. He suggested the following committees: Finance, Fund Raising and Membership, Accessions and Collection, Program and Staff Evaluation, Program Development, Physical Facilities, and Long-Range Planning.[13]

Hanten believed the membership of the committees should be diverse, and that all need not be board members. The point was that there should be a concerted effort to involve the most knowledgeable and interested people available. The president and director could be ex officio members of each committee but could designate another person to be their representative.[14]

Hanten recommended the committees be composed, and function, as follows:

Finance Committee

This Committee, composed of two Administrative Committee members and one other person, will be responsible for monitoring the financial condition of the Institute.

Fund Raising and Membership

This Committee of six will be responsible for planning fund raising and membership drives.

Accessions and Collection

This six-member committee is responsible for recommending the purchase of accessions. No accessions can be made without approval of this Committee and the Administrative Committee. This Committee will also be responsible for evaluating the collection and for making recommendations to the Administrative Committee as to how the collection can be maximized either through sales, trade or whatever other action may seem advisable.

Program and Staff Evaluation

This Committee of three members will be responsible for evaluating the effectiveness of the program and reporting periodically to the Administrative Committee and the Board. It will also be responsible for staff evaluation and make recommendations as to effectiveness and staff classification.

Program Development

This Committee of six members will be responsible for overall initiation of exhibition, education and special programs. It will evaluate and recommend new approaches and study feasibilities for implementation.

Physical Facilities

> This three-member Committee will be responsible for initiating and recommending improvements or other changes in facilities.

Long-Range Planning

> This six-member Committee will be responsible for establishing long-range goals and mapping a plan for goal achievement.
> These Committees should issue written reports which will be submitted to the Administrative Committee and which will be circulated to each Board member.[15]

It was further recommended that the administrative organization be divided into three major areas: policy and development, program planning, and financial management. The recommended administrative and staff reorganization is shown in Figure 9.3.

Hanten saw that this organizational alignment would at least allow for overall program planning, which was minimal at the time. It would also provide for clear delineation of functions: policy implementation, program planning, and financial management. With expanded committees, there could also be a degree of staff accountability, coordination, and planning capability not yet realized.[16]

As Hanten saw it: "In this new alignment development becomes broader than just fund raising; it becomes a support for program development. Program development will provide for the coordination of curatorial and educational functions and should lead to better utilization of staff and a more coordinated program."[17] Present organization, administration, and committee structure reflect an adaptation of Hanten's accepted recommendations.

FACILITIES DEVELOPMENT

During 1971–72, the Akron Art Institute was still in the limbo of past decades as far as the museum building was concerned. If you can imagine the parallel, the museum was functioning in a modern context, but doing so in the sense of someone trying to drive without lights on a freeway in a down-at-the-heels 1922 Pierce Arrow, a kind of elegant car, really, but energy inefficient, slow, and a danger to its own and other drivers. If the new National Gallery building in Washington, D.C. is any kind of standard for a modern collection of art, then trying to develop a modern art museum in Akron's old building cannot be considered the best of all possible worlds.

While each incoming director over past decades had had dreams of new buildings and facilities, (a building complex), the final generating energy has come from Copelans, the museum's new director since early 1978. For some

FIGURE 9.3

Proposed Administrative Organization

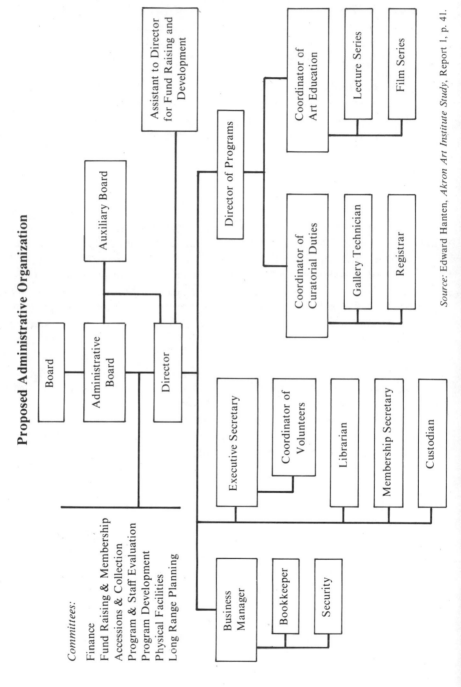

Committees:

Finance
Fund Raising & Membership
Accessions & Collection
Program & Staff Evaluation
Program Development
Physical Facilities
Long Range Planning

Source: Edward Hanten, *Akron Art Institute Study,* Report 1, p. 41.

time there had been perhaps several donors who could provide the immediate base of a genuine building fund, and events struck just right for the new director to come in and initiate a strong movement toward a new facility.

In 1978 Copelans and the board initiated a $6 million fund-raising activity aimed at what will be either new or drastically expanded and renewed facilities. Two anonymous donors have come forward with half the funds necessary, and the mood is optimistic that the effort will succeed.

Alternatives for new development still involve downtown Akron. There will be no flight to the suburbs as one of several central-city schemes will ultimately be adopted. The first alternative calls for the present building to house an auditorium, offices, educational programs, and other services. An old post office building across from the present facility would be renovated and used for collection storage, gallery space, a book store, and a sculpture garden. A bridge or an underground tunnel would connect the two buildings. Costs of this scheme, scheme A, are estimated at $3 million (see Table 9.15).

Scheme B calls for abandonment of the existing building, returning it to the city of Akron, buying land adjacent to the old post office building across from the present site, renovating the old post office for use as gallery space (much like scheme A), and building a new two-story building to provide offices, a shop, an auditorium, and classroom space. This alternative, similarly, is estimated to cost approximately $3.3 million.

Scheme C provides for abandonment of the present building, and renovating the old post office, but doing so with the purpose of turning it into an educational facility. In addition, Scheme C calls for the erection of a new building of a grander design, and costing somewhat more than the building proposed in Scheme B because of the need to provide exhibition

TABLE 9.15

Costs of Major Alternative Schemes for Museum Development

Building Costs	Scheme A	Scheme B	Scheme C
Land	$ 75,000	$ 118,000	$ 226,000
Current building	350,000	0	0
Old post office	2,000,000	2,000,000	2,000,000
New building (under a bridge)	275,000	780,000	1,170,000
Sculpture court	125,000	125,000	125,000
Parking lot	50,000	50,000	50,000
Architects' fees (7%)	196,000	207,000	234,000
Total cost	3,071,000	3,280,000	3,805,000
Operating funds required	620,000	585,000	630,000
Total endowment required	6,142,000	6,560,000	7,610,000

Source: John Copelans, Akron Art Institute Feasibility Study (Akron: Akron Art Institute, 1978).

space in addition to offices, a shop, etc. In the cases of schemes B and C the new building would be separate from the old post office building but connected by a tunnel or bypass from one building to the other. Scheme C, the most expensive, is planned at a cost of $3.8 million. As to similarities, all plans would provide for parking for 33 cars at the same cost. All three plans envision a sculpture garden that costs $125,000. In addition, exterior and interior refurbishing of the old post office is similar in cost in each scheme, at about $2 million. The primary differences appear to be in regard to where facilities within the buildings will be located and the cost differences between renovation of the old art museum (plus the cost of a connecting bridge or tunnel) versus the less expensive new building in Scheme B and the more elaborate building of Scheme C.

As to which represents the more attractive investment for the museum to make, it is difficult to say. In both schemes involving new buildings, they would be smaller than the old museum, but could probably be designed to provide more efficient museum space (23,000 square feet in the old, 12,000 square feet in the case of Scheme B, and 18,000 square feet in the case of scheme C). In addition, while it is not estimated, and assuming the old post office building is included in all three plans, the present museum building has to be more expensive to maintain and operate even after renovation. On balance, it would appear that scheme C represents the better of the alternatives, with the proviso that the museum purchase all of the available land, not just the minimum area suggested by dollar amounts noted under each scheme in Table 9.15. Parking space is minimal in all of the plans, and expanded parking could also provide revenue to the museum, through the operation of a parking facility with the extra land it would hold until such time as further development plans found other uses for it.

The precise way in which the grander scheme might finally provide for space in the post office and in the new building is uncertain. In addition, it is uncertain just what the indirect value the old museum building might have in another use, or whether or not the city would have use for it or would merely sell it. One problem in not using the old building is its use for other purposes. Will such uses (if there are any) be compatible with the new museum?

To fail to buy the available small parcels around the site would be, in the view of this author, a mistake. Similarly, to fail to adopt scheme C and settle for scheme B seems a developmental error. Costs will only rise in the future, and if the capital and operating budget proposed can be achieved, then to somewhat overexpand at this point is the better alternative. To be conservative in investment choice is not likely to prove efficient in the long run. Further, the additional land cost over and above the land required for scheme C (the most land-using of the three major schemes) would only be an estimated $165,000, which, in the light of a $3 million project, is not much. Additional land, of course, would only provide an additional 10,000 square feet, but would link the total land holdings together and increase land

holdings to a total of 77,300 square feet of prime central-business-district land.

In sum, scheme C provides strong development for the museum. Obviously, to have already achieved half of the $6 million fund-raising objective will do the museum little good if it cannot attract the other $3 million as endowment to provide an operating budget. If funds cannot be raised for the schemes, the most likely alternative is to renovate the old post office and move there from the present location. Finally, it is curious that facility development has faltered for so long. With the need well known for at least 20 years, it is obvious that the two donors, some board members, and the new director represent the essential group to serve as change agents. To fail to have a director who provides solid leadership, to fail to have an interested board, or to fail to have a base of endowment support to call upon—a loss of any of the three change elements—would cause certain failure in the development plans.

Recognize, too, that development of a building tends to dominate much thinking, and yet, even back in 1971–72 the Akron Art Institute had a good year in development funding. The argument could be made that the potential for building development was latent but obvious as far back at least as 1972, because funds for development at that time were relatively high. But, it should be remembered that development refers not just to buildings, but to the entire image of the museum, the building, the collection, and the operative elements of staff and organization, all of which hopefully lead to high-quality services in exhibition and education programs.

SUMMARY

This chapter has analyzed some of the major elements of museum development and has provided a benefit-cost analysis for 1971–72, which demonstrates that general development of the museum was the most successful of the three major program areas. Education and exhibition lagged far behind development in generating benefits, and happily for the museum, development benefits are all appropriated by the museum.

The concept of development used was based on the idea of museum survival and the positive ways in which the collection and the museum building contribute to this survival. In both cases, the building and collection, the museum is able to survive, but these two major elements are mediocre ones at best. In looking at other key elements in development— staff size and organizational structure—it was obvious that the museum suffered from a lack of continuity in its staff, and while a viable organizational structure existed, lack of administrative leadership cast a shadow on its effectiveness. A mediocre collection, poor physical facilities, and disloca-

tions in the staff and leadership all contributed to the decline in membership and annual visits. Oddly enough, budgets were maintained through 1977, large enough to account for inflation problems, even while everything else was in a downward spiral. This budgetary increase was thought to come from the steady support of patrons and others who have an interest in the museum but who may not participate much in its activities.

A FINAL NOTE ON THE AKRON ART INSTITUTE

It can be seen that the materials of this work cover a wide range of considerations, which, it is hoped, will assist museum staff persons in systematically examining elements of the museum's operation. Art publics have been initially detailed; a comparative analysis has been presented; education, exhibition, and development activities have been examined. The Akron Art Institute was shown to be an economically effective institution in the community in 1971–72, but, given its decline in visitors and in membership, a museum that by 1977 has probably passed from efficient to inefficient. And yet, it would take so little really to turn the museum around. Budgets have been maintained and the museum looked in 1978 to be ripe for a radical improvement. Plans to expand the facilities have been slow to come, but the latent community support is evidenced by the quickness with which director Copelans has embarked on a building program and the ease with which half the fund has already been committed. Akron will be a good museum yet and take its place in that honor roll of the successful. But let us not forget that a single museum like Akron's will not ever be important as an economic force in contributing to the local community's economy. It is a small economic entity, like most arts institutions. Therefore, perhaps the important aspect of the operation, economically, lies not in its direct contribution to development; but in its providing efficient services, which, along with an effective outreach program, can serve a large number, albeit a minority, of citizens. If the museum can have a developmental impact on the city, it is psychological, not economic, and important in that sense of contributing to the quality of life in the city.

One further word needs to be said concerning the perspective which one should bring to a local art museum. The fact is that museums do not generally represent a major use of the leisure time of most Americans. In the case of Akron, if we use national leisure-participation rates for 1972, and apply them to the Akron population, it is obvious that museum visits are small in comparison to most any other leisure-time pursuit. Illustratively, and on the average, an Akronite can be estimated to go camping about two days a year. Similarly, the Akronite will go hunting about two times a year, fishing about the same, bicycling about 1.3 times a year, swimming about 1.6 times a year; take nature walks once a year; and ride a motorcycle, play golf, and play tennis about once every two years. Frequency of participation in

such things as going to the racetrack, going sailing, water skiing, and hiking is, on the average, about once in three years. The high-priced amusements such as professional baseball will only occur about once every seven years, and once every six years for NCAA football games.

Comparatively, the Akronite consumes little culture through a direct visit or direct participation. On the average, the Akronite goes to the Akron Art Institute only once in 12 years and goes to a symphony-orchestra concert only once in about 20 years.

None of the above invidious comparisons suggests that the Akron Art Institute is trivial, but it is not important to most Akronites. Almost any kind of leisure pursuit is more frequent than a trip to the art museum. Because of this, people who live and work in and around the art world and the world of art museums, no matter how important art is to them, are only minor actors on the urban stage. Consequently, let us be modest about what we think an art museum amounts to in Akron or most cities of Akron's size. Similarly, let us not expect that a single museum can have great impact upon the community in which it exists. Certainly, arts activities in any community when the total is considered are very sizable and very important, but there are many things of higher priority to most city dwellers. Let us not expect too much. From an economic point of view, it can do its work effectively, even though it will have problems in continuing to do so in the future.

Note too that when one looks at the economic size of the museum, as demonstrated by its budget, it is no larger than corner grocery stores, a neighborhood bar, or any small business, and yet in comparison to these institutions, it is very well known, quite widely supported, and promoted rather well in local media. For a single institution of small size, its impact on the community is very large. For a small operation, the Akron Art Institute has a wide effect perhaps because it has a local monopoly position, but nonetheless, it does influence people.

As a final comment, it can be said that policy aimed at the improvement of services provided by this museum should aim specifically at increasing the museum's capability to systematically understand its own internal operations and its service effects, and any efforts at subsidy should focus directly on its outreach programs, its efforts to go out into the community and bring art to that community. In short, take the art to the people.

NOTES

1. John Copelans, *Akron Art Institute Feasibility Study* (Akron: Akron Art Institute, 1978), pp. 33–34.

2. Ibid, pp. 34-35.

3. Ibid.

4. Ibid.

5. Ibid., pp. 28-29.

6. Edward Hanten, *Akron Art Institute Study*, Report 1 (Akron: University of Akron), p. 35.

7. Ibid, pp. 35-37.

8. Ibid, p. 37.

9. Ibid.

10. Ibid.

11. Ibid., pp. 37-38.

12. Ibid., p. 38.

13. Ibid.

14. Ibid., pp. 38-39.

15. Ibid., pp. 38-40.

16. Ibid., pp. 40-42.

17. Ibid., p. 42.

APPENDIX A

QUESTIONNAIRE FOR FORMER MEMBERS OF AAI

1) Address:
 Number _____ Street _____

 City _____ Zip Code _____
2) How long were you a member of the Art Institute? (Number of years) _____
3) Number of children of school age, six to eighteen years old. _____
4) Are you currently a member of any other art institute or museum in north-east Ohio? 1) yes 2) no
5) When you were a member of the Art Institute, in which of the following did you and your family participate?
 _____ 1) viewed exhibitions
 _____ 2) attended art classes
 _____ 3) attended concerts
 _____ 4) attended lectures
 _____ 5) attended films
 _____ 6) used the library
 _____ 7) attended special events (wine tasting, day at the races, etc.)
 _____ 8) other: _____
6) I did not renew my membership in the Akron Art Institute because: (please rank the five most important reasons in order of importance)
 _____ 1) the exhibitions did not appeal to me
 _____ 2) I preferred going to a movie or watching TV rather than attending an Institute function
 _____ 3) the staff at the Institute was not helpful
 _____ 4) the Institute does not involve all segments of the community
 _____ 5) the educational programs were not to my liking
 _____ 6) an art institute is not necessary for Akron
 _____ 7) the programs of the Institute were not what I expected when I had joined
 _____ 8) the annual dues were too high
 _____ 9) I was too busy to use the Art Institute and its facilities
 _____ 10) I don't think the Board of the Institute is aware of the wants of the membership
 _____ 11) the location of the Institute is too inconvenient
 _____ 12) my children didn't like participating in the activities of the Institute
 _____ 13) the Art Institute is really a private social club
 _____ 14) other: _____
7) What did you like most about the Art Institute?_____

8) What did you like the least about the Art Institute? _____

9) What type of painting do you prefer?_____

10) Do you enjoy viewing the work of local artists? 1) yes 2) no

APPENDIX B

STUDY OF EXHIBITION OPENINGS

The University of Akron, in cooperation with the Akron Art Institute, is conducting a long-range study of the Institute, and would appreciate your taking one minute to complete this questionnaire and mail it to the Center in the attached envelope. This will provide us with valuable information in developing long-range plans. Thank you for your cooperation.

Address:

Number _____ Street_____

City_____ Zip Code_____

1. Are you a member of the Akron Art Institute?
 1) Yes 2) No
2. How many openings did you attend in 1972? _____
3. How many people are in your group?_____
4. How long did it take you to get from your home to the Art Institute?

5. If you had not come to the Art Institute tonight, what activity would you have pursued this evening? _____

6. Do you prefer viewing an exhibition at openings or would you rather view it another time?
 1) Openings 2) Other Times 3) No Opinion
7. Where did you learn about the opening tonight?
 1) Mailing List 2) Newspaper 3) Word of Mouth
8. Did you stop at "The Shop" tonight?
 1) Yes 2) No

APPENDIX C

NATIONAL ART MUSEUM SURVEY

Museum or Institute: _____

Name of Respondent: _____

Title of Respondent: _____

1. In what year was the art institute or museum established? _____
2. How old is your present facility? _____
3. What was the original source of funds for the establishment of your facility?
 a. foundation grant
 b. private funding
 c. donation of art collection
 d. public funding
 e. other: _____
4. Describe the physical facilities of the art institute.
 a. presently use only the original structure
 b. original structure plus addition(s)
 c. expansion currently underway or projected
5. If your answer to number 4 is b, when was your addition completed? _____
6. How many square feet are in the physical plant? (including expansion underway, if any). _____
7. How many square feet of exhibition space in the facility? _____
8. Was the building originally built for the purpose of housing an art museum?
 a. yes
 b. no
9. If your answer is no to number 8, has it been adapted successfully to art institute use?
 a. yes
 b. no (explain): _____
10. How far (in miles) is your facility from the center of the city? (main inter-section of the city). _____
11. How many parking spaces do you have on site? _____
12. What is the size of your current annual operating budget?
 a. less than $100,000
 b. $100,000 to $200,000
 c. $200,000 to $300,000
 d. $300,000 to $500,000
 e. over $500,000
13. What proportion of your current operating budget is derived from the following sources?
 Percentage
 _____ a. private foundation grants
 _____ b. membership fees

_____ c. annual or periodic fund raising

_____ d. sale of art reproductions, class fees, admission fees for cultural events, works of art, etc.

_____ e. private donors

_____ f. government support

_____ g. corporate grants

_____ h. endowment earnings

_____ i. other: _____

14. What is the current size of your budget for accessions?
 a. less than $10,000
 b. $10,000 to $25,000
 c. $25,000 to $50,000
 d. $50,000 to $100,000
 e. $100,000 to $200,000
 f. over $200,000

15. Did your institute have an operating-budget deficit in the last fiscal year?
 a. yes
 b. no

16. What kinds of works of art does your institution presently acquire?

17. How would you describe your collection?

18. Do you have annual exhibitions of art produced by local artists?
 a. yes
 b. no (if no, indicate why) _____

19. What proportion of your operating budget (exclusive of accessions and other special funds) is allocated to the following activities?

 _____ a. exhibition of the permanent collection

 _____ b. exhibition of traveling exhibits

 _____ c. educational programs

 _____ d. library functions

 _____ e. other cultural activities (ballet, music, films, etc.)

 _____ f. extension programs

 _____ g. other: _____

20. What is the size of your full-time paid staff? _____

21. Please indicate which of the following are full-time paid staff positions at your art institute?
 a. director
 b assistant director
 c. curator
 d. educational director
 e. librarian
 f. registrar
 g. director of security
 h. business manager

 i. director of development
 j. gallery technician
 k. other, please explain: _____

22. Please estimate the number of volunteer hours of work per week provided to the museum. _____

23. What is the size of your current membership?
individual memberships_____
corporate memberships _____

24. What was the total attendance during the latest fiscal year?
for fiscal year 1970-71 _____
for fiscal year 1969-70 _____

25. Do you operate any special programs for inner-city residents?
 a. yes
 b. no
If yes, please explain: _____

26. What is your admission charge (if any) for the following?
General admission
 adults _____
 children _____
Special events
 adults _____
 children _____
Special exhibitions
 adults _____
 children _____

APPENDIX D

AKRON ART INSTITUTE MEMBERSHIP QUESTIONNAIRE

1. What is your address?

Number _____ Street_____

City _____ Zip Code _____
2. How long have you lived in the Akron area?
 1) less than a year
 2) 1 to 5 years
 3) more than 5 years
3. Are you a native of Akron?
 1) yes 2) no
4. If not an Akron native, in what type of place did you live prior to moving to Akron?
 1) rural area
 2) small town (0-2,500)
 3) small city (2,500-50,000)
 4) medium-size city (50,000-100,000)
 5) large city (over 100,000)
5. Please indicate your educational attainment; check the number of years that you attended school.
 1) 0-8
 2) 8-12
 3) high school diploma
 4) 12-16
 5) B.A. degree-major _____
 6) beyond B.A.
6. Would you please indicate your age? _____
7. What is your marital status?
 1) never married
 2) married
 3) separated
 4) divorced
 5) widowed
8. Number of children. _____
9. What is the occupation of the head of the household?
 1) not employed
 2) housewife
 3) retired
 4) college student
 5) professional

6) managerial
7) clerical
8) sales
9) skilled
10) other

10. What is the occupation of your spouse?
 1) question not applicable
 2) not employed
 3) housewife
 4) retired
 5) college student
 6) professional
 7) managerial
 8) clerical
 9) sales
 10) skilled
 11) other

11. What are your main hobbies/activities; please indicate below.
 1) _____
 2) _____
 3) _____

12. How many hours in the past seven days did you spend on hobbies and other leisure-time activities?

 Activity Time (hours)

 1) _____
 2) _____
 3) _____

13. What is your total family annual income?
 1) under $5,000
 2) $5,000 to $10,000
 3) $10,000 to $15,000
 4) $15,000 to $25,000
 5) more than $25,000

14. If you are a member of other community organizations, how many of each of the following types of organizations are you a member of?
 1) recreational
 2) cultural
 3) social
 4) religious
 5) business
 6) civic

15. How many of the following organizations is your spouse a member of?
 1) recreational
 2) cultural
 3) social
 4) religious
 5) business
 6) civic

16. When was the last time you attended an exhibition at the Art Institute?
 1) never
 2) within the last 30 days
 3) 1-to-6 months ago
 4) 6 months-to-1 year ago
 5) more than 1 year ago
 6) I don't remember
17. Indicate how many of the following activities at the Art Institute you have attended in the past 12 months.
 1) film series
 2) lectures
 3) concerts
 4) members' preview
 5) art classes
 6) others, please specify: _____

18. Have any of your children ever enrolled in an Art Institute program?
 1) yes 2) no
19. Indicate the three most important reasons why you joined the Art Institute. Indicate in order of importance (1, 2, 3, etc.).
 1) I am an art collector
 2) I am a professional artist
 3) I am an art educator
 4) I work in one of the art mediums as a hobby
 5) I am interested in the arts generally
 6) I am interested in supporting the Art Institute
 7) I joined because I have friends who are members
 8) I joined so my children and/or I could take part in the functions that are available
 9) other, please specify: _____
20. How long have you been a member of the Art Institute?
 1) less than 2 years
 2) 2 to 4 years
 3) 6 to 10 years
 4) more than 10 years
21. Do you plan to renew your membership next year?
 1) yes
 2) no
 3) I don't know
 4) if no, please indicate why: _____

22. Have you recommended to your friends that they become members of the Art Institute?
 1) yes 2) no
23. Indicate other art museums in which you may hold membership? (Please indicate below.)
 1) _____
 2) _____
 3) _____

24. Are you a member of the Cleveland Art Museum?
 1) yes 2) no
25. How many times in the past twelve months have you visited the Cleveland Art Museum?
26. Do you know any of the Board members of the Art Institute?
 1) yes 2) no
27. Did you attend the last annual meeting?
 1) yes 2) no
28. Do you serve on any of the Committees of the Art Institute?
 1) yes 2) no
29. If your answer is no to number 28, please indicate why not. _____

30. Do you think the Art Institute is:
 1) growing in membership and use
 2) is constant in membership and use
 3) declining in membership and use
 4) I don't know
31. Rank in order of importance the major sources of financial support for the Art Institute (1, 2, 3, etc.)
 1) membership fees
 2) industrial and commercial contributions
 3) tax support
 4) fees and charges
 5) I don't know
32. Do you think the present location of the Art Institute is convenient?
 1) yes 2) no
33. If you could move the Art Institute, where would you like to see it located?

34. If the Art Institute had daily evening hours during the week, would you visit more often?
 1) yes 2) no
35. Would you please list in order of preference what you would consider to be five points of interest in the Akron area that a visitor to the city should see?
 1)
 2)
 3)
 4)
 5)
36. Indicate if you have purchased art from any of the following in the last twelve months:
 1) at a department store
 2) from an individual
 3) at a private art gallery
 4) at the Akron Art Institute Shop
 5) at another art museum's shop
 6) at an art exhibit
 7) from an art school
 8) other source

37. Please indicate the price range of your last purchase:
 1) less than $50
 2) $50 to $150
 3) $150 to $500
 4) more than $500
38. For whom was the purchase?
 1) own use or collection 2) gift
39. Are you familiar with the Akron Art Institute Shop?
 1) yes 2) no
40. Have you ever made a purchase at the shop?
 1) yes 2) no
41. How did you first find out about the Art Institute?
 1) radio/TV
 2) newspaper
 3) personal contact
 4) school
 5) poster or circular
 6) passed by the building and decided to stop
42. When you took your last vacation, did you visit an art museum?
 1) yes 2) no
43. Have you ever contacted any of the Art Institute personnel for assistance?
 1) yes 2) no
44. How would you grade the Art Institute staff?
 1) very courteous and helpful
 2) courteous and helpful
 3) not courteous and helpful
 4) not applicable; have never had contact
45. Have you found the Board of Trustees to be responsive to the membership?
 1) yes
 2) no
 3) cannot make judgment
46. If you were the President of the Board of the Art Institute, what would you do to change the Art Institute, if anything. I would _____

47. What activities or programs would you like to see added or expanded?
 1) _____
 2) _____
 3) _____
48. Of all the activities at the Art Institute, what do you like the most and what do you like the least?
 1) like most _____
 2) like least _____
49. Generally, the exhibitions at the Art Institute are boring to me.
 1) strongly agree
 2) agree
 3) disagree
 4) strongly disagree

50. I would rather go to a movie, stay at home and watch TV, or go to a restaurant than attend an Art Institute function.
 1) strongly agree
 2) agree
 3) disagree
 4) strongly disagree
51. I am not adequately informed of the upcoming functions at the Art Institute.
 1) strongly agree
 2) agree
 3) disagree
 4) strongly disagree
52. If I had my choice, the types of exhibitions I would like to see at the Art Institute are: _____

53. I think we should have more functions at the Art Institute where we serve refreshments.
 1) strongly agree
 2) agree
 3) disagree
 4) strongly disagree
54. Art should seek to improve the moral fiber of society.
 1) strongly agree
 2) agree
 3) disagree
 4) strongly disagree
55. The best art is that art which realistically imitates nature.
 1) strongly agree
 2) agree
 3) disagree
 4) strongly disagree
56. I feel I profit personally from most art exhibitions because something can be learned from most of them.
 1) strongly agree
 2) agree
 3) disagree
 4) strongly disagree
57. I find as much pleasure in going to a science museum, or a museum of natural history as I find in going to an art museum.
 1) strongly agree
 2) agree
 3) disagree
 4) strongly disagree
58. Art for me is a way of life.
 1) strongly agree
 2) agree
 3) disagree
 4) strongly disagree

59. I think that people who appreciate art are really better than ones who do not.
 1) strongly agree
 2) agree
 3) disagree
 4) strongly disagree

INDEX

ABOUT THE AUTHOR

WILLIAM S. HENDON is Professor of Economics and Urban Studies at the University of Akron. He is the author of *Economics of Urban Social Planning* and the editor of *The Journal of Cultural Economics.*